D1368052

THE RAPE OF EUROPA

The Rape of Europa

The Intriguing History of
Titian's Masterpiece

CHARLES FITZROY

BLOOMSBURY
LONDON

The Rape of Europa

The Intriguing History of Titian's Masterpiece

CHARLES FITZROY

BLOOMSBURY

LONDON • NEW DELHI • NEW YORK • SYDNEY

Bloomsbury Continuum
An imprint of Bloomsbury Publishing Plc

50 Bedford Square 1385 Broadway
London New York
WC1B 3DP NY 10018
UK USA

www.bloomsbury.com

Bloomsbury, Continuum and the Diana logo are trademarks of Bloomsbury Publishing Plc

First published 2015

British Library Cataloguing in Publication Data
A catalogue record for this book is available from the British Library.

ISBN HB: 9781408192092
 ePub: 9781408192115
 ePDF: 9781408192122

10 9 8 7 6 5 4 3 2 1

Typeset by Fakenham Prepress Solutions, Fakenham, Norfolk NR21 8NN
Printed and bound in Great Britain by CPI Group (UK) Ltd, Croydon CR0 4YY

To find out more about our authors and books visit www.bloomsbury.com. Here you will find extracts, author interviews, details of forthcoming events and the option to sign up for our newsletters.

To Rob and Emily

Contents

List of Illustrations viii

Acknowledgments ix

Introduction 1

1 Titian 7

2 Philip II as Ruler and Patron of the Arts 31

3 The Myth of Europa 43

4 The Spanish Habsburgs and the Alcázar
 in Madrid 53

5 The Dukes of Orléans and the Palais-Royal
 in Paris 83

6 The Taste for Titian in Nineteenth-Century Britain 125

7 Isabella Stewart Gardner, Bernard Berenson and the
 Creation of her Museum 161

Conclusion 197

Bibliography 200

Family Trees of Habsburg and Orléans 204

Index 205

List of Illustrations

Plate 1 Titian (Tiziano Vecellio), c. 1488–1576, 'The Rape of Europa',
 (c. 1560–2). (© Isabella Stewart Gardner Museum, Boston, MA,
 USA/Bridgeman Images)

 Titian, 'Danae Receiving the Shower of Gold', (1553), Prado,
 Madrid, Spain. (Bridgeman Images)

Plate 2 Diego Velázquez, 1599–1660, 'The Spinners or The Fable of
 Arachne', (c. 1655–60), Prado, Madrid, Spain. (Giraudon/
 Bridgeman Images)

Plate 3 Titian, 'Portrait of King Philip II', (1551), Prado, Madrid, Spain.
 (Giraudon/Bridgeman Images)

Plate 4 Sir Joshua Reynolds P.R.A., 'Portrait of Louis-Philippe-Joseph
 d'Orléans, Duke of Chartres, later Duke of Orléans', (1779),
 Musée Condé, Chantilly, France. (Giraudon/Bridgeman Images)

 The Palais-Royal, Paris. (Getty Images)

Plate 5 The Picture Gallery at Attingham Park, Shrewsbury, Shropshire.
 (Corbis)

 Cobham Hall, Cobham, Kent. (Alamy)

Plate 6 (Art historian) Bernard Berenson at his home outside Florence,
 Villa I Tatti, 1903. (Biblioteca Berenson, Villa I Tatti – The
 Harvard University Center for Italian Renaissance Studies,
 courtesy of the President and Fellows of Harvard College)

Plate 7 John Singer Sargent, 'Portrait of Isabella Stewart Gardner',
 (1888). (© Isabella Stewart Gardner Museum /Bridgeman Images)

Plate 8 The courtyard of the Isabella Stewart Gardner Museum, Boston,
 Massachusetts. (© Isabella Stewart Gardner Museum)

Acknowledgments

I would particularly like to thank Robin Baird-Smith and everyone at Bloomsbury for all their hard work in the production of this book, and to Jennifer Hassell for her invaluable support since the book was originally commissioned. I am extremely grateful to Lucy Morris for her editorial insight, and to Alastair Laing, Gregory Martin and Professor David Watkin for taking the trouble to read various chapters. A number of senior figures at major museums have kindly helped with my research: Dr Nicholas Penny, former Director of the National Gallery, London, and his colleagues Dr Susanna Avery-Quash, Dr Minna Moore Ede and Alan Crookham, Anne Hawley, Norma Jean Calderwood, Director of the Isabella Stewart Gardner Museum in Boston, and her colleagues Elizabeth Reluga, Lisa Long Feldmann, Courtney Allen and Oliver Tostmann, and Frederich Ilchmann from the Boston Museum of Fine Arts. I should also like to thank a number of other eminent historians and art historians: Sheila Hale, Professor Charles Hope, Baron Thomas of Swynnerton, Sir John Elliott, Professor Jeremy Black, Antonio Mazzotta, Amanda Bradley and Saraid Jones from the National Trust, Gerry McQuillan, Senior Adviser to the Arts Council, Elodie Kong, Mona Ebert and the Earl of Darnley. Charles Hill, Richard Ellis and Ulrich Boser provided me with some fascinating material concerning the burglary at the Isabella Stewart Gardner Museum in 1990. Finally, I would like to thank my wife Diana for her

understanding in putting up with what turned out to be a much longer, but considerably more interesting, project than I had originally envisaged.

Introduction

When you are next in North America, take time to visit Boston, the charming, red brick capital of New England and a thriving intellectual centre, boasting seven universities. One of Boston's most attractive features is a series of parks, laid out by Frederick Law Olmsted in the 1890s. They are known as the Emerald Necklace and encircle the centre of the city. Make a trip out to Fenway Park, a place dear to the heart of all Bostonians as the home of the Boston Red Sox, the legendary baseball team.

Fenway Park is also the setting for one of the most delightful and idiosyncratic museums in North America. Soon after Olmsted had completed his work, Isabella Stewart Gardner, a vivacious and wealthy blue-stocking and one of Boston's leading society hostesses, decided to build a mansion on the edge of the park. It was designed to house her growing art collection formed with the help of the young art historian Bernard Berenson, whom she had met while he was at Harvard University.

Making your way up to the second floor of the museum, you enter the Titian Room and find your gaze immediately drawn to the painting hanging beside the window. Titian's *Rape of Europa*, the last in a series of mythological paintings commissioned by Philip II of Spain, alone merits a visit to Boston and its reputation has spread far beyond the city as one of the finest Old Master paintings in North America. The painting's brilliant colours, the deep blue of the sea and the flaming sunset, completely overshadow the other works in the room.

1

The lustrous flesh tones of the scantily clad princess contrast with her dazzling vermilion drapery silhouetted against the sky. The rocky landscape, viewed through an iridescent light, creates a wonderful illusion of spatial depth and atmosphere. These vibrant colours, so characteristic of all the best works by Titian, play a fundamental part in creating the emotional mood of the painting.

The bull dominates the dynamic composition, surging across the waves, with the hapless figure of Europa lying in a position of abandonment on his back. There is a palpable, erotic charge to the painting, not only in the way that the princess clutches the bull's horn, her arm encircling his neck, but also in the way the flying and swimming cupids gaze at the dishevelled clothing scarcely covering the princess' genitalia, while the fiery colours in the sky seem to match the strength of the animal's lust. The princess gazes up towards two flying cupids, but her right arm is raised, as if to protect her from their bows and arrows, traditional symbols of love.

The pose of the cupid riding a dolphin appears to mimic the two main protagonists and gives the painting a light-hearted feel; this is accentuated by the almost comical way that the bull looks fearfully at the rather harmless fish swimming beside him. The princess' face is half-hidden in shadow so that we cannot read her expression, and her body language, sprawled across the back of the bull, conveys a sense of fearful expectation.

This masterpiece by Titian has enjoyed an extraordinary history. The theme of this book traces this history as the painting has moved in succession from Venice to Spain, France, England and the United States, reflecting the rise and fall of the various nations. The *Rape of Europa* was originally painted in Titian's studio in Venice in the early 1560s. This was a golden moment in Venetian painting, when Titian, the leading artist of the Venetian School, was at the height of his powers and the most sought after artist in all Europe. Venice herself, however, had entered a period of decline as her trading monopoly in the Mediterranean was increasingly affected by wars with the Ottoman Empire and new trade routes to India and the Americas. Her place had been supplanted by

Spain, mistress of a vast empire in the Americas and the Pacific, and it was the Spanish King Philip II who commissioned the *Rape of Europa* from Titian, as part of a series of mythological paintings, based on the *Metamorphoses* of Ovid. The painting was brought to Spain, where it was to reside in the private apartments of the Habsburg kings in the Alcázar in Madrid.

Although the seventeenth century was a golden age for Spanish art, dominated by major writers and artists such as Cervantes and Velázquez, the country had now entered a prolonged political and economic decline. After Charles II, the last Habsburg king, died in 1700, the great European powers fought to take possession of the Spanish Empire. France took the lion's share of the spoils, with Louis XIV's grandson succeeding to the Spanish throne as Philip V, and it was to Paris that the *Rape of Europa* moved at the beginning of the eighteenth century where it hung in the Palais-Royal, the residence of the Sun King's nephew Philippe, Duke of Orléans. For the remainder of the century it remained in the palace, where it formed part of the most celebrated art collection in France. During the French Revolution Philippe's great-grandson Louis Philippe Joseph very nearly succeeded in replacing his cousin Louis XVI as King of France, and it was his failure and subsequent bankruptcy that led to the *Rape of Europa* being brought to London, capital of the burgeoning British Empire.

Throughout the nineteenth century the painting hung in Attingham Park and Cobham Hall in England while Britain was at the zenith of her power, enjoying the enormous wealth acquired during the Industrial Revolution. By the end of the century, however, this supremacy was being challenged by America. Isabella Stewart Gardner, like a number of her newly enriched compatriots, began to collect art at the moment when the United States was beginning to overtake Britain as the world's leading economic power. The *Rape of Europa* was sold by Lord Darnley and crossed the Atlantic to enter her collection in Boston. It has resided in the museum she created ever since.

The *Rape of Europa* has been the centrepiece of a number of great art collections, but it has also survived a number of

near catastrophes. In the mid-eighteenth century the painting might easily have been destroyed by Louis, Duke of Orléans, a religious fanatic who attacked two of the finest mythological works by Correggio, a contemporary of Titian, because he disapproved so strongly of their erotic content. At the end of the century it was fortunate to emerge unscathed from the chaos of the French Revolution, when so many works of art were damaged or destroyed.

More recently, the most successful art heist in history took place in the Isabella Stewart Gardner Museum in Boston. On the night of St Patrick's Day, 1990, two thieves, disguised as policemen, gained access to the museum, and, having tied up the two security guards, proceeded to steal works of art with a conservative value of some $500 million, including two portraits by Rembrandt, his only seascape, and the priceless *Concert* by Johannes Vermeer, whose oeuvre consists of less than 40 paintings. Although these are all works of the highest quality, the thieves, surprisingly, also took a number of relatively minor objects such as the finial of a Napoleonic standard. More importantly, they left behind a number of far more valuable works, notably Titian's *Rape of Europa*.

The robbery remains the most important unsolved art crime in the world. Every major gangster and hoodlum in Boston has been linked to the crime, but nobody has ever been brought to trial for the heist and, despite supposed sightings of the paintings, they have never come to light. For all lovers of Titian's painting, it is a near-miracle that the *Rape of Europa* was not taken. Leading art detectives reckon that the Titian is simply too important to steal, since it would be all but unsaleable, but there are precedents. Even the *Mona Lisa*, arguably the most famous painting in the world, has been stolen, removed from the walls of the Louvre in broad daylight on 21 August 1911. It took the Parisian police two years to track it down to Florence, where an ex-museum employee, Vincenzo Peruggia, had hidden it in his apartment (much to the French police's annoyance, Peruggia claimed that he had only stolen the painting because a work by such an important Florentine artist should never have been in

France and deserved to return to Leonardo's native city). More recently, iconic works such as Monet's *Impression, Sunrise* from the Marmottan Museum in Paris, and Edvard Munch's the *Scream* from the National Museum in Oslo have also been stolen (all have, thankfully, been successfully recovered). We can only be profoundly thankful that the Titian is still hanging in pride of place in the Isabella Stewart Gardner Museum and that we can still appreciate the beauty of a masterpiece by one of the truly great Old Masters.

1

Titian

Titian was the grand old master of Venetian painting and enjoyed an extraordinarily long and productive life. By the time he died of the plague in 1576, he was the most esteemed artist in Europe and his works adorned the walls of the palaces of kings, princes and popes. Like many ambitious artists, from early in his career Titian sought the patronage of the most powerful rulers of the day.

He was born in Pieve di Cadore on the Venetian mainland, probably around 1490, and enjoyed a first-class training as a painter, entering the studio of Giovanni Bellini in Venice at the beginning of the sixteenth century. Under Bellini, the most brilliant Venetian painter of the *Quattrocento*, the *Serenissima* produced a painter who could vie with the best in Florence, hitherto the dominant artistic centre in Italy. Bellini's studio proved a magnet for aspiring artists in Venice, and Titian was joined by Giorgione and Sebastiano del Piombo.

The early death of Giorgione in 1510, and the departure of Sebastiano for Rome, followed by the death of the aged Bellini in 1516, left the field clear for Titian. The success of his altarpiece of the *Assumption*, with the majestic, red-robed figure of the Madonna ascending to heaven against a gold background, painted for the high altar of the Franciscan church of the Frari, proclaimed Titian as the leading painter in Venice. The

ambitious young artist now sought recognition from the rulers of neighbouring states, notably Alfonso d'Este, Duke of Ferrara and Federico Gonzaga, Duke of Mantua, both leading patrons of the arts.

In the early 1520s Alfonso d'Este commissioned works for the *camerino*, or little study, in his palace in Ferrara. The duke wished to secure the services of the greatest living Italian artists: Michelangelo and Fra Bartolommeo from Florence, Raphael from Urbino, and Giovanni Bellini from Venice, with the aim to surpass his sister Isabella D'Este, whose famous *studiolo* in Mantua contained paintings by Andrea Mantegna and Pietro Perugino. Alfonso, however, was largely unsuccessful: Raphael and Fra Bartolommeo died before they could carry out the commission, and Michelangelo failed to execute a single painting, so the frustrated duke was left with just one work by Giovanni Bellini.

Alfonso therefore decided to commission Titian from nearby Venice. The ambitious artist was only too happy to oblige, and painted three mythological subjects for the duke: the *Worship of Venus*, the *Bacchanal of the Andrians* (both Prado, Madrid) and *Bacchus and Ariadne* (National Gallery, London), pastoral idylls set in beautiful landscapes filled with pagan, pleasure-loving figures. They were to serve as the prototype for Titian's second series of mythological paintings, of which the *Rape of Europa* is the last and finest example.

The mythological paintings for the Duke of Ferrara were an example of Titian's versatility; he was already regarded as a master of religious works, portraits and female nudes. Following the success of these works, he was commissioned to paint portraits by the leading rulers of Northern Italy: the Gonzaga Dukes of Mantua, the Medici Dukes of Florence and the della Rovere Dukes of Urbino. These rulers were under the suzerainty of Spain, which had defeated France in a series of wars at the beginning of the sixteenth century and now exerted direct or indirect control over the entire Italian peninsula, with the exception of the independent Republic of Venice. The King of Spain and the Holy Roman Emperor Charles V, was the ruler

of a world wide empire encompassing Spain, the New World, Germany, the Netherlands, Milan and Naples. During the 1530s and 1540s, following an introduction by Federigo Gonzaga, a close ally of the emperor, Titian executed a number of portraits of Charles V. It was to be Charles' son Philip who was to become the Venetian artist's most important patron.

The two men met for the first time in Milan in December, 1548, when Philip was touring the Habsburg possessions in Northern Italy. The prince had been brought up in Spain and this was the first chance to visit the extensive patrimony that he was soon to inherit from his father. It was a disparate empire comprising Spain, the Netherlands, much of the Italian peninsula, extensive Habsburg landholdings in Germany, Bohemia and Austria, and the newly discovered Americas. Although Philip was given royal treatment on his travels, his reserved character and inability to speak foreign languages made a poor comparison with his father, an outgoing man, possessing regal presence, and a natural linguist.

The prince had blond hair, pale blue eyes, large lips and the prominent Habsburg jaw. The Venetian ambassador Federigo Badovaro described his appearance:

'He is small in stature and his limbs are mean. He has a fine large forehead, his eyes are large and blue, his eyebrows are thick and close together, the nose well proportioned; his mouth is big and the lower lip protuberant; this last is rather unbecoming. His beard is short and pointed. His skin is white and his hair is fair, which makes him look a Fleming; but he has the manners of a Spaniard.' Overall, Philip appeared to have made little impression on those he met on his travels. He was 'not very agreeable to the Italians, not very acceptable to the Flemish, odious to the Germans', in Badovaro's words.

At this early stage Philip was already showing an interest in the arts, and had been particularly impressed by the Palazzo Doria in Genoa and the Palazzo del Te in Mantua, with its large collection of paintings by Titian, but he was not yet a major patron. However he knew how pleased his father had been with a number of portraits he had commissioned from

Titian, including the magnificent *Equestrian Portrait of Charles V* (Prado, Madrid) celebrating the emperor's victory over the German Protestant princes at the battle of Muhlberg (since 1517, when Martin Luther had first taken a stand against the Roman Catholic Church, the Reformation had divided Germany on religious lines and Charles, as Holy Roman Emperor, had spent years attempting to control his unruly, Protestant subjects). Charles was flattered by Titian's depiction of him as a modern-day St George, mounted on his black charger, holding a spear, portrayed against a brilliant sunset. He decided to create Titian Knight of the Golden Spur and appointed him Count Palatine of the Holy Roman Empire, unheard of honours for a mere artist. The painter celebrated by commissioning the Sienese medallist Pastorino de' Pastorini to portray him in profile as an ancient Roman with the inscription EQUES prominently displayed beneath.

Like his father, Philip enjoyed Titian's company and decided to ask the artist to paint his portrait. The result was a splendid full length portrait of the prince wearing a suit of damascened armour, designed to show that Philip was worthy to inherit his father's mantle.

Shortly afterwards, the prince and the painter parted, and Philip continued his tour of the Habsburg patrimony in the Netherlands, where he enjoyed spectacular celebrations at the palace of Binche, the magnificent residence of Charles V's sister Mary of Hungary, an assiduous collector of the works of Titian. When he rejoined his father in Augsburg, Philip was able to admire a work that the painter had just given to his father entitled *Venus with Cupid and an Organist* (there are five versions of this painting, showing its popularity), a highly erotic work where the organist gazes back at the naked Venus lying behind him, her foot nonchalantly resting on his tunic, while Cupid fondles her breast. What is particularly remarkable about this painting is that the organist's features bear a marked resemblance to those of Philip.

If Titian intended this to be a tribute to the young prince, he was completely successful. From this moment onwards Philip

acquired a passion for the artists's work. Initially, he had voiced some criticism over the painter's technique in a portrait of his aunt Mary of Burgundy, writing: 'you can easily see the haste with which he [Titian] painted it, and if there had been more time I would have made him work on it again.' However, any reservations the prince may have held about the freedom of the painter's technique soon disappeared. In 12 September 1550, Philip wrote to the Spanish ambassador to Venice, Juan Hurtado de Mendoza, urging him to speed Titian's return to Augsburg: 'it would greatly please me that he [Titian] should come as soon as possible, I commission you, if he has not already left when you receive this, to urge him to hasten his departure'.

Titian was keen to accept such a prestigious invitation, spending the winter of 1550–1 as the prince's guest in Augsburg. By the time the two men parted (they were never to meet again), they had made an agreement whereby Titian was to supply Philip with paintings on a regular basis. In effect he was appointed court artist *in absentia*, serving his master in Spain while remaining in Venice. This was to continue for the rest of the artist's life.

The next commission that Titian executed for the prince, a series of six mythological paintings taken from Ovid's *Metamorphoses*, depicts the loves and lusts of the Gods. He referred to these paintings as *poesie*, poems in paint, where the paintings should aspire to the level of poetry and inspire similar feelings and intellectual thoughts as the poems themselves (in the sixteenth century mythological painting was ranked alongside religious works as the highest form of art). Unlike the light-hearted nature of the mythologies that he had painted for the Duke of Ferrara, however, these works convey a more complex message. Titian, like many Renaissance humanists, was influenced by Aristotle's *Poetics*, which defined the main characteristics of tragedy as pity and fear.

All six *poesie* follow Aristotle's work in demonstrating an ambivalent mood, where the force of love between Gods and mortals is fragile and fraught with danger, and may lead either to ecstasy or to tragedy. The myths that Titian chose to depict,

in chronological order, were: *Danae, Venus and Adonis, Perseus and Andromeda, Diana and Actaeon, Diana and Callisto* and the *Rape of Europa*, the last in the series. The mood of these paintings varies, commencing with an ecstatic Danae, awaiting her ravishment by Jupiter, who descends in a cloud of gold. In contrast Venus clings to the departing Adonis, only too aware that the huntsman is going to his death. Love is triumphant once again as Perseus swoops through the air to kill the dragon threatening the chained Andromeda. But the two scenes with the goddess Diana are full of impending tragedy as the unsuspecting Actaeon comes across the naked goddess bathing with her maidens, while her maid Callisto, who is carrying Jupiter's child, tries to hide her pregnant body from the unflinching gaze of the goddess. In the last scene, Europa sprawls in a position of abandonment across the back of Jupiter, disguised as a bull, who will ravish her as soon as she arrives on the shores of Crete.

A further painting, of *Jason and Medea*, was never executed but the *Death of Actaeon* (National Gallery, London), painted after the *Rape of Europa* remained in the artist's studio until his death. It is therefore not part of the series that was sent to Philip II, and is the darkest painting of all, depicting the moment when the goddess Diana fires her arrow at the startled Actaeon, who is already being transformed into a stag. The actual myths themselves are discussed in more detail in Chapter 3.

Various attempts have been made to give the *Rape of Europa* and the other *poesie* a Christian or philosophical interpretation. Philip was a fervent Catholic who owned a copy of the standard translation of Ovid's *Metamorphoses* into Spanish by Jorge da Bustamente that stressed the moral and Christian content in the myths. Proponents of this interpretation put forward a metaphysical point of view, citing Philip's awareness of the prevailing Neo-Platonist philosophy, an attempt to reconcile paganism with Christianity.

But there is not a shred of evidence to support these arguments. What seems much more likely is that the time artist and patron spent together in Augsburg during the winter of 1550–1 gave them ample opportunity to discuss the commission in detail

and this resulted in a shared vision. Philip relished Titian's love of painting the female nude (interestingly all six heroines are nude, or almost nude, while the three male protagonists, Adonis, Perseus and Actaeon, are all clothed) and appreciated the paintings primarily for their physical beauty.

In addition, Philip trusted Titian's judgement. Working for a prince who was shortly to become the most powerful ruler in Europe (Philip's father Charles V abdicated in 1555, leaving his brother Ferdinand to succeed him as Holy Roman Emperor while Philip himself took control of all his other possessions), Titian was given complete independence in his choice of subjects and how he interpreted them. Despite his broad, humanist education which meant that he was much better versed in the classics than Titian, who was unable to read Latin, the prince allowed the artist to take the liberty of changing one mytho-logical subject for another and eliminating a third one without any consultation. This appears all the more remarkable since Philip was famed for exerting such close control over every aspect of his life, including his other artistic commissions.

There is no correspondence to demonstrate what Philip agreed with Titian in Augsburg and some major art historians have therefore exaggerated the degree of artistic independence enjoyed by Titian, regarding this as a turning point in his career, and indeed in the history of sixteenth-century art. David Rosand, who has written extensively on the artist, was convinced of this, stating: 'With the courtly know-how of a Raphael and the almost arrogant self-confidence of a Michelangelo, Titian seemed to have achieved the social status that had been a goal of Renaissance painters at least since Alberti's [a multi-talented Florentine artist and writer] first articulation of such a program in 1435.'

Ernst Gombrich, an Austrian émigré who came to England in the 1930s and whose *The Story of Art* is generally regarded as the best introduction to the visual arts, claimed that 'in earlier times it was the prince who bestowed his favours on the artist. Now it almost came to pass that the roles were reversed, and that the artist granted a favour to a rich prince or potentate by

accepting a commission from him.' He concluded the passage by making an even bolder statement: 'At last the artist was free.' Gombrich was thinking in particular of the polymath Leonardo da Vinci, a brilliant artist, scientist, architect, engineer and inventor who made a series of astonishing designs of weapons of war, flying machines and water systems, as well as executing paintings and sculpture, while working at the court of Milan in the 1480s and 1490s (though his patron, the Duke of Milan, was endlessly frustrated by Leonardo behaving as a free spirit and failing to complete the various commissions he undertook, notably the fresco of the *Last Supper*).

These claims are too bold, but Titian does deserve to be ranked alongside Leonardo, Michelangelo and Raphael at the summit of sixteenth-century art. The four men raised the position of the artist to a new level in society. Leonardo ended his days as the confidant of François I of France. Michelangelo was a sculptor, painter, architect and poet who dared to confront the fearsome Pope Julius II during the painting of the Sistine Chapel. Raphael was a painter and architect, and the friend of Pope Leo X who presided at the artist's wedding in the villa of the wealthy banker Agostino Chigi in Rome (now known as the Villa Farnesina).

Titian, however, was a painter, not a polymath, and his exalted status was due entirely to his ability with the paintbrush. Carlo Ridolfi, writing his life in the seventeenth century, recorded a famous story of how the artist dropped his paintbrush while painting Charles V's portrait 'which the emperor picked up [an unheard breach of protocol], and bowing low, Titian declared: 'Sire, one of your servants does not deserve such an honour.' To this Charles replied: 'Titian deserves to be served by Caesar.'

To show his appreciation of his favourite painter, Charles' son Philip paid Titian an annual salary of 500 ducats, the sum that a leading member of the Venetian government was likely to earn in a year, ten times the wages of a manual worker in the Arsenal (the dockyard in Venice where ships were built and repaired). But the note of flattery that the painter liked to use when writing to his patron shows that he was a consummate courtier,

anxious not to take any liberties. Titian compared Philip with Alexander the Great, with the painter cast in the role of Apelles, pre-eminent among ancient painters and famed for his portrait of Alexander.

The large number of letters between artist and patron during the 1550s shows the importance both men attached to the commission of the six *poesie*, Philip urging haste in the completion and delivery of the paintings, Titian anxious to ensure that they have arrived safely and that they have been well received. The tone for the whole series was set by the first subject Titian chose, possibly the most erotic picture he ever painted. *Danae* was a reworking of a theme that he had executed some 20 years earlier for Cardinal Alessandro Farnese, another great patron of the arts. Alessandro was grandson of Pope Paul III, whose portrait had been painted by Titian. The pope had renounced his sybaritic youth, during which he had sired a number of illegitimate children, when he was elected to the papacy, and had subsequently led the reform of the Catholic Church and set up the Council of Trent.

Alessandro, however, although a cardinal and a prince of the church, had shown little desire to give up the sins of the flesh and conform to the new morality espoused by his father. He commissioned Titian to execute two paintings of his mistress Angela, one clothed, the other naked. In order to provide a modicum of decorum, Titian portrayed the cardinal's mistress as the mythical figure of *Danae* (Capodimonte, Naples) lying naked on a bed about to be seduced by Jupiter, who is descending in a shower of gold (remarkably, it was deemed perfectly acceptable for women to appear nude in mythological subjects though it was seldom a cardinal's mistress who posed in this manner).

The painting arrived in Madrid in 1554, much to the delight of the king. Later that summer Titian sent *Venus and Adonis* (Prado, Madrid) to London shortly after Philip's marriage to the English Queen Mary I. To show the personal nature of the commission, the features of Adonis bear a marked resemblance to those of the king. Philip could scarcely wait for the painting's arrival, cajoling his secretary in Italy Diego de Vargas in a letter

dated May 1556: 'The sooner you send them to me, the greater pleasure you will give me and the greater will be your service to me.' At the same time he urged Titian, whom he addressed fondly as *'amado nuestro* [our friend]' (a singular compliment) to complete 'some pictures that I commissioned and that I am looking forward to very much.' Anxious to comply, the painter obliged, sending the king *Perseus and Andromeda* (Wallace Collection, London), the third in the series.

A letter from Venice dated 19 June 1559, in which Titian describes the completion of both paintings recounting the myths of Diana (the fourth and fifth in the series and now in the National Gallery), shortly to be sent to Spain, includes the first mention of the *Rape of Europa*:

> After their dispatch I shall devote myself entirely to finishing the 'Christ on the Mount', and the other two poesies which I have already begun – I mean the 'Europa on the shoulders of the Bull,' and 'Actaeon torn by his Hounds [National Gallery, London]'. In these pieces I shall put all the knowledge which God has given me, and which has always been and ever will be dedicated to the service of your Majesty. That you will please accept this service so long as I can use my limbs, borne down by the weight of age.

It is important to note the title that Titian used for the painting: Europa on the shoulders of the Bull. He was to use other titles such as *Europa sopra il tauro* (Europa on the bull) but none of them contained the word 'Rape' which is therefore a misnomer. It was Cassiano del Pozzo, a Roman connoisseur who saw the painting in the Alcázar in Madrid in 1626, who first gave it the title by which it has been known ever since. All later comments on the painting, therefore, which have tended to be coloured by the word 'Rape', need to be treated with great caution.

Subsequent correspondence between artist and patron shows how concerned Titian was about Philip's reaction on receiving the paintings. He wrote several times to ascertain whether the paintings of *Diana and Actaeon* and *Diana and Callisto* had arrived safely (they finally reached Spain in the spring of 1561).

In a typical letter dated 22 April 1560 he enquired: 'if they have not pleased the perfect judgement of Your Majesty I will labour to remake them again, to correct past errors'. Once the king was satisfied, Titian continued, 'I will be able to put more heart into finishing the fable of Jove with Europa [the *Rape of Europa*] and the story of Christ in the Orchard [the *Agony in the Garden*, the Escorial], in order to make something that will not prove entirely unworthy of such a great King.'

It is also interesting to note that, at this point, Titian was painting both mythological and religious subjects for Philip. The king had a complex character which has puzzled historians ever since. But (as I will describe in more detail in the next chapter) the seeming discrepancy between a man who could savagely persecute Protestants throughout his dominions while secretly enjoying a succession of mistresses is reflected in his patronage of the arts where he could take equal enjoyment from Titian's deeply religious *Agony in the Garden* and his highly erotic *Rape of Europa*.

Titian was certainly determined that his work should be up to the highest standards and, as a result, he took his time. Over a year later, the paintings remained unfinished. On 2 April 1561 Titian wrote to the king, informing him that his *Magdalen* [the Escorial] was now completed, and ready to be dispatched to Spain, 'and, in the meanwhile, I shall get ready the *Christ in the Garden* and the *Poesy of Europa*, and pray for the happiness which your Royal Crown deserves.' Progress was slow, however. Four months later, on 19 August, he gave Philip more news: 'Meanwhile, I shall proceed with the *Christ in the Garden*, the *Europa* and the other paintings which I have already designed to execute for your Majesty.' Philip, in his careful way, made a note on the letter for Titian to hasten the completion of the pictures and that they should be dispatched with great care from Genoa, and not suffer the fate of an earlier painting of the *Entombment*, lost at sea.

Eventually, the *Rape of Europa* was dispatched to Spain, together with the *Agony in the Garden*, in 1562, with an accompanying letter to Philip. Once again there is an anxious tone to the letter which ends: 'still, having dedicated such knowledge

as I possess to Your Majesty's service, when I hear – as I hope to do – that my pains have met with the approval of Your Majesty's judgement, I shall devote all that is left of my life to doing reverence to your Catholic Majesty with new pictures, taking care that my pencil [i.e. brush] shall bring to that satisfactory state which I desire and the grandeur of so exalted a King demands.'

Unfortunately, there is no record of what Philip's Spanish contemporaries thought of Titian's work. It is in Venice that we find contemporary opinions of Titian's *poesie* and of Titian's art in general. Lodovico Dolce's influential *Dialogo della Pittura*, published in 1557, championed the art of Titian. It was written shortly after Giorgio Vasari's first edition of his *Lives of the Artists*, first published in 1550, had omitted Titian completely. Vasari's work, with its vast array of information on all major Italian painters from the time of Giotto onwards, ever since regarded as the single most important source on Italian Renaissance painting, was designed to show the supremacy of the Tuscan School of Painting.

Dolce and Vasari argued in favour of the two opposing ideas that dominated sixteenth-century Italian painting: the art of *colore* (the supremacy of colour over drawing) and that of *disegno* (the creation of idealized forms based on drawing). For Dolce, the art of *colore* was perfected in Venice with Titian as its leading practitioner, while Vasari considered the art of *disegno*, the main characteristic of Florentine art, to have reached its highest point in the figure of Michelangelo. The debate over the merits of the two schools of art was to continue into the seventeenth century when the art of *colore* was championed in the art of Peter Paul Rubens, a great admirer of Titian (he was to execute a copy of the *Rape of Europa*), while the French classical painter Nicholas Poussin favoured the art of *disegno*.

Despite the disagreements between Dolce and Vasari, and the latter's omission of Titian in the first edition of his work, it is interesting to observe the consensus between the two men over the *Rape of Europa*. Dolce had marvelled over the slightly earlier *Venus and Adonis* in a letter to the Venetian nobleman

Alessandro Contarini, how the goddess seemed to be alive and the effect she has so that a spectator feels himself 'warmed, softened, and all the blood stirring in his veins. Nor is it any wonder: if a statue of marble could somehow with the stimuli of beauty so penetrate the marrow of a youth that he leaves a stain there, then what must this painting do, which is of flesh, which is beauty itself, which seems to breathe?'

For Dolce, the *Rape of Europa* possessed a similar truth to nature. Titian's compositions were seen to be entirely original, showing true invention (the concept of *invenzione* was very highly regarded in the Renaissance). It was the combination of the extraordinarily lifelike depiction of everything he painted and his astonishing use of colour that singled Titian out from his contemporaries. Dolce contrasted this with the more stylized creations of the school of *disegno*, where artists made careful use of a series of preparatory drawings to create their compositions.

Vasari, who was an important painter in his own right, included Titian in his second edition of the *Lives of the Artists*, published in 1568 after he met the painter on a visit to Venice in 1566. He praised works such as the *Rape of Europa* for the way that they 'seemed alive'. Vasari gave a sensitive analysis of the work and of Titian's technique, showing how the painter was able to achieve his effects by painting in a much bolder and freer style than he had used in his youth:

Titian also painted a Europa crossing the ocean on the bull. These paintings are held most dear because of the vitality Titian gave to his figures with colours that make them seem almost alive and very natural. But it is certainly true that his method of working in these last works is very different from one he enjoyed as a young man. While his early works are executed with a certain finesse and incredible care, and made to be seen both from close up and from a distance, his last works are executed with such large and bold brush-strokes and in such broad outlines that they cannot be seen from close up but appear perfect from a distance.

Vasari's last sentence introduces a major new development in the art of painting. Titian was now a complete master of the medium of oil paint and, to show his skill, the objects he painted, where individual brushstrokes are clearly visible close up, make perfect sense when seen from a distance. To his contemporaries, this ability was semi-miraculous. And it was this aspect of the Venetian master's art that appealed to later artists such as Rubens and Velázquez, both of whom made a close study of the great Titians in the Spanish royal collection.

Moreover, Titian made painting look easy. The idea of casual elegance or nonchalance was very fashionable at the time. It had been put forward by Baldassare Castiglione, in his highly influential *The Courtier*, published in 1528, as the ideal way to behave for those living at a princely court, and Titian, acutely aware of his status as an artist working for the most powerful men and women of his time, aspired to the rank of a courtier. Consequently, he wanted to show a similar sense of ease in his paintings.

Vasari, who worked as both a painter and an architect for the Grand Dukes of Tuscany, understood this very well. He knew that Titian's seemingly spontaneous way of painting was, in fact, the result of much careful labour:

> And this comes about because although many believe them to be executed without effort, the truth is very different and these artisans are very much mistaken, for it is obvious that his paintings are reworked and that he has gone back over them with colours many times, making his effort evident. And this technique, carried out in this way, is full of good judgment, beautiful and stupendous, because it makes the pictures not only seem alive but to have been executed with great skill concealing the labour.

The *Rape of Europa* is a magnificent example of Titian's late technique. Throughout his career he had experimented with the possibilities of slow-drying and semi-translucent oil paint. He also added numerous glazes which give his paintings an

extraordinary transparency and luminosity, and enabled him to achieve an infinite variety of hues and gradations of tone. This technique allowed flexibility; an analysis of the substantial under-drawing in his works shows how often he changed his mind as the work progressed.

Initially, the artist used a thin white gesso ground into which he drew an outline of the figures. He then proceeded to build up the composition by using numerous layers of pigment, opaque or semi-opaque scumbles (thin or dragged layers of paint) and translucent glazes (thin coats of transparent colour). The lighter passages were painted with impasto (a thick layer of pigments), while the darker ones were painted more thinly. The paint layers would then soak into and practically absorb the gesso ground. This was a very slow and complex process, allowing the paint to dry completely before the next layer of paint was applied.

Palma Giovane, who completed a number of Titian's canvases after his master's death (he was the son of Palma Vecchio, one of the best Venetian painters of the early sixteenth century), gave the best account of the complexities of his technique. It is extremely revealing of how Titian worked.

'He laid in his pictures with a mass of colour, which served as a groundwork for what he wanted to express. I myself have seen such vigorous under-painting in plain red earth for the half tones or in white lead. With the same brush dipped in red, black or yellow he worked up the high parts and in four strokes he could create a remarkably fine figure.' This freedom of brushwork is very apparent in the hands of the *amorini* in the *Rape of Europa*, which have been summarily blocked in.

Palma continues his description:

'Then he turned the picture to the wall and left it for months without looking at it, until he returned to it and stared critically at it, as if it were a mortal enemy ... Thus by repeated revisions, he brought his pictures to a high state of perfection and while one was drying he worked on another. This quintessence of a composition he then covered in many layers of living flesh.' The complications of Titian's technique explain why there was such a delay in the delivery of the six *poesie* to Philip II.

As Vasari had pointed out, the effect that Titian achieved was one of spontaneity, but, in fact, this was the product of much careful labour. Nevertheless, despite the high praise he accorded Titian, the Tuscan was still determined to prove the superior qualities of the art of *disegno* in which he had been schooled. Vasari could not resist including the remarks made by Michelangelo when shown the *Danae* by Titian (the first version belonging to Cardinal Farnese). The Florentine lavished praise on Titian's style, saying that it

> ... pleased him very much but that it was a shame that in Venice they did not learn to draw well from the beginning and that those painters did not pursue their studies with more method. For the truth was, that if Titian had been assisted by art and design as much as he was by nature, and especially in reproducing living subjects, then no one could achieve more or work better, for he had a fine spirit and a lively and entrancing style.

When Francisco de Vargas, Charles V's ambassador to Venice, asked the artist why he did not paint in a more refined manner, Titian defended the way in which his original technique singled him out and ensured his fame, replying:

> Sir, I am not confident of achieving the delicacy and beauty of the brushwork of Michelangelo, Raphael, Correggio and Parmigianino; and if I did, I would be judged with them, or else considered to be an imitator. But ambition, which is as natural in my art as in any other, urges me to choose a new path to make myself famous, much as the others acquired their own fame from the way that they followed.

Titian, of course, was absolutely right to disagree strongly with Michelangelo's verdict. It was precisely his ability as a colourist as opposed to a draughtsman that was his greatest talent, and one that constitutes his claim to be one of the very greatest Old Masters.

Titian was famous in his native Venice and enjoyed a life of some splendour in the Biri Grande, the northern quarter of the city. The painter inhabited the top floor of a grand palazzo, from where he could enjoy distant views across the lagoon towards his native Dolomites, which appear through a translucent haze in the background of the *Rape of Europa*. During the day-time the house was full of activity, with models and sitters coming and going. They were heading for the artist's studio in his garden. From contemporary accounts this was a well organized space, with all the accoutrements of his trade neatly arranged: the brushes cleaned and sorted, packets of linseed and walnut oil, gums and resins used as varnishes or to manufacture pigments, sacks of plaster and wood for stretcher-making, all stacked and sorted. As a maritime city, Titian was able to buy his canvases from the sail-makers who worked in the Arsenal, where the great galleons were built and supplied.

Titian also capitalized on Venice's position as centre of the pigment trade in Italy. It was the only city in Italy where there were specialist colour suppliers as opposed to general apothecaries. For an artist with Titian's reputation and means, he could afford the richest colours to create a sumptuous effect: lead white, brilliant vermilion and lead-tin yellow from Venice itself, earth pigments from Siena and Umbria, malachite from Hungary, scarlet cochineal from Mexico (a dye made from the dried bodies of a Coccus insect found in cactuses) and the extremely expensive ultramarine made from lapis lazuli imported from far-away lands in Asia (present day Afghanistan). Venetians were a trading nation, always open to new ideas. This was the first city in Italy to adopt the novel technique of oil paint, something that had been discovered in the Netherlands in the early fifteenth century. Titian was a master of this medium a meticulous worker who took great trouble to find exactly what he wanted. When he was based in Augsburg, he asked his friend Aretino to bring some red pigment, 'the kind that so blazes and is so brilliant with the true colour of cochineal that even the crimson of velvet and silk would seem less than splendid in comparison with it'.

Titian was a highly proficient technician, an absolute master of his trade, but he was also acutely aware that he was more than a mere artist. He therefore made sure that when a visitor came to his studio, he would find the painter dressed as befitted his social position and not in a paint-stained overall. Titian painted a number of self-portraits wearing a fur-lined cloak and adorned with the chains showing his knighthood, with not a paint brush in sight. He depicts himself with a high brow and skullcap to demonstrate the painter's intellectuality.

Visitors were amazed that such an immaculately dressed figure could transform his female models, invariably women of low virtue, into goddesses and saints. Shortly after finishing the *Rape of Europa*, a Florentine visitor to his studio was amazed at the voluptuous beauty of a *Mary Magdalen* painted for Philip II. He recorded:

> I remember that I told him she was too attractive, so fresh and dewy, for such penitence. Having understood that I meant that she should be gaunt through fasting, he answered laughing that he had painted her on the first day she had entered, before she began fasting, in order to be able to paint her as a penitent indeed, but also as lovely as he could, and that she certainly was.

What relations Titian enjoyed with his female models has always been an open question. As early as 1522, when the artist had been painting the set of *poesie* for Alfonso d'Este, there were rumours that he enjoyed their favours. The duke's agent Jacopo Tebaldi had written to his master: 'I have been to see Titian, who has no fever at all. He looks well, if somewhat exhausted, and I suspect that the girls whom he paints in different poses arouse his desires – which he then satisfies more than his limited strength permits. Though he denies it.' Tebaldi's insinuation is backed up by a painting (now lost) by an anonymous Venetian contemporary entitled *Titian and his Courtesan* where the artist has placed his hand on the pregnant belly of his companion.

On the other hand, Titian's close friend Pietro Aretino, a salacious and gossipy writer, whose scurrilous lampoons of the

ruling powers in Italy had driven him to seek refuge in Venice, did not subscribe to this view. Considering his reaction at the sight of *Danae*, there is little doubt how Aretino would have behaved if he had been in the artist's shoes: 'My God, her neck! And her breasts ... would have corrupted virgins and made martyrs unfrock themselves ... The front of her body drove me wild, but the wonder and marvel which really maddened me were due to her shoulders, loins and other charms.' But, surprisingly, he defended his friend's morality in dealing with his models in a letter to the sculptor and architect Jacopo Sansovino, another close friend of Titian: 'What makes me really marvel at him, is that, whenever he sees fair ladies, and no matter where he is, he fondles them, makes a to-do of kissing them, and entertains them with a thousand juvenile pranks, but goes no further.'

Whatever the truth, all the evidence suggests that Titian was happily married to Cecilia, a barber's daughter from his hometown of Cadore, who bore him two sons and two daughters, but she died very young in 1530. Thereafter his household was run by his sister Orsa. The painter certainly enjoyed an enviable lifestyle in his house in Venice. After a day spent painting in his studio Titian loved to entertain his friends in his house. His two closest companions were Pietro Aretino and Jacopo Sansovino, a sculptor turned architect (he was to build the Library and several fine palaces on the Grand Canal). Both originally hailed from Tuscany, but made their names in Venice. The three talented figures formed a literary and artistic triumvirate that dominated Venetian society. Aretino was a brilliant conversationalist with an obscene wit (he was reputed to have died by suffocation laughing at a filthy joke he had just told). He was also a great champion of Titian's art and had been painted by the artist three times. Sansovino had originally been a sculptor but, after moving to Venice following the Sack of Rome in 1527, he became chief architect to the *Serenissima* and enjoyed numerous commissions to build churches and palaces all over the city.

Francesco Priscianese, a visitor to Titian's house, gave a memorable account of a convivial evening in the spacious garden laid out in front of the house, where the guests included Pietro

Aretino, 'a new miracle of nature, and next to him as great an imitator of nature with the chisel as the master of the feast is with the brush, Messer Jacopo Tatti, called il Sansovino'. Priscianese continues by praising the beauty of the garden and the view towards the island of Murano: 'This part of the sea, as soon as the sun went down, swarmed with gondolas, adorned with beautiful women, and resounded with the varied harmony and music of voices and instruments, which till midnight accompanied our delightful supper.'

This delectable lifestyle is indicative of Venice's status as the richest and most politically stable city in Europe. Titian certainly enjoyed a great deal more freedom living in Venice than he would have done had he obeyed Philip's wishes and moved to Spain. Not only would he have been subject to the king, but also to the Catholic Church, a much more intrusive organization than in his native Venice. The painter knew that the Council of Trent, held in an imperial town just north of Venice, had greatly increased the power and authority of the Spanish king as secular spearhead of the Catholic revival, with the Inquisition as one of his main weapons. Venetians feared that, despite its reputation for religious toleration, the decrees of the Council would lead to interference in its internal affairs and the persecution of its citizens.

The contrast between the treatment meted out to the sculptor Leone Leoni, working in Spain, who was imprisoned by the Spanish Inquisition, and Titian's star pupil Paolo Veronese's encounter with the Venetian equivalent, was very instructive. Veronese was summoned in 1573 to explain why he had filled his painting of the *Last Supper*, in the words of the Inquisitor, with 'buffoons, drunken Germans, dwarfs and other such scurrilities'. The painter was contrite, agreeing with the tribunal's findings but, in an act of bravado, made just one alteration to the picture, changing the title to *Feast in the House of Levi*. The Inquisition in Venice accepted this without demur, something that it is impossible to imagine happening in Spain.

No wonder Titian wished to remain in his native city, enjoying this congenial lifestyle. Venice was the safest city in

Italy (since the city's founding eight centuries earlier, no foreign power had succeeded in invading the Venetian lagoon). The city was still rich, and there were plenty of commissions from the government, the guilds, known as *scuole* (schools), and wealthy private individuals. In contrast, leading Florentine artists such as Leonardo and Michelangelo left their home town to seek the patronage of powerful rulers elsewhere, Leonardo with the Duke of Milan and Francis I of France, whereas Michelangelo, whose republican sympathies put him at odds with the ruling Medici, particularly after they became Grand Dukes of Tuscany (he commanded the fortifications of the city when it was besieged by an imperial army supporting the Medici in 1529–30), preferred to serve the papacy in Rome, where his greatest work was to rebuild St Peter's.

Titian was, however, an exception among the major Venetian painters – Giovanni Bellini, Giorgione and Palma Vecchio, followed by Tintoretto and Veronese – in his reluctance to execute works for organizations within the city, either the government or the confraternities, charitable foundations that did good works and commissioned paintings for their own buildings. The few paintings that he did complete often led to a dispute over payment for his services, and he was usually extremely late in delivery. Philip II paid him an annual salary far greater than anything he could earn in Venice, and many of his fellow Venetians, no doubt envious of this largesse, considered Titian to be avaricious. This is how he is portrayed by Jacopo Bassano in his *Purification of the Temple* (National Gallery) where he appears as a grasping moneylender.

In addition relations between Spain and Venice were rarely amicable. Although there was a great deal of trade between the two countries, with a constant supply of oriental rugs, silks, glassware and gems heading from Venice to the palaces of Philip and his courtiers, Venetians, proud of their independence, knew that they were almost completely surrounded by Habsburg possessions. Philip II and his allies ruled Milan, Genoa, Florence and Naples. The king constantly strove to make an alliance with the *Serenissima*, intending to create a joint Spanish–Venetian

navy which would drive the Turks and their allies from the Mediterranean. This strategy appeared to work when the Spanish–Venetian fleet won a decisive victory at the battle of Lepanto in 1571, but even this alliance did not last. Just two years later, anxious to protect their commercial interests in the Levant, the Venetians changed sides and concluded an alliance with the Turks, much to the consternation of Spain.

Nevertheless, there was a continuous shift in power between Venice and Spain during the sixteenth century, symptomatic of a general movement from the Mediterranean states to nations bordering the Atlantic. Venice reached its apogee in the late Middle Ages and this was when the city assumed the shape it has retained to the present day. A bird's eye view woodcut of the city by Jacopo de' Barbari, dated 1500, gives a fascinating view of the city at that time. With the exception of some churches built by Palladio, and some palaces on the Grand Canal, almost all of the major buildings that we would recognize were already in place. Despite her great wealth, however, the *Serenissima*'s power was steadily diminishing, as the Ottoman Turks gradually conquered her territories in the Adriatic and the Aegean which she, in turn, had taken from the Byzantine Empire.

By the mid-sixteenth century the only Christian power able to fight on equal terms with the Ottomans were the Spanish, who possessed far greater resources than Venice. Maritime trade routes were opened up by Spanish and Portugese mariners to the Americas in the west, and to India and the Spice Islands in the east (Philip II conquered Portugal in 1580 thus acquiring her vast overseas empire). Venetian ships may have played their part in the battle of Lepanto, but it was Philip's half-brother Don John of Austria who had commanded the fleet. On the Italian *terra firma* the Veneto (the area of north-east Italy, including the cities of Padua, Vicenza, Verona and Bergamo ruled by Venice) was surrounded by states under Spanish control. The movement of the *Rape of Europa* from Venice to Spain is the first of a number of occasions in its history that the painting follows the shift in power and economic strength between nations.

This is also true in terms of the arts. At Titian's death in 1576, Jacopo Tintoretto, Paolo Veronese and Jacopo Bassano were all working in Venice. All three, in their different ways, were strongly influenced by Titian. The seventeenth century, however, marks a severe decline in the quality of Venetian painting. In contrast, the reign of Philip II was followed by a golden age in Spanish painting and it is no coincidence that Velázquez, the greatest Spanish artist of the seventeenth century, should have been so strongly influenced by the great Titians in the royal collection, including the *Rape of Europa*.

2

Philip II as Ruler and Patron of the Arts

Titian's patron Philip II, who presided over the greatest era in Spanish history, remains a deeply controversial figure. Over 400 years after his death, historians continue to argue over the nature of the man and the scale of his achievements. Venetian ambassadors, masters of diplomacy and displaying an acute analysis of foreign rulers, had a particular interest in the Spanish king, whose control of Northern Italy was a constant threat to their security. One of these ambassadors, Federico Badovaro, considered Philip to be 'phlegmatic and melancholic', by nature 'inclined toward the good', adding that 'his disposition is feeble, his is a somewhat timid spirit ... He is more inclined to mildness than to anger.' Badovaro's use of the adjectives 'feeble' and 'timid' holds the key to an understanding the king. Philip had grown up in awe of his father, and hid behind his natural shyness and reserve.

The way that Philip learned to cope with his heavy responsibilities was to acquire an inscrutable mask in public, hiding his private emotions. This discrepancy between the public and the private persona is apparent in every aspect of Philip's life. He inherited the Spanish crown at a time of political crisis. The 1550s was a time of great religious unrest in Europe, with increasingly violent clashes between Protestants and Catholics. Philip, a fierce defender of Catholic orthodoxy, was determined to stamp

out heresy in his dominions, particularly in the Netherlands. The Council of Trent, the major reform of the Catholic Church, was coming to a conclusion, advocating the condemnation of heresy and the total rejection of the Protestant belief in salvation through faith alone. Philip, as a leading Catholic ruler, therefore felt fully justified in publishing decrees, known as *placards*, in the Netherlands, encouraging the widespread persecution of his Protestant subjects. It was a similar story in England, where Philip, as husband to Queen Mary, whom he married in 1554 (a dynastic marriage that Charles V hoped would bring England into the Habsburg fold), supported her decision to burn leading Protestants at the stake in London and Oxford. In Spain the king attended a number of *autos-da-fé* and witnessed the execution of 100 Protestants by the Inquisition.

Philip's public support for religious persecution contrasted with his private enjoyment of a number of mistresses (he was also to have four wives). During the 1550s he carried on affairs with Doña Ana de Osorio, a lady-in-waiting at court, and Eufrasia de Guzman, lady-in-waiting to his sister Juana. Paolo Tiepolo, the Venetian ambassador, writing in 1563, described how the king liked the company of women 'in whom he takes a great deal of pleasure, and with whom he is often secluded.' He continued by referring to the queen (Philip's second wife, Elizabeth of Valois) who 'knows that the king has many affairs with other ladies, but she has learned from her mother [Catherine de Medici, Queen of France] to put up with this.'

Considering how hard Philip worked, it seems surprising that he had enough time to cultivate a string of mistresses. Meticulous by nature, a natural bureaucrat, he devoted unremitting energy in an effort to centralize his empire so that he could exert control over every aspect of government. But with such widely disparate possessions, scattered over four continents, where it took weeks, or even months, to relay his orders, this proved impossible to achieve. The king was therefore forced to rely on subordinates. The problem was that he was loath to delegate and found it very difficult to find servants whom he could trust. As Lorenzo van der Hammen, who wrote a generally sympathetic biography of

Philip, emphasizing his devotion to duty and hard work, stressed: 'suspicion, disbelief and doubt were the basis of his prudence'. As his reign developed, Philip was increasingly afflicted with a chronic mistrust of other people's motives, something that badly affected his dealings with his most able servants. To take the example of his leading generals, whose military brilliance made Spain the dominant military power in Europe, the Duke of Alba, the premier Spanish grandee, victorious in Italy, Germany, the Netherlands and Portugal, was exiled, the Flemish Count Egmont, who defeated the French at the decisive battle of San Quentin, was executed, Philip's half-brother Don John of Austria, victor of Lepanto, and his nephew Alessandro Farnese, duke of Parma, Governor General of the Netherlands and the greatest general of the age, were both removed from office. Philip's most able secretary Antonio Perez was suspected of treason, arrested and tortured, but managed to escape from prison.

Not surprisingly, the king's powerful position meant that he also had many genuine enemies and they used every opportunity to blacken his character. The most effective attack was the *Apology*, written by William the Silent, leader of the Dutch Revolt against Spain. The *Apology* began what was to be known as the Black Legend, depicting the king as an ogre: a cold, duplicitous and scheming religious bigot who enjoyed attending *autos-da-fés* where Protestants were burnt at the stake, and spent hours closeted with his precious relics in the depths of the Escorial. He would stop at nothing, even ordering the death of his own son Don Carlos, who was to be the hero of a play by Friedrich Schiller and an opera by Giuseppe Verdi. When he was not weaving sinister plots to destroy his enemies, the king amused himself in the company of dwarfs, jesters and buffoons.

Philip retaliated to this attack by ordering William's assassination, which was carried out at Delft in 1584 (William's supporters regarded it as act of semi-sacrilege to order the death of a fellow head of state, though the king regarded William as merely a rebellious subject). This provided further ammunition to Philip's enemies who had broadcast his political failings. They depicted him as a feeble military leader who had failed to crush

his rebellious Dutch subjects, lost the 'invincible' Armada sent to destroy England, and failed to prevent his bitter foe Henry IV from becoming King of France (though Henry had to convert to Catholicism to gain the throne).

This one-sided picture failed to give any credit to the extraordinary achievements during Philip's long reign. Spain had won a series of military and naval victories, culminating in the Duke of Alba's conquest of Portugal in 1580, thus uniting the Iberian peninsula, the dream of Spanish kings for centuries. The Spanish achievement in exploring, colonizing and governing a worldwide empire was quite astonishing. To put it in context, John Cabot had discovered Newfoundland at much the same time as Columbus had reached America in 1492, but it was to be well over a century later that the English, despite abortive efforts by Sir Walter Raleigh and others, made a successful, permanent settlement in North America, by which time the Spanish had colonized the whole of South and Central America (the Portuguese, now part of Spain, had colonized Brazil), defeating the mighty Aztec and Inca empires in the process, and had even reached Florida, New Mexico and California. Although Philip's fierce championship of Catholicism had backfired badly in the Netherlands, it had led to the eradication of Protestantism in Spain and throughout the Spanish empire in the Americas and the Far East.

In Spain itself leading theologians and jurists at the School of Salamanca, following the lead given by the Dominican Francisco de Vitoria (1483–1546), acted as the nation's moral conscience, discussing the legitimacy of conquest and championing the rights of all races, a counter to the conquistadors' rough-shod methods of dealing with the conquered natives in their pursuit of gold. The reign of Philip II was dominated by the Counter-Reformation, a revival of Catholicism which led to the persecution of heretics by the Inquisition, but which also produced major religious figures such as St Teresa of Avila who exerted a powerful influence on Spanish religious thought. She also influenced leading artists such as El Greco, whose paintings are perhaps the closest artistic expression of her mystical strain of Catholicism.

Philip proved himself to be the greatest patron of the arts of the later sixteenth century. The king's most outstanding artistic achievement was the building of the vast palace of San Lorenzo de Escorial, situated in the bleak foothills of the Guadarrama mountains, 50 kilometres north-west of his new capital of Madrid. It is difficult to form a proper picture of Philip without visiting his greatest creation. Even today, it is impossible not to feel its chilling effect. This is partly geographical: the site is much higher than Madrid so that, no matter how hot it might be in the capital, the very fabric of the building seems to chill the soul. But it is even more the nature of the building, with its unremitting expanse of blank granite walls, and endless cold, stone corridors.

From the moment you enter, you are made very aware that this is a religious foundation, built to fulfill a vow made by the king on the eve of the battle of San Quentin on 10 August 1557, the feast day of St Lawrence. If God granted the Spanish victory over the French, Philip vowed to build a palace-monastery which would house a mausoleum to his parents, the Emperor Charles V and the Empress Isabella of Portugal. The king deliberately chose an austere style of architecture to reflect the religious nature of the whole complex, run by Jeronymite monks, with the basilica placed over the mausoleum at its heart.

Turning his back on the light, decorative style of late Gothic architecture known as plateresque (the word comes from *plata*, the Spanish for silver), Philip instructed his architects to construct a square, rigidly symmetrical building in the classical style, devoid of ornament. It rivals St Peter's in Rome in sheer scale as the greatest architectural project of the late sixteenth century. Indeed, the original architect, Juan Bautista de Toledo, had worked under Michelangelo on St Peter's, though his early death meant that the majority of the building was done by his successor Juan de Herrera. The complex consists of a pantheon, basilica, monastery, seminary and library, encompassing the whole world of knowledge. It has often been remarked that the building was designed on a grid plan, resembling the grid on which St Lawrence was martyred, though there is no evidence that this was Philip's intention. It seems more likely that the king

saw the building as a modern version of the Temple of Solomon in Jerusalem, with Philip cast as a latter-day Solomon.

The Escorial (inappropriately, it takes its name from a slag heap from an abandoned iron mine nearby) was a highly suitable location for Philip's collection of art. He amassed a total of some 1,500 paintings, of which about 1,100 were housed in the Escorial, 100 statues of famous people in marble and bronze, dozens of caskets filled with jewellery, cabinets containing over 5,000 coins and medals and whole suites of rooms filled with furniture and armour. The king's collection demonstrates the complexity of the man. Deeply pious, or, as his enemies maintained, a religious bigot, he accumulated 7,000 relics including ten whole bodies, 144 heads, 306 arms and legs, countless bones, fragments said to have been taken from the True Cross and Crown of Thorns, and hairs of Christ and the Virgin.

But the king was also intellectually curious, forming a whole compendium of natural and man-made wonders, and dozens of scientific and musical instruments, including 137 astrolabes and watches, showing the king's profound interest in scientific discovery. The royal library of 40,000 volumes contained the usual quota of orthodox Christian works, but also included a considerable number of forbidden books devoted to magic and the occult, and 1,800 titles in Arabic taken from the Moors in Andalucia after Philip ordered their expulsion from Spain.

The Escorial also housed the king's religious paintings, including Titian's dramatic nocturnal depiction of the *Martyrdom of St Lawrence*, designed to hang over the main altar of the great church arising in the middle of the complex. In addition, Philip possessed a superb collection of Flemish Primitives, including Rogier van der Weyden's magnificent *Descent from the Cross*, which had originally hung in the chapel of his aunt Mary's palace at Binche in the Netherlands.

Philip showed unexpected taste in his passion for Hieronymus Bosch, the Flemish artist whose fantastic, visionary landscapes are some of the most unusual works of the sixteenth century. They are peopled with a strange and often grotesque array

of humans and animals, which appealed to Philip but bore no relation to his orthodox religious beliefs. As in the case of Titian's mythologies, he took profound aesthetic pleasure from all forms of great art. Various interpretations have been given to Bosch's strange and original creations, ranging from an allegorical or moral one, satirizing the sins of mankind, to a more esoteric one, stressing astrological and even heretical views, and to a more straightforwardly religious one, inspired by the Book of Revelations. For the king, it appears that the paintings were simply objects of fascination, beauty and truth, as Jose de Siguenza, the Jeronymite monk (the austere order of St Jerome was very popular in the Iberian peninsula) who was the king's librarian in the Escorial, wrote:

> there are some people ... who are foolish as to think that Bosch was a heretic; which is absurd, for if that were so, the king would never have had his pictures near him. No, Bosch is a devout and orthodox satirist of our sins and follies ... [He had] the courage to paint men as they really are.

The building of the Escorial, the personal creation of Philip, acts like a metaphor for the changing character of the king. As the vast complex gradually rose above the Castilian plain, a chilly sanctuary where Philip could retreat from the world outside, so the king withdrew within himself. He increasingly disliked courtly life, with its horde of courtiers and placemen jostling for position. A man of rigid self-control, the king preferred the monastic purity of the Escorial, where he could live an ordered life, seated at his desk in his small study, surrounded by a mass of paperwork. All major decisions had to be referred to the sovereign, and letters were dispatched by his secretaries to every corner of the empire signed *Yo el Rey* (I the king). There are a surprising number of paintings showing Philip in direct communion with God which support the view that the king believed that he enjoyed a direct communion with God.

Not surprisingly, the subdued, silent atmosphere of the palace-monastery had a detrimental effect on many of the artists who

came to work here. It was as though the building, like the monarch who had commissioned it, had a deadening hand on the artists he enticed to Spain. Philip seems to have been pleased with the Genoese Luca Cambiaso's rather lifeless painting of the vault in the choir of the basilica, but the effort seems to have been too much for the artist, who died soon after completing the work. Pellegrino Tibaldi, whose mythological paintings in Bologna have an almost Michelangelesque power, painted a number of fine works, especially his ceiling fresco of the library, but the Central Italian painter Federico Zuccaro, a renowned artist who had worked for the papacy, fared less well. Having been granted a salary of 2,000 gold ducats a year (four times that awarded to Titian), he soon found himself in trouble. The king, pedantic as ever, objected to his *Adoration of the Shepherds*, painted for the high altar of the basilica, on the grounds that the basket held by the shepherds contained too many eggs, something that a shepherd, running from tending his sheep in the middle of the night to Christ's manger, was very unlikely to be holding, especially as he probably did not keep chickens. Soon he was dismissed with a golden handshake and sent back to Italy, and his frescoes painted over, while the king commented sadly: 'The blame does not belong to him, but to him who sent him this way.'

The most talented painter working in the Iberian peninsula was the Cretan Domenikos Theotokopoulos, known as El Greco, who arrived from Italy in the ancient capital of Toledo in 1576, having previously worked briefly in Titian's studio in Venice. El Greco made his name in Toledo with highly charged religious works that seem to epitomize the Spanish Counter-Reformation. It therefore seemed appropriate that Philip, an ardent champion of the Catholic revival, should have wanted to patronize such a major figure working on his doorstep. However, this was not the case. Shortly after his move to Toledo, Philip commissioned the Cretan to paint *St Maurice and the Theban Legion* to celebrate the fact that the saint's body lay in the Escorial. El Greco did his best, including portraits of three of Philip's leading generals: Emmanuel Philibert of Savoy, victor of the battle of San Quentin, the event that had inspired the

king to build the Escorial, Alessandro Farnese, and Don John of Austria. But his strange elongated bodies and flickering light effects, and his relegation of the scene of St Maurice's martyrdom to the background, was not to Philip's liking and he was never to commission another work from the Cretan artist.

Philip may not have seen anything strange in Bosch's works but, in general, he wanted his artists to display religious orthodoxy. When the sculptor Pompeo Leoni, whose sculpture, like Titian's portraits, had played a key role in creating the image of the Habsburg monarchy, was suspected of being a Lutheran heretic, he was sentenced at an auto-da-fe and confined for a year to a monastery. Alarmed at these events, Antonio Mor, the brilliant Flemish portraitist who had accompanied Philip on his return to Spain, fled back to the Netherlands.

It is understandable why Titian should have been so reluctant to come to Spain despite Philip's warm appreciation of the works he sent from Venice. These were, however, treated in very different ways. His portraits of the royal family were for public consumption, designed to show the majesty of the Habsburg monarchy, while his religious works were designed for the king's spiritual meditation. The group of *poesie* was for Philip's personal pleasure, and this accounts for the silence that descends on the paintings once they reached Spain. Italian commentators may have been united in their praise for the *Rape of Europa*, and the method Titian used, but the king had little doubt that the reaction would be very different in Spain. The Spanish ambassador to Venice had described *Venus and Adonis* in a letter to Philip II as 'a thing of great esteem, in which Titian has put much effort, but it is excessively lascivious'.

The king was well aware that if one of his subjects owned such a painting, he or she was liable to prosecution by the powerful Inquisition, who would have labelled it as obscene, with the possibility of punishing the owner by excommunication, and a fine of 1,500 ducats. Philip may even have baulked at the sexuality of the *poesie*. Charles V had prized Correggio's four erotic mythological paintings so highly that he had taken them to the monastery of Yuste in Extremadura after his abdication,

but his son had chosen to give two of the series away to his secretary Antonio Perez after his father's death.

Owing to the dearth of documentary evidence there has been much dispute about where the *poesie* were originally hung. What is certain is that they were intended to be hung together as a set. This means that the *Rape of Europa*, as the last in the series, needs to be seen in context of the other five paintings which were already in the possession of the king.

Philip had settled in Spain permanently in 1559. Initially, the king travelled extensively between his various palaces, inspecting the work being carried out. The scale of the alterations to these palaces also meant that many of them were, at times, uninhabitable. Major alterations were made to the Alcázars of Madrid and Toledo, which Charles V had begun to modernize, and to the palaces of Aranjuez and El Pardo, while work commenced on the Escorial in 1564.

As the king had no fixed abode, it seems most likely that he simply took his key possessions with him, as he had probably done while travelling in the 1540s in Northern Europe. One of the few facts that we do know is that Philip first saw *Diana and Actaeon* and *Diana and Callisto* in the Alcázar in Toledo in August 1560, and it may have been that the others in the series were also in the castle when the king received his new bride and third wife, the fourteen-year-old Elisabeth de Valois, there before their marriage in Toledo Cathedral on 3 January 1561.

Later in his reign, in an effort to escape from the gossip and intrigue of life at court, Philip was to make the palace-monastery of El Escorial his main residence, but he still visited his other palaces in and around Madrid. One of his courtiers made a humorous record of his peripatetic lifestyle in *The Great and Notable Voyages of King Philip*, describing how the king still liked to move 'from Madrid to the Escorial, from the Escorial to the Pardo, from the Pardo to Aranjuez, from Aranjuez to Madrid, from Madrid to the Escorial ...'

The two most likely destinations of Titian's *poesie* during Philip's reign were the Alcázar in Madrid, where they were to be located throughout the seventeenth century, and the royal palace

of Aranjuez, where work finished in 1584. Unfortunately, they are not listed in the key inventory of Philip's possessions, carried out after his death in 1598. When he could escape from his duties the king enjoyed masked balls, jousts and bull fights at the Alcázar in Madrid, but it was to his palaces in the country that he retired to for relief from life at court. On occasions Philip would rise before dawn, mount his horse and ride off to his palace at Aranjuez, leaving strict instructions that none of his courtiers or ministers was to follow him. El Pardo had the best hunting, whereas it was the garden at Aranjuez that gave Philip the most pleasure.

He liked to come here in the spring and autumn, when he could supervise the laying out of the gardens and waterworks. Philip loved to fish in the Tagus, and laid out new gardens by the river, designing a medicinal herb garden, supervising the planting of some 230,000 trees here during his reign, and digging new lakes which 'would encourage birds to come and improve our hawking'. There was a small zoo with camels, used as beasts of burden in the gardens, and ostriches, one of which escaped and attacked a gardener on one occasion. In May 1564 Philip spent a second honeymoon here with his third wife Elisabeth, eating picnics together in the gardens. The royal family enjoyed sailing on the Tagus though even here Philip was not able to completely escape his duties, feeling obliged to sign some dispatches which his valet brought him while the ladies of the court danced on board, accompanied by music.

The semi-nomadic existence that Philip led in Spain during the early part of his reign, and the lack of certainty over the location of Titian's *poesie*, has led to different theories on how they hung as a group. Titian left no written account of his intentions, but did offer an idea of how the paintings would look their best, as he outlined to the king in a letter of September 1554. He was particularly concerned with the pose of figures, offering a variety of interest, something that had preoccupied Leonardo at the beginning of the century:

And since the Danae which I have already sent to Your Majesty, was seen entirely from the front, I wanted to vary

[the pose] in this other poesia [*Venus and Adonis*], and have
the figure show the opposite side, so that the room in which
they are to hang will be more charming to the sight.

Soon I will be sending you the poesia of Perseus and
Andromeda which will offer still another view, different from
these; and likewise with Jason and Medea.

The position of the *Rape of Europa* is the most confusing in
the series. In a letter to Philip II dated 19 June 1559 Titian
mentioned that he had just completed *Diana and Actaeon* and
Diana and Callisto, and begun the final two paintings in the
series, the *Rape of Europa* and the *Death of Actaeon* (the latter
executed but never sent to Spain). Looking at the composition
of the six paintings, it seems very possible that Titian decided
to divide the six canvases into three pairs: *Danae* and the *Rape
of Europa* (the first and the last to be painted), *Perseus and
Andromeda* and *Venus and Adonis,* and *Diana and Actaeon* and
Diana and Callisto. The *Rape of Europa* links with the *Danae*:
both paintings show reclining female nudes enjoying the favour
of Jupiter, they are almost portrayed as mirror images of each
other and both are painted in the same warm tonalities, with
Titian displaying a broad handling of paint.

If there is a unifying theme in the way that the spectator was
intended to view all six paintings, it begins with *Danae* where
the composition flows from right to left through the princess'
body, continues with *Perseus and Andromeda*, where it rises and
falls, the movement continuing to the right in *Venus and Adonis*
through the naked figure of the goddess, striving to prevent her
lover from setting off for the hunt. Europa, reclining to the right,
and balancing *Danae*, closes the four-fold composition. The two
scenes with Diana stand apart, and appear to balance each other
in perfect harmony, with Actaeon on the left, with the red curtain,
balancing Diana's nymphs on the right of *Diana and Callisto*,
gathered around the goddess beneath a curtain of silver and gold.
Renaissance humanists, of course, would have had a much deeper
understanding of the connections between these myths.

3

The Myth of Europa

From the start of his reign Philip had been the champion of Catholic orthodoxy and this increased as he retreated within the walls of the Escorial, administering his vast empire. Nevertheless, he had been educated in the culture of Renaissance humanism, based on a revival of interest in antiquity. The classical myths were central to all humanists, with Ovid's *Metamorphoses* one of the most popular interpretations of the myths, its success greatly enhanced by the spread of printing and an increase in literacy.

The six paintings, *Danae, Venus and Adonis, Perseus and Andromeda, Diana and Actaeon, Diana and Callisto* and the *Rape of Europa*, represent some of the most famous myths of antiquity. Danae's father King Acrisius had been told by an oracle that he would be killed by his daughter's son so he shut her up in a tower. Jupiter, King of the Gods, desired the princess and Titian chose to depict the moment at which the God, descending in a shower of gold, is about to ravish her. Acrisius was unwilling to provoke the wrath of the gods by killing his offspring, and cast Danae and her son Perseus to sea in a wooden chest. Much later Perseus was participating in the Greek Games at Larissa and accidentally struck Acrisius on the head and killed him, thus fulfilling the prophecy.

The second painting in the series relates to the myth of Venus and Adonis, the tragic story of the goddess of love who was

43

smitten by Cupid's dart and fell passionately in love with the handsome Adonis. In Titian's painting Venus tries to prevent the young mortal from setting off for the hunt, fearful of the tragedy to come. Her fears are realized when Adonis is mortally wounded by a boar, his blood being turned into an anemone.

The subject of the third painting is closely related to Danae, the myth of Perseus freeing Andromeda. The princess' mother Cassiopeia, Queen of Ethiopia, had the temerity to boast that her daughter was more beautiful than the Nereids (sea nymphs, daughters of the sea god Nereus), whereupon Neptune sent a sea monster to ravage the coast of Ethiopia. To appease the monster, King Cepheus consulted the oracle which advised him to sacrifice his daughter, who was left chained to a rock. Titian depicted Perseus, who had just slain the Gorgon, flying to the rescue of the princess, who is about to be devoured by the sea monster. Having slain the monster, the victorious hero married Andromeda. She was to gain immortal fame after her death when Minerva placed her among the constellations of the northern sky.

The next two paintings in the series are a pair of myths depicting the goddess Diana the huntress. The first tells the tragic story of Diana and Actaeon, the hunter who stumbled unwittingly upon the goddess and her nymphs bathing naked in a stream. This dramatic moment is captured unforgettably by Titian who shows a naked Diana punishing the unfortunate Actaeon by transforming him into a stag. The hunter fled in terror but was pursued by his own hounds, who caught him and tore him apart (the subject of Titian's *Death of Actaeon*). Diana and Callisto is another dark myth featuring the goddess Diana. Jupiter seduced her nymph Callisto, disguised as Diana herself. Once again Titian chose the most dramatic point in the story, the moment when Callisto, bathing in a stream, is revealed to be pregnant and expelled by an enraged Diana from her presence. After Callisto had given birth to Arcas, Juno transformed her into a bear. Mother and child were later placed by Jupiter among the stars and named Ursa Major and Minor.

The origin of the *Rape of Europa* describes how Jupiter, King of the Gods, on Mount Olympus, spied the beautiful Princess

Europa (whose brother Cadmus was Actaeon's grandfather), daughter of Agenor, King of Tyre and Sidon, Phoenician cities on the eastern coast of the Mediterranean, and decided to seduce her. Transforming himself into a bull, Jupiter appeared on the seashore and captivated the princess, who garlanded him with flowers and caressed his flank. Eventually she felt bold enough to mount his back, whereupon the bull entered the sea and swam across to the island of Crete, the moment that Titian chose to depict in his painting. Once on the island Jupiter resumed his normal form and made love to the princess who became Queen of Crete and gave birth to three sons: Minos, Rhadamanthus and Sarpedon, destined to be judges of the underworld. Jupiter later created the constellation Taurus in the shape of a bull (in modern times the smallest of the planet Jupiter's Galilean moons was named after Europa). Europa's brother Cadmus was also to play a major part in Greek mythology, bringing the alphabet to mainland Greece.

Interestingly, Philip II identified himself with the figure of Jupiter. As King of the Gods, the deity was associated with imperial propaganda surrounding the king, dispensing justice and punishing those who threatened his authority. Both Philip and his father had been immensely impressed when they visited the Palazzo del Te in Mantua, the creation of Giulio Romano for Federico Gonzaga, Duke of Mantua, a close ally of the Habsburgs (he commissioned Correggio's *Loves of Jupiter*, now in the possession of Philip and a key influence on Titian's *poesie*), where the *Fall of the Giants* was seen by contemporaries as an allegory of the emperor crushing his Protestant foes. When Charles and Philip toured the Netherlands in 1549, a series of triumphal arches were erected in their honour, showing them with the world on their shoulders and in the company of the Gods of Olympus.

The myth of Europa and the Bull was a very ancient one based on the island of Crete, where the bull was associated with strength and fertility. Far back in antiquity the islanders placed the youthful Bull God on a par with the Sun. The Cretans celebrated games involving bulls and bull fights, linked to fertility

rites, and there are ancient images of youths playing dangerous games with bulls, grabbing their horns and vaulting on to their backs. The ancient Greeks acknowledged this obsession and had a saying that Cretan women preferred bulls to men. One of the most powerful Greek myths is that of the Minotaur.

The myth is known as the Rape of Europa, with its modern connotations of violence, but this is not how it is normally portrayed, either in literature or in art. There are two distinct parts of the story: the scene on the sea-shore, where Europa, often depicted as a regal bride, either garlands the gentle bull, or is seated on his back. In the second part of the myth she is taken away across the sea to Crete, often in a state of ecstasy, by a virile bull. For most writers and artists the first part of the myth has traditionally proved more popular, but Titian preferred the second part which allowed a more dynamic interpretation.

The earliest literary source of the myth is in the *Iliad*, dating back to at least the eighth century BC, where Europa is the daughter of Agenor's son, the 'sun-red' Phoenix. The most famous account of the myth in antiquity, however, is in Ovid's *Metamorphoses* where the Roman poet emphasizes the beauty and gentleness of the bull, and the way that he is garlanded with flowers by Europa and her maidens on the sea-shore before she mounts him and is taken across the sea to Crete. The bucolic poet Moschus and the rhetorician and satirist Lucian followed Ovid's lead in portraying the bull as a likeable creature, who seduces a willing Europa. Lucian linked Europa to the moon-goddess Astarte, sacred to the Phoenicians:

> But according to the story of one of the priests this temple is sacred to Europa, the sister of Cadmus. She was the daughter of Agenor, and on her disappearance from Earth the Phoenicians honoured her with a temple and told a sacred legend about her; how Zeus was enamoured of her for her beauty and changing his form into that of a bull carried her off into Crete. This legend I heard from other Phoenicians as well; and the coinage among the Sidonians bears upon it the effigy of Europa sitting upon a bull, none other than Zeus.

The Alexandrian Greek Achilles Tatius, author of *The Adventure of Leucippe and Clitophon*, also set the myth in Sidon, where his two characters saw a painting of Europa. What is interesting in his description of this painting is the number of details it contains which reappear in Titian's painting: Europa's drapery blowing in the wind, and the cupids that accompany her, flying through the air and swimming in the sea. We know that Titian's friend Diego Hurtado de Mendoza, the Spanish ambassador to Venice, owned a copy of Achilles Tatius translated from the Greek by Lodovico Dolce and Francesco Angelo Coccio.

A few ancient writers took a different line on the myth. The Greek historian Herodotus, always keen to see such stories as historical reality, saw the rape as a retaliatory attack by the Minoans, who seized Europa in revenge for the kidnapping of Io, princess of Argos. The Roman lyric poet Horace took a highly personal line, analysing the psychology of the victim; he considered Europa to be a tortured soul who feels deep shame and contemplates suicide at her action.

During the Renaissance, when these ancient myths were much studied, the fifteenth-century philosopher Angelo Poliziano, living at the court of Lorenzo de' Medici in Florence, and a leading exponent of Neo-Platonism, which explored the union between man and the divine, followed Horace's lead in describing the fearful side of the myth. His physical description of Europa, grasping the bull by the horn, bears some similarity to Titian's depiction and it seems likely that the artist would have known of Poliziano's text.

It was Ovid's *Metamorphoses*, however, with its graphic and light-hearted description of the loves of the gods and mortals, that was to prove the most popular source for artists. The first illustrated copy of the *Metamorphoses*, published in Venice in 1497, showed to a wider audience what a rich source of visual imagery his myths possessed. A number of translations proved an instant hit when they were published in the sixteenth century.

The myth of Europa, so popular with ancient authors, has also provided a constant source of inspiration for artists. It has been portrayed many times in every conceivable type of material,

ranging from vases, mosaics, terracottas, tomb reliefs and coins in antiquity, to paintings, prints, sculpture, majolica (glazed or enamelled earthenware much produced in the Renaissance, particularly in Central Italy) and on cassoni (wedding chests) in the Renaissance, and later on porcelain and enamel snuff boxes.

Shortly before Titian painted his version, Correggio, Parmigianino and Dosso Dossi, three of the greatest Emilian painters of the early sixteenth century (the towns of Bologna and Parma in the province of Emilia-Romagna were major art centres), followed the prevailing norm in painting the myth as an Arcadian idyll. This essentially sedentary image was adopted by Titian's fellow Venetian, Paolo Veronese, who depicted Europa as a princess, full of keen expectation, bejewelled as befits a regal bride. Veronese's painting, which hung in the Doge's Palace in Venice, was to prove immensely popular and influential.

Titian also knew the myth well and had the chance to discuss it with his literary friends, who would have told him of its source. In addition, he had numerous artistic precedents to draw on. As so often, he created an entirely original composition, one of the boldest in his entire oeuvre. Titian wanted to portray the key moment when Europa realizes her fate. The fact that art historians still argue whether the painting is a tragic or light-hearted interpretation of the myth shows the ambiguous nature of Titian's interpretation. His composition is highly original and it seems exceedingly unlikely that he could have been aware of two similar representations of the myth in late fifteenth-century Florence: a terracotta relief from Luca della Robbia's workshop and a beautiful pen and ink drawing by Filippino Lippi. They portray Europa on the back of the bull, her clothes and hair flying in the wind.

Titian himself must have felt very pleased with the painting, since he supervised the production of a copy in his workshop which was offered to the Emperor Maximilian (a Habsburg cousin of Philip II) in 1568 (the painting has been lost, though there is a copy by the seventeenth-century Flemish painter David Teniers). There is also a copy which belonged to the fourth Marquess of Hertford, a major benefactor of the Wallace

Collection. But the most important copy of the Titian was executed by Rubens, who was privileged to study the painting in the Alcázar on his second visit to Madrid in 1628–9. Painters of the Bolognese school, in particular, seem to have been strongly influenced by the Titian composition, and Guido Reni's version of the subject shows the same combination of fear and ecstasy. A late sixteenth-century bronze group by Giambologna displays a similar interest in drama and movement. Rembrandt's version of the subject, though the composition differs from that of Titian, shares the same emotional intensity and the immediacy of the drama as Europa gazes back fearfully to the safety of the shore.

In general, however, the majority of later artists preferred to follow the lead of Veronese in their depictions of the myth, showing the princess as an almost childish figure, playfully picking flowers, while the beautiful, white bull is a creature from a fairy tale. She has tamed the bull with her flowers, and rides off to her fate full of optimism and, sometimes, even triumphant. Her maidens may be scared and shocked, but the princess is serene. In the eighteenth century, painters loved to depict light-hearted allegories of love, and numerous painters, notably Watteau and Boucher, with his seductive nudes, were inspired by the Veronese. Similarly, porcelain manufacturers, in particular, made free use of the image of Europa, a pretty woman, sometimes crowned, often playing with the bull. There is never any question of violence or rape.

Curiously, there does not seem to be a direct connection between Europa and the continent of Europe. The origin of the continent's name is uncertain, possibly deriving from the Greek word *eurus* meaning wide or broad, and *ops*, meaning eye of face, hence wide-eyed or broad of aspect. The Ancient Greeks originally regarded Europa as an area comprising the province of Thrace but, by the time Strabo wrote his 17-volume *Geographica* in the late first century BC, he included the whole continent from the Straits of Hercules to the river Don. In the eighth century Christian forces fighting Muslims invading south-west France were known as *Europenses*, and Europe became associated with the Latin Church. A popular cartographic

depiction of the continent in the sixteenth century as *Europa Regina* showed the continent from the Habsburg perspective as a standing queen, with the Iberian peninsula as her head wearing a crown and Bohemia as her heart (heretical Britain and Scandanavia were excluded). *Europa Regina* is surrounded by water, an allusion to the mythical Europa carried over the sea to Crete.

Recently, the myth of the Rape of Europa has been adopted by the European Union, and the image of the princess being abducted by the bull has become a semi-official symbol of the institution, a supranational personification of the European region. An image of Europa has appeared on a number of coins and banknotes. The image itself is open to numerous interpretations, mostly concerning the theme of peace and unity triumphing over hardship, with the bull seen as a dangerous animal, undermining this concept of peace and unity, or as a liberator, freeing Europa by taking her across the sea from Sidon/Asia to Crete/Europe.

There have been many translations of the myth, and one written by A. E. Watts in 1954 best conveys Ovid's original.

The poem begins with Jupiter commanding Mercury:

'Dear son, and servant faithful to obey,
Swoop down to earth post-haste your wonted way;
And turning leftward, where those regions are,
That men call Sidon, 'neath your mother's star,
Drive from the hills, and bring beside the sea
The royal herd that crops the upland lea.'
So said, so done: the herd grazed before
The mountain heights, was headed to the shore,
Just where the great king's daughter, day by day,
With train of Tyrian maids was wont to play.
'Tis ill when love and lordship in one mind
Together dwell. His sceptred state is hurled
The three-forked fire, whose nod convulse the world,
Among the herd, transformed in voice and mien,
Treading the sward, a comely bull was seen,

In colour like untrodden snows, that last,
Unmelted by the south wind's watery blast.
The muscles bulged upon his neck; the fall
Of dewlap was superb; the horns were small;
Seeming handmade, such work as craftsmen do,
They gleamed like agate as the light shone through;
A brow of peace, wherein no terror lie,
A calm and unintimidating eye.
'How fair, how friendly!' thought Agenor's child;
Yet feared at first to touch him, though so mild,
Soon, to her lover's joy, she nearer drew,
And gave his milk-white mouth sweet flowers to chew.
He kissed her hands, as earnest of the sum
Of hoped-for joys, scarce waiting what's to come;
And now on grass he leaped and played; now rolled
On sand, to show his white on green and gold;
Offering the maiden, as her fear grew less,
His breast to stroke,
His horns with flowers to dress;
And she, unweeting what form could hide,
Upon his back at last made bold to ride.
Then, sidling seaward, that four-footed cheat
Came step by step where land and water meet;
Then out to sea! While the fair prize he bore
Looked back in panic at the fading shore.
One hand was on his horn; one pressed his back;
Her robes, wind-wafted, fluttered in her track.

From the point of view of Titian's interpretation, what is interesting is how little of the text relates to Europa's actual rape, the moment of maximum drama that Titian chose to depict. Most of Ovid's description concerns the appearance of Jupiter as a bull on the seashore and how he is feted and garlanded by the princess and her maidens. Watts' translation of Ovid referring to Jupiter as 'that four-footed cheat' makes clear the god's intentions, and Europa 'looking back in panic at the fading shore' seems to indicate that she is fearful of her abduction. However,

an earlier reference to her wish 'of hoped-for joys, scarce waiting what's to come' states quite unequivocally that she is a willing accomplice, and this seems to sum up Titian's image of Europa where her desire overcomes any initial fear.

4

The Spanish Habsburgs and the Alcázar in Madrid

Although the reign of Philip II had seen the Spanish Empire reach its greatest extent, and Spain's armies had proved all but invincible on the European mainland, this hegemony had come at great cost (the country had gone bankrupt on four occasions during the late sixteenth century). Consequently, as the new century dawned, there was a widespread feeling that the country was in urgent need of reform. A number of reformers, known as *arbitristas*, made a genuine attempt to analyse ways of creating an economic recovery and promoting social and moral regeneration. Their ideas involved cutting government expenditure, reforming the tax system, encouraging immigration into Castile, the Spanish heartland, improving transport and industry and arranging the more equal distribution of the economic costs among the five constituent kingdoms of the Iberian peninsula (from 1580 until 1640 Portugal was a part of Spain). It was to be Spain's tragedy that these ideas should never have been implemented.

The country that benefited most from Spain's inability to reform was its neighbour France. After suffering from a series of civil wars between Catholics and Huguenots in the later sixteenth century, the nation was reunited by Henry IV, who converted to Catholicism in 1593, supposedly making the

cynical statement that 'Paris was worth a mass'. His finance minister Maximilien de Bethune, Duke of Sully, centralized the administration, overhauled the tax system, reduced expenditure and consolidated the state's debt. These reforms, together with Henry's concerted effort to placate the rebellious nobility by awarding them titles and privileges, led to the revival of France. Henry's son Louis XIII appointed the immensely able Cardinal Richelieu as his chief minister and it was the cardinal who led France into the Thirty Years' War on the side of the Protestant forces of Holland and Sweden against Spain and Austria. France and her allies won a series of notable victories, and Richelieu's policies were continued by his equally talented successor Cardinal Mazarin and resulted in France making a number of important territorial gains in Flanders and Catalonia at the Treaty of the Pyrenees in 1659.

A year later Louis XIV entered his majority (he had been king since 1643) and his aggressive attempts to extend France's borders into the Spanish Netherlands led to a series of wars with Spain. France's ability to pay for these wars was largely due to Jean-Baptiste Colbert, the able and energetic Minister of Finance. Like Sully, he continued to reform the tax system, punishing corrupt officials employed in collecting taxes, reorganized industry and commerce, increased the manufacture of high quality goods and built up the navy. Colbert's reforms were dedicated to the basic principle that the nation with the most money would be the most powerful, and the success of his reforms meant that by 1700 the strength of France was feared by all other European nations, particularly the much-weakened Spanish.

Although Spain had failed to implement much-needed reforms, and suffered a number of defeats at the hands of the French, nevertheless the seventeenth century was a golden age in terms of the arts. Indeed, many of Spain's most remarkable literary works actually gloried in this failure to reform. The picaresque novel, perhaps the most important literary development in seventeenth-century Spain, celebrates the craftiness of idle, low-born rogues triumphing over the idealistic world of *hidalgos*, or gentlemen. *Don Quixote*, by Miguel de Cervantes, published in 1605 and

1615, is both a comedy and a satirical commentary on the rigidity of Spanish society, with its obsession with class, where a well-meaning *hidalgo*, deceived by the chicaneries of the world, ends up tilting at windmills. The three major playwrights, Lope de Vega, Tirso de Molina and Pedro Calderon de la Barca, wrote conventional morality plays depicting conflicts between all classes of society, imbued with good humour and cynicism.

Despite her economic problems, gold and silver continued to pour into Spain from the New World, and, although this led to inflation, the city of Seville, in particular, which enjoyed a monopoly on all trade with the New World, boomed. Diego de Velázquez and Bartolomé Murillo, two of the great names in Spanish seventeenth-century painting, both hailed from Seville, and Francisco de Zurbarán, the third leading painter in Spain, spent much of his career in the Andalusian port. However, it was Madrid, the home of the court and therefore the centre of patronage, that gradually took over from Seville as the main artistic centre. Unlike Philip II, his successors lived in the Alcázar, the main royal palace in their capital, and Velázquez was one of a number of ambitious painters who came to Madrid to advance their careers. At the Spanish Court he was welcomed by his fellow-Andalusian Gaspar de Guzman, Count-Duke of Olivares. Olivares was chief minister of Philip IV and introduced the promising artist to the king. It was to prove one of the most successful unions of artist and patron in the history of art.

Philip IV (1621–65) rivalled his grandfather Philip II as the greatest art collector of his day. This was in contrast with his father Philip III (1598–1621), who made a negligible contribution to the arts, the only painting that excited the king's imagination being Titian's *Venus del Pardo* (Paris, Louvre), the most overtly erotic of all his mythological works, for which he developed a passion. This was not for lack of opportunity; the king's powerful chief minister, Francisco Gomez de Sandoval, Duke of Lerma, amassed some 1,400 paintings, many by the great Venetian artists of the sixteenth century, as well as commissioning a magnificent equestrian portrait of himself by the young Flemish painter Peter Paul Rubens.

Owing to Philip III's lack of interest in the arts, there is no record of the *Rape of Europa* during his reign and it is not until the 1620s that we begin to find accounts of the painting by notable visitors to Madrid. These included Charles, Prince of Wales, who came to Spain in 1623, and Cassiano del Pozzo in 1626, secretary to the papal ambassador Cardinal Francesco Barberini and a noted Roman connoisseur, who named it the *Rape of Europa* (Titian had originally entitled it *Europa on the Bull*). Rubens was the most important foreign artist to visit Madrid, and was strongly influenced by Titian's painting. The Fleming executed a copy during his visit of 1628–9, while Velázquez, who worked for many years in the Alcázar as the court painter and palace marshal, included it in the background of one of his greatest works.

Philip IV, like his grandfather, kept the *Rape of Europa* and Titian's other *poesie* away from public view, hanging them in the south-west corner of the Alcázar, where the king's apartments were situated. These apartments looked on to a garden, known as the Garden of the Emperors, named after 25 statues of Roman emperors that were housed here, alongside bronzes by Leone Leoni of Philip II and his half-brother Don John of Austria. Juan Gomez de Mora, architect to Philip III, had constructed arched spaces round the garden at the beginning of the seventeenth century to protect the king and his family from the fierce summer sun. In these rooms Philip IV hung Titian's erotic mythologies: the *Rape of Europa* and the other *poesie*, together with *Venus and the Organ-player* and *Tarquin and Lucretia*. They were joined by *Venus with a Mirror*, which was moved here from Philip IV's bedroom.

Few people were allowed into these rooms, an exception being the famous collector Cassiano del Pozzo, who noted the number of nudes by Titian and Rubens. Philip's Queen Elizabeth found the overt sexuality of Titian's nudes so disturbing when she came to visit her husband that she ordered them to be covered over (her own apartments were in a separate quarter of the vast palace beyond the royal chapel of St Michael). The queen's prudishness was almost certainly exacerbated by Philip's numerous infidelities.

Despite his lugubrious and melancholy appearance, so brilliantly captured by Velázquez, the king had a number of mistresses and was rumoured to have sired as many as 32 natural children. His son by Maria Ines Calderon, known as La Calderona, was even brought up as a royal prince. No doubt the queen imagined that her husband's ardour was increased at the sight of Titian's naked beauties. It was not only Titian's nudes that the queen found offensive. In the early 1630s Rubens' mildly erotic *Diana and her Nymphs setting out for the Hunt* was moved from the queen's apartments to the summer ones of the king.

Not surprisingly, in the light of the queen's reaction, Philip was careful who was allowed to view the *Rape of Europa*. He knew that many people in Counter-Reformation Spain, a highly conservative, Catholic society, disapproved of Titian's mythological paintings. The poet and historian Bartolome Leonardo de Argensola, an influential figure at court in the early seventeenth century, was one of many to be scandalized by them. He recorded his feelings in a poem (despite its strongly disapproving tone the author had obviously studied the paintings closely):

Invite others to visit the breasts
In the grand city [Madrid] filled with silk and gold and
 amazing paintings
Which by the laws of talent are worth a fortune
Only God knows what they are worth
Leda on the swan, Europa on the bull
Venus wantonly unseemly
Promiscuous satyrs, fleeing nymphs
Diana immodestly among her companions
That she would keep them as living beings
He who allowed his eyes to judge
As he judges them as lewd
Why did he not use the brush for a tentative veil
To hinder our view

Despite Argensola's disapproval, Titian's *poesie*, however, hidden away in the king's private apartments did little to disturb

the rigorous formality of life at court in the Alcázar. Visitors to the palace in the seventeenth century found the experience extremely unsettling. Philip IV was so impassive when he appeared in public that he resembled a statue. He was reputed to have laughed only three times in public during his entire life. Foreign ambassadors visiting the Alcázar for an audience with the king recorded the claustrophobic formality of life at court. The ambassador would be led through a succession of dark and gloomy rooms, with not even one chair to provide a modicum of comfort, before he reached the audience-chamber, where he would be greeted by Philip IV, standing beside a console table. Having saluted the ambassador by touching his hat, the king would stand motionless throughout the interview, which he would terminate by making a number of courteous but anodyne remarks. No wonder Alonso Carrillo, in his *Origin of the dignity of the grandees of Castile* of 1657, described Philip IV's court as 'a school of silence, punctiliousness and reverence'. Occasionally, the king escaped from this ultra-formal world to indulge his love of hunting. He was a brilliant horseman and a keen hunter; a contemporary, writing in 1644, praised Philip's ability at pig-sticking and claimed that his trophies included a grand total of 400 wolves, 600 stags and 150 wild boar.

The occasional hunting excursion was one of the few opportunities Philip had to escape from his duties. Even his love of art was a part of his public persona. Philip ruled Spain throughout the Thirty Years' War (1618–48), which the Spanish regarded as a crusade against Protestantism. Philip was leader of the Catholic cause and promoted a number of moral reforms including closing legal brothels in Spain and attempting to regulate priests' sexual behaviour. His subjects would have been horrified if they knew that the king spent hours gazing at a series of erotic nudes by a Venetian artist.

In contrast, Titian's major portraits, historical and allegorical paintings were shown in the public rooms in the Alcázar. Great care was taken in hanging them in the main reception room, known as the New Hall, or Hall of Mirrors, so that they could demonstrate the power of Spain. This was where Philip received

ambassadors from as far afield as Russia and Ottoman Turkey, seated on his throne beneath Titian's *Equestrian Portrait of Charles V*. A number of changes were made to the Hall of Mirrors during his reign, but they did not affect the Titian which remained in place, the most potent image of the Habsburg monarchy. Other works by the artist in the room included *Religion aided by Spain*, an allegorical portrait of Philip II after the battle of Lepanto, the great victory by the Christian navy, led by Spain, over the Ottoman fleet in 1571.

The painter Vincenzo Carducho, who had worked for Philip II, Philip III and Philip IV and was the author of *Dialogues on Painting*, thought the scheme of decoration in the Hall of Mirrors was worthy of the highest praise, 'grave, majestic, exemplary, and worthy of imitation'. Interestingly, he contrasted this with paintings that depicted scenes from the myths of Ovid with 'impure and immodest boorishness', a criticism that seems to refer directly to Titian's *poesie*.

One of the reasons why the Hall of Mirrors was constantly being redecorated was because of the urgent need for the king to bolster his faltering reputation. This was both personal and political. Philip IV possessed a diffident character and, in the words of Velázquez, 'he mistrusts himself, and defers too much to others', in particular his chief minister, the commanding Olivares, whose extravagant and ambitious personality dominated the court during the first half of Philip's reign. Having renewed war with the Netherlands in 1621, which then proceeded to engulf the whole of Europe, Spain was committed to a generation of warfare.

Two years later Philip IV received an unusual visitor to Madrid. Charles, Prince of Wales, decided to make an impetuous visit to the Spanish capital with his friend George Villiers, Duke of Buckingham, the favourite of Charles' father James I, the two men travelling incognito under the pseudonyms Thomas and John Smith. The ostensible reason for the visit was an attempt by Charles to woo the Spanish Infanta Maria Anna, sister of Philip IV.

As it turned out, however, the most interesting outcome of the expedition was that the prince developed a passion for Old

Master paintings. Before coming to Spain the Venetian ambassador in London had noted the prince's love of Venetian painting, but Charles' only major purchase had been Raphael's cartoons of the *Acts of the Apostles* (now hanging in the Victoria and Albert Museum) from which he intended to commission a series of tapestries from the recently established Mortlake tapestry factory, the first of its kind in England. It was to be the sight of the Titians in the Spanish royal collection that inspired Charles to form his magnificent artistic collection.

At first, however, after his arrival in Madrid, political concerns took precedence. James I had been negotiating the marriage of the Prince of Wales to the Infanta with the Spanish ambassador, the Count of Gondomar, for many years, hoping thereby to secure a large Spanish dowry to help alleviate his acute financial problems (the dowry was initially set at £500,000, later raised to £600,000). This was a major political gamble since the majority of his Protestant subjects held strongly anti-Catholic views. For the latter part of the sixteenth century England had been at war with Spain, and James' older subjects had vivid memories of the triumphant defeat of the Spanish Armada.

The Spanish, with their love of protocol, were aghast at the unexpected arrival of two such important guests on such a delicate diplomatic mission. Charles and Buckingham made a formal entry into Madrid on 26 March. They were greeted by Philip IV and the Count-Duke of Olivares who, with typical love of self-dramatization, was dressed in gold-embroidered clothes. The two Englishmen, in contrast dressed 'in the English manner' without jewels or embroidery, were then escorted in a lavish procession from the monastery of San Jeronimo to the Alcázar. Crowds gathered to watch the king riding alongside the prince beneath a canopy, entertained by dancers as they went, and one spectator commented that Charles was 'a handsome youth of about twenty-two with a long face ... rather sunburnt from the journey, and his beard is just beginning to show'.

At the Alcázar a suite of rooms had been hastily prepared for Charles and Buckingham. During the spring and summer they had ample opportunity to study the works of art in the

royal apartments, particularly the wonderful group of Titians. Buckingham was already in the process of forming an important collection, including an *Ecce Homo* by Titian, purchased by his agent Balthasar Gerbier in Italy, and Gerbier now joined the royal party in Madrid, along with his fellow agent Tobie Matthew. The duke was later to acquire a total of 19 Titians for his London Residence, York House. Charles followed Buckingham's lead in developing a passion for the works of Titian and the other leading artists of the Venetian School. What is apparent from the outset is that the two Englishmen regarded these works of art purely on their aesthetic merits, and their aim was to purchase examples whenever they could.

The Spanish took a very different view. They had noticed the prince's growing interest in works of art and determined to take political advantage of this. They observed the lack of progress in the relationship between Charles and the Infanta, largely because the couple only met formally during pageants, masquerades and firework displays. But could the prospect of acquiring important paintings from the royal collection be used to persuade the Prince of Wales to convert to Catholicism? The Spanish were fighting a protracted war with the Dutch for control of the Netherlands. Just as in Philip II's day, there was a major logistical problem in transporting troops from Spain to the Low Countries. One route was to bring them by sea up the English Channel. Protestant England was likely to favour an alliance with fellow Protestants in Holland rather than Catholic Spain, but, if there was a Catholic monarch on the English throne, it was much more likely that England would remain neutral. For Olivares, who had renewed war with the Dutch in 1621, this was of cardinal importance.

Despite Charles' success in purchasing two Titians, he had difficulty in buying major works by the artist on the open market (Spanish nobles, acutely conscious of status, were reluctant to part with their paintings to a foreign prince until he was married to the Infanta, and would then become part of the Spanish royal family). Olivares calculated that Spain could benefit from the Prince of Wales' new-found passion by persuading his royal

master to part with some Titians from the royal collection. The first painting to be offered to Charles was Titian's magnificent portrait of *Charles V with his Hound* (Prado, Madrid), painted in 1530 shortly after he had been crowned Holy Roman Emperor by Pope Clement VII. This priceless gift sums up the difference between the two parties. For the Spanish, the painting carried a clear, political message: Charles V had been crowned as emperor by the pope for his championship of Catholicism. By accepting the gift they assumed that the Prince of Wales was going to join the Habsburg royal family, accepting the authority of the pope and converting to Catholicism. Charles, however, chose to ignore the political message, and accepted the Titian purely for its aesthetic qualities. On 11 June, the prince was offered another masterpiece by Titian, his *Jupiter and Antiope*, better known as the *Venus del Pardo* (Louvre, Paris), a particular favourite of Philip III.

As a final inducement Olivares persuaded his sovereign to offer Charles the *Rape of Europa* and the rest of the *poesie*, so beloved of Philip II, and widely regarded as some of the greatest works of the Venetian master. There could be no better example of the role that major works of art played as a diplomatic counter. Vicente Carducho, like the rest of the Spanish Court, was amazed at this largesse, recording in his *Dialogues on Painting*: 'I then saw them packed into crates, for shipping to England, these being *Diana Bathing*, *Europa*, *Danae*, and the rest.'

The gift appeared to have had the desired effect with Charles agreeing to the key religious issues. Although the prince was not willing to convert to Catholicism, he ignored warnings from his senior advisers, the English ambassador John Digby, First Earl of Bristol, and Sir Francis Cottington, ex-ambassador and Charles' secretary, and consented to grant freedom of worship to English Roman Catholics, repealing anti-Catholic legislation and allowing the Infanta, once they were married, to control her children's religious education. Remarkably, James I acquiesced in the agreement. This was all the more surprising, considering the unpopularity of his pro-Spanish policy with his

predominantly Protestant subjects. He had been compelled to dissolve Parliament two years earlier when the Commons, led by Sir Edward Coke, the most important jurist in England, had presented him with a petition in favour of a war with Spain and that the Prince of Wales should marry a Protestant.

Bristol and Cottington were increasingly concerned that the prince was giving too much away. They realized that he was a virtual captive in Madrid, under pressure from the Catholic divines, who frequently visited him, to convert to Catholicism. Their concerns appeared amply justified when Charles suddenly caved in to further Spanish demands on 7 July, agreeing to give the Spanish total control over the proposed marriage and to allow English Catholics virtual independence from governmental control. By now James I had had second thoughts at events in Spain, and when he heard of these new concessions his son had made on this crucial issue, he was so aghast that he feared he would lose his crown.

In fact Charles had decided that capitulation was the only course to adopt if he was to escape Madrid. Once he was free from the Spanish capital, he had decided to repudiate the agreement. This cynical ploy was to be typical of Charles' negotiating technique throughout his reign, particularly when he felt that he had been cornered by his opponents, notably when he was a prisoner of the Parliamentarians after the Civil War. His tactic was to make an agreement he had no intention of honouring.

The Spanish, however, were taken in. On 9 September, Charles and Buckingham left Madrid, their first stop being the Escorial, where the two Englishmen had a further chance to admire the extraordinary collection formed by Philip II, centred on the works of Titian. Charles then took leave of Philip IV, reiterating his promise to marry the Infanta by proxy once he had received papal dispensation. In fact, as soon as he reached Segovia, he instructed the Earl of Bristol to formally call the match off. This greatly upset the Spanish and, not surprisingly, they made haste to prevent Titian's paintings, which had been packed up, from leaving for England. They were brought back and rehung in Philip's apartments in the Alcázar.

Bristol, who had spent many years promoting the idea of the marriage, but had strongly opposed the sudden appearance of the Prince of Wales in Spain, was most upset that the Spanish, with whom he was on excellent terms, should have felt that he was acting in bad faith when he relayed the news. The earl was made the scapegoat for the whole affair. As a typical example of Charles' bad man-management, on returning to England Bristol was confined to his estates but was permitted to return to court if he would admit his fault. This he refused to do, resulting in Charles, by now king, sending his stubborn minister to the Tower where he remained until 1628. Charles thus alienated one of his most able servants; the two men were not reconciled until the eve of the Civil War in 1641.

The failure of the expedition inflamed anti-Spanish sentiment in England. The nation celebrated the Prince of Wales' return without a Catholic bride (though their jubilation was short-lived as Charles was shortly to marry a French Catholic princess, Henrietta Maria, sister of Louis XIII). Englishmen flocked to watch Thomas Middleton's *A Game of Chess*, which opened in London in August 1624 to packed audiences. Spectators particularly enjoyed the ridicule heaped on the Jesuits, portrayed as lecherous and avaricious, and the Count of Gondomar, Spanish ambassador to England for many years, caricatured as the Black Knight, with numerous jokes about his physical impediments. The Privy Council, sensitive that this was subtle criticism of the government's promotion of the Spanish alliance, closed the play after just nine days. The king, however, influenced by the mercurial Buckingham, was soon leading England into a war with Spain and the idea of an Anglo–Spanish marriage between Charles and the Infanta was therefore politically dead. (The Infanta was to marry her cousin Ferdinand III, the Holy Roman Emperor, a much more suitable match.)

For Charles, however, the Spanish trip was a voyage of discovery. The prince had been very impressed by the court of Philip IV and on his return to England he took to wearing sober, Spanish costume and based his courtly protocol on the Habsburg model. Charles brought back three major works by Titian: the *Portrait*

of Charles V with his Hound, the *Pardo Venus* and the *Woman in a Fur Wrap* (Kunsthistoriches Museum, Vienna) but, tantalizingly, the group of *poesie*, including the *Rape of Europa*, never left Spain. Charles lamented his failure to land this ultimate artistic coup (copies made by Michael Cross, a minor painter, sent over by the king, proved a scant substitute). Six years later, the king was still pestering Sir Francis Cottington, who was now English ambassador to Spain, to try to extricate the Titians from Spain.

The situation in 1629, however, was very different from that of 1623. The Spanish could see no political advantage in sending the paintings to England, so they remained in situ. Spurred on by this failure, Charles was to spend the rest of his reign amassing as many works by Titian and his fellow Venetians as he could buy to form the central part of his collection, the finest formed by any British monarch. His greatest artistic coup was the acquisition of the Gonzaga collection from Mantua. As in his dealings with the Spanish on his adventurous trip to Madrid in 1623, Charles took a very different view of the purchase of these paintings to that of his opponents. For the king, the acquisition of these magnificent Renaissance and Baroque paintings was well worth the enormous price he had to pay for them. His Puritan enemies, however, condemned the numerous religious paintings, filled with Catholic symbolism, which they felt gave clear evidence of the king's crypto-papism.

Interestingly, Charles I's taste was very similar to that of Philip IV. Both monarchs had a passion for the work of Titian; Philip, of course, was fortunate enough to inherit his collection from his grandfather while Charles was obliged to purchase his collection of 45 works by the Venetian artist. The two monarchs also enjoyed the works of Raphael and his followers. Among contemporaries, Charles I preferred to patronize Anthony Van Dyck, whose majestic portraits, strongly influenced by the richness of Titian's colours, created an iconic image of the king, based on the idea of the Divine Right of Kings (he was knighted by the grateful monarch). His portraits were to exert a formative influence on the great eighteenth-century British portraitists Sir Joshua Reynolds, Thomas Gainsborough and Sir Thomas Lawrence.

Philip IV preferred the works of Van Dyck's master Peter Paul Rubens, and the Fleming was to make an impact on Spanish painting as great as that of Titian. Rubens had already visited Spain in 1603, where he had paid homage to Titian in his powerful equestrian portrait of Philip III's chief minister the Duke of Lerma. Rubens had been struck by the 'splendid works of Titian, of Raphael and others', comparing them with works by contemporary painters, which he dismissed as showing 'incredible incompetence and carelessness'.

The Flemish painter made his visit during an eight-year sojourn in Italy, where he made an intense study of the great works of art in the main artistic centres, Venice, Genoa, Florence and Rome. He also spent several years based in Mantua, making a careful study of the Titians in the Ducal Palace, commissioned by the duke's ancestor Federico Gonzaga (this was the collection that Charles I acquired in 1627–30). On returning to his native Antwerp, Rubens became the leading painter in Flanders. He acknowledged his debt to Titian, and was seen as the leader of the colourists, who took their inspiration from the great Venetian painters, as opposed to the classicists led by Nicholas Poussin, the leading French artist working in Rome, who based their style on the art of Raphael and antique sculpture.

Rubens executed a number of works for Philip IV's aunt the Archduchess Isabella and her husband the Archduke Albert, joint rulers of the Spanish Netherlands. Isabella was impressed with Rubens' intelligence and sent him to Spain in 1628 in the role of a diplomat, rather than a painter. The snobbish Spanish grandees were not impressed at the painter's new-found status, the Duke of Aarschot writing dismissively to Rubens: 'I should be very glad that you should learn for the future how persons in your position should write to those of my rank.' Rubens, however, was more concerned to win the friendship of the king, and brought with him eight of his own paintings which were soon displayed in a state room in the Alcázar. As he had hoped, the king was full of admiration and the painter was soon enjoying a close relationship with Philip.

Rubens was an indefatigable worker and, despite his arduous diplomatic duties negotiating a peace treaty between Spain and England, he still managed to find time to execute a large number of paintings, notably an *Equestrian Portrait of Philip IV*, with a landscape showing the view out of the window of the Alcázar. It was hung as a pendant to Titian's *Equestrian Portrait of Charles V*, a true vote of confidence for the Fleming. In effect, it proclaimed Rubens as the heir of Titian. There is a note of self-satisfaction in the letter Rubens wrote on 2 December to his friend Nicolas-Claude Peiresc, the French astronomer, antiquary and collector, describing the intimate relationship he enjoyed with the king: '[Philip IV] takes an extreme delight in painting, and in my opinion this prince is endowed with excellent qualities. I know him already by personal contact, for since I have rooms in the palace, he comes to see me almost every day'. The two men obviously got on very well. At the end of the month Rubens was writing to Jan Gevaerts, the poet, philologist and historiographer: 'The king alone arouses my sympathy. He is endowed by nature with all the gifts of body and spirit, for in my daily intercourse with him I have learned to know him thoroughly. And he would surely be capable of governing under any conditions, were it not that he mistrusts himself and defers too much to others.'

Staying in the Alcázar, Rubens was in an ideal position to study the Titians which formed such a prized part of the royal collection, and he managed to make an astonishing number of copies (there is no record of Rubens copying the work of any other artist). According to Velázquez's father-in-law Francesco Pacheco: 'He copied every work by Titian owned by the king, namely the two bathing scenes [*Diana and Actaeon* and *Diana and Callisto*], Europa, Adonis and Venus, Venus and Cupid, Adam and Eve, and others ...'

Rubens attached a lot of importance to these copies and kept them in his studio until his death in 1640. He particularly admired the *Rape of Europa* and was reputed to have referred to it as the first painting in the world; his copy is very faithful to the original. It was bought by Philip IV for 1,450 florins

from Rubens' estate after the artist's death in 1640, along with a number of further copies after Titian including a much-cherished self-portrait of the artist in old age.

The Italian painter and engraver Marco Boschini, who had studied under Palma Giovane, who in turn had worked in Titian's studio, described Rubens' passion for Titian in a poem:

Rubens was as preoccupied with Titian
As a lady has her heart with her lover
And when he spoke of Titian
The marvels he had seen made by him
He confirmed in just truth
Without passion, but with certainty
That Titian had been the ultimate in painting
And the greatest master of all

As well as copying Titian's work, Rubens was also inspired to produce original works of his own based on Titian's *poesie*. These included his *Venus and Adonis* where the painter has reversed the composition so that the female nude, fully visible to the spectator, appears even more alluring than in Titian's original. Some of his most beautiful mythological paintings hung in the Alcázar, including his romantic *Garden of Love*, hung in the king's bedroom. Two other favourites of the king were Rubens' erotic *Three Graces* and *Diana and Callisto*, a subject already painted by Titian, where Rubens focuses the spectator's attention on the disgraced nymph, who bears the features of the artist's beautiful second wife Hélène Fourment.

Rubens was now regarded, in the words of the Spanish writer Lope de Vega, as 'the new Titian' and he was to play a crucial role in the rediscovery of the Venetian artist whose works were still little known in Spain outside court circles. The brilliant colours and the freedom and energy of his brushwork paid obvious homage to the Venetian and the large number of works he executed for the Spanish king made a strong impact on Spanish artists working in Madrid. Artists such as Francisco Rizi and Francisco de Herrera the Younger painted

with a virtuosity that owes a clear debt to both Titian and Rubens.

Rubens himself did not stay long in Spain, leaving in April 1629 laden with gifts, including a valuable ring worth 2,000 ducats given by the king. He continued his diplomatic mission in England, where negotiations ultimately led to the successful conclusion of a peace treaty in 1630, for which Charles I knighted the painter in Inigo Jones' Banqueting House in Whitehall, beneath the ceiling on which he had painted the *Apotheosis of James I*. In 1631, Isabella petitioned Philip IV on Rubens' behalf that he should be granted a similar honour, citing the precedent set by Titian who had been knighted by Charles V, and Philip made haste to acknowledge the request. Interestingly, the petition stressed that Rubens was in a class of his own, and that 'his services in important matters ... will not have the consequence of encouraging others of his profession to seek a similar favour'.

Velázquez was a generation younger than Rubens but a mutual love for the paintings of Titian helped to draw the two artists together. As Pacheco recorded: '[Rubens] communicated little with painters. He only established a friendship with my son-in-law ... and together they went to see the Escorial [to study the Titians].' Velázquez, however, paid homage to Titian in a subtler and less overt manner than Rubens. Unlike the Fleming, he did not make direct copies of paintings of the Venetian master.

Rubens encouraged Velázquez to go to Italy to study the works of the great Italian masters. Within three months of the former's departure, Velázquez had left Madrid for Italy where he was to spend 18 months. He greatly admired the works of Titian and Tintoretto in Venice, and Raphael and Michelangelo in Rome. Sadly, the self-portrait that Velázquez executed in 1630 while in Rome, 'a famous likeness of himself', as Pacheco described it, 'painted in the manner of the great Titian', has been lost. Back in Madrid Velázquez assumed the role of court painter, executing portraits of the king and members of the royal family in his studio in the Gallery of the North Wind in the Alcázar, which he had invited Rubens to share on his visit to Madrid. The two

artists got on very well and it seems that Velázquez accepted the fact that, when commissioning mythological paintings, Philip preferred the internationally renowned Fleming.

In 1650, Velázquez was to visit Italy again. This time the painter went with specific instructions from the king to purchase works of art, both paintings and antique sculpture. He assured Philip that he would succeed in this, listing the Italian artists he ranked highest, with Titian top of the list. However, although Velázquez had ample opportunity to refresh his knowledge of the greatest artistic treasure-trove in Europe, his attempt to buy top quality Old Masters proved largely unsuccessful. His most notable purchases were two paintings by Veronese and numerous casts of antique statues.

On his return Philip IV appointed Velázquez to the office of Palace Marshal. This office was largely devoted to arranging court festivities and overseeing daily affairs. It shows the overwhelming importance attached to court protocol that one of the foremost artists in Europe should have devoted so much of his time to such weighty matters as opening the king's doors and windows, making sure that Philip was correctly attired, and placing the king's chair in the right spot when he dined in public. The job also involved Velázquez in the maintenance of the royal collection and, in the 1650s, he was put in charge of the decoration of the Alcázar. The *Rape of Europa* was now moved to a long, formal gallery overlooking the Garden of the Emperors, where it was hung between *Diana and Actaeon* and *Diana and Callisto*. Lazaro Diaz del Valle, writer, genealogist and historian, and author of *The Lives of Artists*, a work similar in concept to that of Vasari in Italy, considered 'that there is no Prince in all the earth who has his Alcázar adorned with such precious and admirable paintings and statues of bronze and of marble, nor such rare, showy, furnishings.'

Velázquez was an important figure at court and, to cement his status, he longed to emulate Titian and Rubens and earn a knighthood from the king. To do this he needed to overcome the in-built conservatism of the Spanish nobility who controlled the Council of Orders, the governing body that awarded honours.

The nobles continued to regard the profession of a painter as that of a mere artisan, and there was considerable resistance before Velázquez was finally awarded the coveted Order of Santiago in 1659. This is the cross that the painter so proudly displays in *Las Meninas*, his final masterpiece.

As Palace Marshal, Velázquez had the run of the palace and was therefore one of the few with the opportunity to study the *Rape of Europa* and Titian's other *poesie*. The morality of Counter-Reformation Spain, where the whole question of depicting the nude in art aroused considerable controversy, meant that the king would never have dared to display these paintings in public. Foreign artists may have been permitted to paint nudes, and Rubens was keen to emulate Titian in taking advantage of this, but Spanish artists were forbidden to do so and anyone suspected by the Inquisition of painting 'obscene pictures' could have their works seized or repainted, and the artist could suffer excommunication, a fine of 1,500 ducats and even banishment for one year.

There were, however, double standards, and some collectors ignored the ban on painting nudes and while others sought out erotic works. As one commentator recorded, figures at the court of Philip IV greatly 'appreciated painting in general, and the nude in particular, but ... at the same time, exerted unparalleled pressure on artists to avoid the depiction of the naked human body'. This discrepancy is portrayed very clearly in Lope de Vega's play *La Quinta de Florencia* where an aristocrat commits rape after viewing a scantily clad figure in a mythological painting by Michelangelo (interestingly the playwright chose an Italian, not a Spanish artist).

Velázquez, too, ignored the ban and painted a number of nudes, none of which have survived with the exception of *Venus at her Mirror*, better known as the *Rokeby Venus* (after leaving Spain during the Peninsular War, it hung in Rokeby Hall in Yorkshire until 1906, when it was bought by the National Gallery, London). This beautiful painting, painted in sumptuous colours and in a wonderfully free style, shows a very obvious debt to Titian.

Velázquez paid more direct homage to Titian in his painting known as *The Spinners* or *Arachne's Fable*, executed in 1656–8. Like Titian's *poesie*, Velázquez chose a myth from Ovid's *Metamorphoses*, depicting the scene where Arachne had the temerity to challenge the goddess Minerva to a spinning competition. It is one of the Sevillian painter's most sophisticated compositions. On the surface the painting depicts a tapestry works, perhaps the Royal Factory of St Elizabeth in Madrid (Velázquez knew the Factory intimately since one of his jobs as Palace Marshal was to supply tapestries for religious feasts and public festivals). In the painting, spinners are hard at work in the foreground, while in the background Minerva, wearing a helmet and watched by three courtly ladies, appears before Arachne, who is standing in front of a tapestry depicting the *Rape of Europa*, a copy of the Titian.

On closer inspection the picture appears like a theatrical performance, a picture within a picture, the two main protagonists appearing twice: Arachne on the right in the foreground winding a ball of yarn (an allusion to her subsequent transformation into a spider for daring to challenge the goddess), while Minerva appears disguised as the old woman handling the distaff, before they reappear in the middle distance. The light pours in through windows on the left of the composition, brilliantly illuminating the figures in the background.

All sorts of allegorical interpretations have been put forward and it is possible that the composition represents the Art of Painting, and that the courtly ladies in the middle distance, who present such a contrast with the working spinners in the foreground, may be the Muses, with the lady standing beside the viol de gamba, propped up in the alcove, representing the Muse of Music. What is clear is that the depiction of the *Rape of Europa* as the subject of the tapestry in the background is a deliberate act of homage by the Spanish artist to Titian. Velázquez's painting was highly regarded by contemporaries. The first record of the painting was in 1664 when it was owned by Don Pedro de Arce with a valuation of 500 ducats, considerably higher than that of any of the other important Spanish and Italian works in his collection.

Interestingly, Velázquez's last great work, *Las Meninas*, also pays homage to the *Rape of Europa*, but more indirectly. The painting depicts a group of royal children, with their maids of honour (known as *las meninas*) who have just entered a vast room in the Alcázar, where the painter, standing at an easel, is at work. A mirror in the background shows the king and queen, who seem to be posing for the artist. On the back wall are two mythological paintings by Rubens, one of them depicting the *Rape of Europa*, a work that was strongly influenced by Titian's original.

The collection formed by Philip IV was the finest in Europe. His long reign, though disastrous politically, was a golden age of Spanish arts and literature. The king studied history and geography and spoke several languages, earning himself the epithet of the Planet King, the sun that blazed at the centre of the Spanish Court. This idea was to be taken up by Philip's son-in-law the French King Louis XIV, who was to portray himself as the Sun King. The Spanish king attended literary salons where he and his friends could indulge in a light-hearted analysis of contemporary literature and poetry. Philip also loved the theatre and attended plays by Lope de Vega, Pedro Calderon de la Barca and Tirso de Molina, who wrote the best dramatists of the age. Their humorous and cynical plays poked fun at the rigid morality of Spanish society.

But Philip made his strongest mark in the visual arts. As well as carrying out work restoring and improving the Alcázar, the king continued the tradition of his ancestors in building two new palaces, the hunting lodge Torre de la Parada and Buen Retiro, and filling these palaces with paintings he had commissioned. These were to hang alongside the great collection of Old Masters that he had inherited. Vicente Carducho noted the pre-eminence of the Venetian School: 'There are many paintings [in the Alcázar] and the most esteemed of all were always those by Titian, in which colour achieves its force and beauty'.

When Philip IV decided to decorate Torre de la Parada in the late 1630s, he preferred to commission mythological subjects from Rubens rather than Velázquez. Like Titian before him,

Rubens was treated as a court painter in absentia. For Philip IV, his work contained a pastoral lyricism close to that of Titian's *poesie.* The Fleming was also a famously fast worker with a well-organized studio. During the 1630s he despatched over 100 paintings from his workshop in Antwerp to Madrid.

Velázquez's paintings for the royal hunting lodge consisted of portraits of the royal family, antique subjects, two paintings of dwarves and one hunting scene. Few other Spanish artists were represented, giving some justice to the bitter criticism made by the painter Juseppe de Ribera, a major Spanish artist working in Naples, where he felt that he could earn more commissions than in his native land. He considered Spain 'a loving mother to foreigners and a very cruel stepmother to her own sons'.

The king's preference for Rubens was not shared by his chief minister Olivares. The palace of Buen Retiro, the other major royal residence to be decorated during this period, was placed under the overall control of the count-duke, who proceeded to fill the interior with Spanish paintings. To demonstrate his powerful position, Olivares placed his portrait by Velázquez beside that of the king, an unheard of liberty. The count-duke was a great admirer of Velázquez, a fellow Andalucian, and hung many of his finest works in the palace: the *Surrender of Breda* (Prado, Madrid), a major Spanish triumph in the Thirty Years' War, *Apollo in the Forge of Vulcan* (Prado, Madrid), the *Water-Carrier* (Apsley House, London) and several equestrian portraits of the royal family. The *Surrender of Breda* hung in the central room, known as the Hall of the Realms, as part of a series of 12 scenes of great Spanish victories in the Thirty Years' War, designed to impress all visitors with the increasingly illusory might of Spain. Many of these battle pieces were by Francisco de Zurbarán, who also executed a series of scenes from the *Labours of Hercules* (Prado, Madrid), the mythical hero from whom the Spanish Habsburgs (along with many other royal families) claimed descent.

Olivares wanted Buen Retiro to be a palace of the arts, with its own theatre, galleries and ballroom. Tournaments and jousts were staged in the bull ring and the gardens, adorned with

fountains, alleys, hermitage chapels and artificial lakes. Works of art were brought from all over the Spanish Empire: tapestries from Lisbon, Leone Leoni's bronze statue of Charles V from Aranjuez, and Old Masters despatched by the Spanish viceroy from Naples. There was also a gallery with 50 paintings by northern artists working in Rome, including works by Claude Lorraine, Nicholas Poussin, Jan Both and Gaspard Dughet. The finest work Rubens executed for Olivares' palace was the *Judgement of Paris*. The painting of the three nude goddesses, one of them modelled on the artist's second wife, was regarded as so erotic that it was kept behind a curtain.

Building these two royal palaces and filling them with major works of art proceeded throughout the Thirty Years' War, despite the political and financial disasters that afflicted Spain. During the 1620s the Spanish armies scored a number of military successes, such as the capture of Breda in the Netherlands, painted by Velázquez. The tide turned when France and Sweden entered the conflict in the 1630s, their cavalry and musketeers inflicting a number of defeats on the Spanish pikemen who had previously been such a potent force on European battlefields. To finance the ruinously expensive war Castile, the heartland of Spain, was forced to endure punitively heavy taxation. Olivares' attempts to distribute this financial burden among other Spanish provinces and in the empire overseas led to the outbreak of widespread revolts in Portugal, Catalonia, Naples and Sicily during the 1640s. These revolts led to the dismissal of the count-duke as chief minister.

Remarkably, despite these setbacks, Philip continued to buy the best paintings that came on the market. When there was a sale following Rubens' death in 1640, the king instructed his agent to bid for major works such as the *Rest on the Flight into Egypt* and the *Peasant Dance*. A decade later Philip had an even better opportunity to make important additions to the royal collection. In England Charles I, who had formed an outstanding collection of painting following his visit to Madrid in 1623, had proved a disastrous ruler. His political and religious policies aroused increasing opposition which culminated in civil

war in the 1640s, ending with Parliament's defeat of the royalist forces and the imprisonment of the king. Late in 1648 Charles was put on trial, and on 30 January 1649 he was beheaded outside the Banqueting House in Whitehall, which had been so lavishly decorated by Rubens. Following the king's execution, Oliver Cromwell, leader of the Commonwealth, decided to sell off Charles' art collection.

This was a golden opportunity for Philip to add to his collection. As early as 1645 he heard that the English king's enemies in Parliament were considering selling some works from the royal collection, and wrote to his ambassador in England, Don Alonso de Cardenas, to look out for possible acquisitions. He was, as always, particularly interested in paintings by Titian and Veronese. When Cromwell authorized the sale of Charles' collection of works of art Philip was determined to benefit from this unique opportunity. In order not to be seen to be too obviously taking advantage of the plight of a fellow monarch, he encouraged his chief minister Don Luis de Haro, Sixth Marquis of Carpio, nephew of the disgraced Olivares, to buy master-pieces in the sale, using Cardenas as his agent. The king would then acquire them from Don Luis after they had been inspected and valued by Velázquez.

The system worked extremely well and Cardenas proved a highly effective agent, purchasing major works by Raphael, Andrea del Sarto, Durer and Philip's favourite Venetian artists. Among the Titians the king acquired were a set of 12 paintings of the *Caesars*, a *Rest on the Flight into Egypt* and a half length *Venus*. In addition, the enterprising Cardenas bought two Titians that Charles had acquired in Madrid in 1623: the *Allocution of the Marquis of Vasto* and *Lady in a Fur Wrap*. Philip was particularly pleased to buy back the *Portrait of Charles V with a dog,* a key component of the Habsburg patrimony, which he had given to the Prince of Wales.

In a further irony the portrait was bought by Cardenas from Balthasar Gerbier, who had accompanied Charles to Spain, for £200. In an act of breath-taking hypocrisy, Gerbier, fearing that his former royalist connections would land him in trouble

with the new government, now disclaimed his previous career as artistic agent for the king, railing against the money 'squandered away on braveries and vanities; On old rotten pictures, on broken nosed Marble'. Mythological paintings by Titian continued to fetch very high prices. The French ambassador Antoine de Bordeaux-Neufville managed to acquire his *Venus del Pardo*, another gift to Charles from Philip IV, but was obliged to pay the enormous price of £7,000.

Philip wanted to compare his new purchases with the greatest paintings in his collection. Many of them were brought to the Sacristy of the Escorial where they were hung alongside religious works by Titian commissioned by Philip II: his *Gloria*, *St Margaret with the Dragon*, *Penitent St Jerome*, *Martyrdom of St Lawrence*, *Entombment*, *Ecce Homo* and *Christ in the Vestibule*. To give some idea of the extraordinary wealth of paintings by Titian in the royal collection, when the Sacristy was rehung by Velázquez in 1656 he replaced these masterpieces with an equally impressive array of paintings by the Venetian artist: *St Catherine at Prayer*, the *Penitent Magdalen*, the *Tribute Money* and *Mater Dolorosa*. No wonder Don Luis de Haro was moved to write to Cardenas, praising the 'many magnificent works by Titian in San Lorenzo de Real'. The royal collection remained intact, an inventory of its contents at Philip's death in 1665 listing some 2,000 paintings, including 614 'originals' by Titian.

By this date there was a general, broad appreciation of the radical technique of Titian's late works, such as the *Rape of Europa*, particularly among his fellow artists. Francesco Pacheco described this technique in his highly influential *Art of Painting*: 'It is commonplace, when a painting is not finished, to call it "smudges of Titian"'. Friar Hortensio, a leading theologian at court, who often preached before the king, was also astonished at his seemingly miraculous ability to create a realistic image with such broad brushstrokes: 'a Titian painting is no more than a collection of warring smudges, a dash of shadowy red glows, but seen in the light in which it was painted, it is an admirable and spirited mass of colour, a lively painting that, beheld by the eyes, lays doubt to the truth.'

The pleasure that Philip IV took from his art collection provided some consolation for the personal and political calamities that afflicted his old age. The death of Queen Isabella in 1644 was followed by that of his son and heir Balthasar Carlos, and his son Philip by his second marriage to his niece Mariana of Austria (this marriage was one of a considerable number of intermarriages between the Spanish and Austrian branches of the Habsburg family). But he continued to sit for his court painter, and Velázquez's portraits of the king in old age, his sad, mournful face gazing out at the spectator, are some of the artist's finest works.

Philip's personal tragedies coincided with political disaster. At the Treaty of Munster in 1648 Holland ended 80 years of warfare with Spain, and finally gained its independence. Eleven years later Spain made peace with France at the Treaty of the Pyrenees, making a number of important territorial concessions in Flanders and Catalonia. After the treaty was signed, Cardinal Mazarin, the chief negotiator, gave his Spanish counterpart, Don Luis de Haro, a highly esteemed painting by Titian.

Owing to the death of his two elder sons, Philip was succeeded by his third son, Charles II, at the tender age of four. The young king suffered from extensive physical, intellectual and emotional disabilities. He had only just learned to speak, and even then his tongue was so large that his speech was all but unintelligible. This also meant that he was unable to chew and he frequently drooled uncontrollably. It was to be four more years before he could walk and his health was so frail that he did not attend school. Charles' disabilities were widely attributed to his inbreeding; for generations the Spanish and Austrian branches of the Habsburgs had been inter-marrying so that all eight of Charles' grandparents were descendants of Joanna and Philip I of Castile. Moreover, his mother was niece of his father.

The severely handicapped young king inherited a country that was bankrupt, plague and famine were widespread in the countryside, and the government's hold on the still extensive Spanish Empire was under grave threat. Portugal had regained its independence in 1668, with the consequent loss of an overseas

empire encompassing Brazil, the East Indies and parts of India. During Charles' infancy, his mother acted as regent, relying on a series of favourites whose chief merit was that they enjoyed the queen's fancy. With the country in severe decline, people looked for scapegoats to blame for the nation's ills. The king himself was widely thought to be afflicted by sorcery, which had caused his disabilities, a theory to which Charles himself subscribed. The Spanish Inquisition engaged in widespread persecution of unbelievers and carried out a number of autos-da-fe, with victims garrotted or burnt at the stake.

However, despite the desperate state of the nation, the arts continued to flourish. Visitors were amazed by the splendour of the works displayed in the royal palaces. A Frenchman visiting the palace of Buen Retiro in Madrid in 1667 recorded the extraordinary legacy of Philip IV:

> In the palace we were surprised by the quantity of pictures. I do not know how it is adorned in other seasons, but when we were there we saw more pictures than walls. The galleries and staircases were full of them, as well as the bedrooms and salons. I can assure you, Sir, that there were more than in all of Paris. I was not at all surprised when they told me that the principal quality of the deceased king was his love of painting, and that no one in the world understood more about it than he.

Although there was no longer a painter of the stature of Velázquez, artists such as Alonso Sanchez de Coello, Juan Carreno de Miranda, Francisco Rizi and Francisco Herrera the Younger proved worthy successors, painting in a dramatic, Baroque style that was so popular throughout Catholic Europe. They studied works in the royal collection, but it was now Rubens, rather than Titian, who provided the strongest influence. Antonio Palomino, appointed court painter in 1688, was to write a three-volume *Account of the lives and works of the most eminent Spanish Painters, Sculptors and Architects*, published in 1715–24, in which he included Titian, Rubens and the

Neapolitan Luca Giordano, the three foreign artists he perceived to be most influential on Spanish painting, despite the fact that the Venetian had never set foot in Spain.

The king loved art, perhaps seeking solace from his grave afflictions. At the end of his reign, he turned to Italy, as his great-grandfather Philip II had done before him. Charles succeeded, where his father had failed, in persuading Luca Giordano, a brilliant master of fresco and nichnamed '*fa presto*' for the speed with which he worked, to come to Madrid, where he painted a number of stupendous frescoes glorifying the Habsburg dynasty. It brought to an end the golden age of Spanish painting, just as the dynasty itself was about to die out.

Charles II died in 1700, the last of the Spanish Habsburgs. European heads of state had watched with fascination for several years the gradual demise of the invalid king. By the time of his death Charles was speechless and stone deaf, suffering from constant fits of dizziness and nausea. He was subjected to the most dreadful treatments, ranging from conventional methods such as bleeding and applying leeches, to more outlandish ones: freshly killed pigeons were placed on his head and the steaming entrails of slaughtered animals on his stomach. Eventually his doctors despaired of saving the unfortunate monarch and the last Spanish Habsburg finally expired in the Alcázar in Madrid on 1 November 1700. His coroner pronounced that his body 'contained not a single drop of blood, his heart looked like the size of a grain of pepper, his lungs were corroded, his intestines were putrid and gangrenous, he had a single testicle which was as black as carbon and his head was full of water'. In this gruesome way the Habsburg dynasty, that had brought such glory to Spain, came to an ignominious end.

The pitiable death of Charles II seemed symbolic of the demise of Spain as a great power. While England, Holland and France had utilized their economic, financial and military resources, and had seen major developments in science and philosophy, the reign of Charles II had been a time of political and intellectual stagnation. Olivares' attempt to reform Spain's administration by the creation of a uniform taxation among the various provinces

had been thwarted by Spain's military defeat and economic collapse. His less capable successors were content to preside over an inward-looking country whose dominant characteristics appeared to be superstition, idleness and ignorance.

Across the Pyrenees, the increasingly powerful and aggressive France under her ambitious King Louis XIV determined to take full advantage of this apathy. He had launched a series of invasions of the Spanish Netherlands which Spain was ill-equipped to prevent. By 1700, Louis's success meant that France had replaced Spain as the dominant nation in Europe. The *Rape of Europa*, which had travelled from Venice to Spain, following the rising fortunes of the Habsburg monarchy, was about to move to a resurgent France, where it was to be housed in one of the most splendid palaces in the kingdom.

5

The Dukes of Orléans and the Palais-Royal in Paris

At the beginning of the eighteenth century, France dominated Europe both politically and culturally. Her artists, writers and composers had perfected a restrained version of the Baroque style. The French took great pride in the achievements of their artists. When Gian Lorenzo Bernini, probably the most famous artist in all Europe, came to Paris in 1664 to design the east front of the royal palace of the Louvre (automatically assuming that he would be given the commission) he was amazed when it was awarded to the virtually unknown Claude Perrault instead. Symptomatic of this general cultural shift from Italy to France, the French language was to become the lingua franca of courts throughout Europe in the eighteenth century.

Painters of the calibre of Nicholas Poussin and Claude Lorraine had chosen to work in Rome in the earlier part of the century, but their successors preferred to remain in France where they could enjoy the lavish patronage of Louis XIV. When Sir Christopher Wren, architect of the rebuilding of London following the Great Fire of 1666, went abroad to study architecture, he came to look at buildings in Paris, not Rome. As a measure of this new interest in the arts, Louis XIV's chief minister Colbert founded a series of Academies devoted to Belles Lettres, Science, Architecture and Music. In addition Colbert

reorganized the Academy of Painting and Sculpture, and set up the French Academy in Rome.

The best example of the French version of the Baroque style was the palace of Versailles, which was to serve as a model of princely magnificence for rulers from all over Europe. Unlike Philip II, whose palace of the Escorial, hidden away in the Guadarrama mountains, had attracted few visitors, every prince in Europe came to admire Louis XIV's palace at Versailles, which proclaimed the power and splendour of the Sun King, and returned home determined to replicate this statement of royal magnificence. Versailles became the show-piece for all the leading French artists. Foreign visitors were deeply impressed by the splendour of the architecture of Jules Hardouin Mansart, the paintings of Charles Le Brun and the immense park laid out by André Le Notre. In the palace theatre they could watch plays by the greatest dramatists of the day: tragedies by Jean Racine and Pierre Corneille, and comedies by Molière. Louis XIV loved music, and visitors had frequent opportunities to listen to the operas and *sarabandes* of his favourite composer Jean-Baptiste Lully.

Every aspect of the Sun King's life was governed by a public display of his royal majesty. Those deemed important enough were granted the privilege of attending the king's Grand Levée, where he was washed, combed and shaved, his walk through the magnificent Galerie des Glaces to the Royal Chapel, where he attended mass, his afternoon sortie into the grounds of the palace for a promenade or a hunt, and his Grand Public Supper. The timing of these activities was so precise that the Duke of Saint-Simon, in his *Memoires*, claimed that he could calculate precisely what the king was doing from a distance of 300 leagues. Foreigners who came to Versailles were awestruck at the mystique surrounding the Sun King.

However, Louis XIV's grandiose ambitions came at a price. The wars that France waged during the later seventeenth century, and the cost of building and maintaining Versailles, proved immensely expensive. The mercantile system devised by Colbert promoted and protected French manufactured goods, with an open invitation to workmen from foreign countries

while prohibiting French workmen from emigrating. Within France roads and canals were improved, and overseas special privileges were granted to the French East India Company. Colbert's investment in luxury goods such as the Gobelins and Beauvais tapestry works helped to establish France as the arbiter of European taste.

These economic policies were not, however, totally successful. State interference proved overly restrictive on workers, discouraged inventiveness and had to be supported by high tariffs. The Revocation of the Edict of Nantes in 1685, which ended a century of freedom of worship for Huguenots, brought about the emigration of some 200,000 Protestants, many of them highly skilled workers. Their displacement to France's opponents in England and Holland was a major economic blow, and mirrors the forcible eviction from Spain of the Jews in 1492, and of the Moors under Philip II and Philip III. Despite attempts at tax reform through the capitation which taxed everyone including the nobility and the clergy, though members of both bodies could buy an exemption, and the dixième, a tax on income and property value – France was massively in debt.

In addition French military supremacy, like that of Spain before it, meant that the nation attracted many enemies. To counter Louis's grandiose ambitions, his opponents, Habsburg Spain and Austria and Holland, formed a series of alliances to limit French expansionism. In the 1690s they were joined by England, where the pro-French Charles II and his brother James II (their mother Henrietta Maria was sister of Louis XIII and they were therefore first cousins of Louis XIV) were succeeded by William III, married to James' daughter Mary. During the following century it was to be England, or Great Britain as it became, (James VI of Scotland had succeeded to the English throne as James I in 1603, but the two nations were only formally united in the Act of Union of 1707) that was to prove France's most redoubtable opponent, destroying French dreams of creating a worldwide empire.

The first attempt to challenge French supremacy was caused by the death of the childless Charles II of Spain in 1700. The

best claimant to succeed him was the Dauphin Louis, son of Charles' half-sister Maria Theresa, and the nephew of Philip IV. Louis had a better claim than the other main contender, the Holy Roman Emperor Leopold I, Charles' first cousin. Since the succession of either candidate would dramatically alter the balance of power in Europe in favour of France or Austria, the two claimants had handed on their claims to the crown to their younger sons, the Dauphin naming Philip, Duke of Anjou and Leopold the Habsburg Archduke Charles. By this means they intended to preserve Spain's independence by separating their own position as rulers of France and Austria with that of their respective descendants. England and Holland, fearful of this dramatic change to the balance of power, backed a third candidate, the Electoral Prince Joseph Ferdinand of Bavaria, who had a more distant claim to the Spanish crown, as a compromise candidate.

In the event Charles proclaimed Louis XIV's grandson Philip as his heir and French determination to take up his claim led to the War of Spanish Succession (1701–13). From 1701 on the Duke of Anjou, now known as Philip V, was based in Madrid. For the remainder of the war he fought for control of the Iberian Peninsula, backed by a Franco-Spanish army against Anglo-Portugese forces led by the Habsburg Archduke Charles, who styled himself Charles III. The heartland of Castile supported the new Bourbon king (though Philip knew very little about his adopted realm and did not even speak the language), while the provinces of Catalonia, Aragon and Valencia, always keen to assert their independence, favoured the Habsburg archduke. Despite French defeats elsewhere by the two main allied commanders, John Churchill, soon to become Duke of Marlborough, and Prince Eugene of Savoy, and, although Philip was driven out of Madrid briefly in 1706, the war ended with the Bourbon faction in Spain in the ascendancy.

One of Philip V's key supporters during the conflict was the French ambassador to Spain, Antoine V de Gramont, Duke of Guiche and later, Fourth Duke of Gramont, a veteran of Louis XIV's wars against the Dutch. Gramont's family already had a

close connection with Spain. His grandfather Antoine III, Duke of Gramont, whose vain and boastful character was the inspiration for Edmond Rostand's *Cyrano de Bergerac*, had also served as French ambassador, arranging the marriage of Louis XIV and Maria-Teresa in 1659. Gramont was acting under instructions from Cardinal Mazarin who hoped that this marriage would lead to the union of the crowns of France and Spain, something that was to occur a generation later in 1700.

During the War of Spanish Succession, Philip resolved to thank his ambassador for his assistance by giving him a very special gift, some of the greatest works of art in the Spanish royal collection. The king chose three of Titian's *poesie*: the *Rape of Europa*, *Diana and Actaeon* and *Diana and Callisto*. Philip was a cultured man (he founded the National Library and the Royal Academy of History in Madrid), but he had little love of the visual arts, and had no compunction in disposing of these erotic works by Titian, formerly regarded by his art-loving Habsburg predecessors as some of the jewels in the collection.

The gift of works of art as a diplomatic counter was common practice among rulers. Philip IV had offered Titian's *poesie*, including the *Rape of Europa*, to Charles, Prince of Wales, when he visited Madrid in 1623. In the same way, the set of four paintings of the *Loves of the Gods* by Correggio, containing similar subjects to Titian's *poesie*, had been presented by Federico Gonzaga, Duke of Mantua, to his overlord the Emperor Charles V. One of the reasons why Philip V decided to give Gramont the Titians was because he knew how impressed the duke had been by the works of art in the Alcázar. Gramont gave a flattering description of the building:

What are admirable are the pictures that all the chambers are full of, and the superb tapestries, many more beautiful than those of the crown of France, of which this Catholic Majesty has 800 hanging in his furniture repository. Once I was compelled to say to Philip V, when I was an ambassador extraordinary to him, that he ought to sell 400 of them

in order to pay his troops to fight the war, and that enough would still remain for him to furnish four palaces like this.

This was high praise coming from a man who had said of the royal palace at Aranjuez: 'there isn't a petit bourgeois on the outskirts of Paris who does not have one more comfortable, more beautiful, and more embellished.'

Despite the praise that Gramont lavished on the Alcázar, however, he does not seem to have shown much interest in the gift from the king, and, probably in 1768, he sold the three Titians on to Philippe, Duke of Orléans, who was about to become the greatest art collector in France (the two men had an intimate connection, since Gramont's glamorous brother Guy Armand, Count of Guiche, said to be the handsomest man at the French Court, was reputed to have been the lover of both Philippe's father the bisexual Philippe, younger brother of Louis XIV, and his mother Henrietta Anne, youngest daughter of Charles I and Henrietta Maria).

The Duke of Orléans had been born to the purple, a grandson of Louis XIII, a 'petit-fils de France' and 'Prince of the Blood', the highest rank in French society, indicating that he was descended in the male line from the sovereign, and a member of the immediate family of the king. He was treated with enormous respect, referred to as Monsieur le Prince, his household was paid for out of the revenue of the state and he was one of the very few permitted to sit in an armchair in the king's presence, something regarded with the utmost importance at the class-conscious court of Louis XIV.

Good-natured, easy-going, generous to a fault and full of charm, Philippe was immensely popular at court. Highly intelligent and endowed with a prodigious memory, it seemed that the worldly-wise and pleasure-loving duke, who so closely resembled his ancestor Henry IV, was destined for great things. The problem was that the self-centred Louis (his motto was *L'etat, c'est moi*) disliked promoting people whom he deemed too capable, and the duke was compelled to attend court at Versailles but given little to do. In his minority Louis XIV had

experienced the Fronde, a series of civil wars between 1648 and 1653 instigated by the nobility as a direct attack on the crown. Consequently, he was determined that no subject should ever be in a position to challenge his authority and one of his first acts on gaining his majority in 1660 had been to overthrow his over-mighty finance minister Nicolas Fouquet (Louis had no qualms, however, in using Fouquet's architect Le Vau, his painter Le Brun and his gardener Le Notre, who had been working on Fouquet's beautiful château at Vaux-le-Vicomte, on his own palaces).

Once he had built Versailles, Louis instructed his nobles to attend the court, where he could keep a close eye on them. This tactic succeeded in curtailing their power but it meant that they were obliged to neglect their country estates. In eighteenth-century England, in contrast, enlightened landowners such as Charles, Second Viscount Townshend, of Raynham Hall, Norfolk, pioneered new ideas of crop rotation, earning him the nickname 'Turnip Townshend'. His neighbour Thomas Coke, First Earl of Leicester, of Holkham Hall, and Robert Bakewell, a farmer in Derbyshire, were highly successful in the selective breeding of new strains of cattle and sheep. There was no equivalent agricultural revolution in France where the aristocracy became completely detached from the countryside, leading to their growing unpopularity among the peasantry, something that was to have disastrous consequences in 1789.

Philippe, however, was finally permitted by his uncle to leave Versailles and join the army. He served with distinction on campaigns in the Spanish Netherlands in the 1690s where his left arm was badly damaged by a cannonball. During the War of the Spanish Succession Philippe fought in Italy in 1706 before being appointed commander-in-chief of the French forces in Spain in 1707. While in Madrid he lodged in the Alcázar when he was not on active service, and this gave the duke the opportunity to study the greatest paintings in the royal collection, including the Titians commissioned by Philip II. It was soon after his stay in Madrid that Gramont, no doubt aware of this, offered Philippe the *Rape of Europa*, together with *Diana and Actaeon* and *Diana and Callisto*.

Orléans was shortly to become the most important figure in French politics. A great many of Louis XIV's descendants had predeceased him, and, on the Sun King's death in 1715, his heir was his great-grandson, also called Louis, born in 1710. Although he had been taught little in the ways of government by his uncle, Philippe was the outstanding candidate to become regent and, in 1715, after a short power struggle with his brother-in-law the Duke of Maine, son of Louis XIV's mistress Madame de Montespan, he was appointed to the post. To ensure that he had full control of the young king, the regent brought him to Paris in 1716, where he was housed in the Tuileries Palace near the Palais-Royal, the main residence of the Dukes of Orléans, and the seat of government throughout the Regency of Louis XV. With the king and the regent living in close proximity, the area around the Palais-Royal and the Tuileries now replaced the Marais, fashionable since the time of Henry IV a century earlier, as the smartest quarter in the city.

The Palais-Royal had enjoyed a prestigious history. Standing opposite the north wing of the Louvre, it was built by Jacques Lemercier in the 1630s for Louis XIII's chief minister Cardinal Richelieu, who named it the Palais-Cardinal. Richelieu was a notable collector, creating a Gallery of Illustrious Men featuring portraits of great Frenchmen by Philippe de Champaigne and Simon Vouet. After the cardinal's death the palace passed to Louis XIII, who renamed it the Palais-Royal. During the 1640s and 1650s it was the residence of the dowager queen, Anne of Austria, and her two young sons, Louis XIV and his younger brother Philippe, Duke of Orléans. During the 1650s it also housed Henrietta Maria, exiled widow of Charles I and sister of Louis XIII, and her daughter Henrietta Anne.

When Philippe married Henrietta Anne in 1661, the palace became the main residence of the House of Orléans, where the duke and duchess entertained the cream of French society and staged plays by Molière in Lemercier's theatre, known as the *Salle de Spectacles*, one of the finest in Paris. The palace lost its pre-eminent position after Henrietta Anne's death in 1670 (she was reputed to have been poisoned by her jealous, bisexual

husband), but re-emerged as the centre of society in 1692 when Philippe's son Philippe Charles, Duke of Chartres, married his cousin Francoise Marie de Bourbon, illegitimate daughter of Louis XIV, in the palace chapel. On the death of his father in 1701, the new Duke of Orléans, now First Prince of the Blood, and his wife took up permanent residence at the Palais-Royal. Since Louis XIV's current mistress, the austere Madame de Maintenon, strongly disapproved of lavish entertainments at Versailles, Parisians flocked to the Palais-Royal, which was open to the public. The palace, adorned with marble and lacquer cabinets, the walls hung with Italian paintings and tapestries, had already earned a reputation as an artistic centre, staging exhibitions held by the Academy of Painting and Sculpture.

Philippe determined to redecorate the palace with no expense spared. The duke's favourite architect was the talented Gilles-Marie Oppenord, who had returned from Italy in 1708, determined to replace the heavy Baroque decoration so popular under Louis XIV with a lighter style. Oppenord set to work, designing everything from wall panelling and chimneypieces to clocks, chandeliers, mirrors and candlesticks. The architect loved exuberance, filling panels and frames with an abundance of foliage, flowers, shells, birds, mythical animals and military trophies. Oppenord was to prove the leader of fashion, and his light and playful style, known as the Rococo or, more irreverently, the 'salon et boudoir style', ideally suited to the fun-loving regent, was to prove immensely popular.

Richelieu's gallery had fallen into ruin, so a new one was constructed in 1702 by Jules Hardouin-Mansart, the architect of Versailles, known as the Gallery of Aeneas, with paintings by Antoine Coypel of the gods and goddesses of Olympus. Coypel was assisted in decorating the gallery by a number of pupils, including the artistically-minded duke himself. The end of the gallery was designed by Oppenord as a great triumphal arch. The painter developed a close relationship with his patron, and dedicated a series of lectures he gave at the Royal Academy to Philippe, in which he proposed that an aspiring painter 'who

wants to perfect his art' must study and imitate the Old Masters in the Palais-Royal.

A second gallery in the palace, known as the Gallery of Orléans, comprised the extraordinary collection of paintings acquired by Philippe, numbering almost 500 works by his death in 1723. It rivalled the great royal collections of Europe, its fame greatly enhanced by the fact that it could be viewed by the public. The paintings were displayed in two suites of grand rooms running side-by-side down the west wing of the palace. The undoubted *piece de resistance* was a *Galerie en Lanterne* or *Lanteron*, a top-lit grand salon rising through two floors, and projecting on consoles over the rue de Richelieu. While musicians played from a balcony on the higher level, visitors could gaze in awe at the beauty of the ensemble.

This was where Philippe hung many of his finest paintings, including the *Rape of Europa* and two *Diana* paintings by Titian, alongside works by Raphael, Rubens and Annibale Carracci. When the duke instructed Oppenord to alter the interior in 1721, the *Rape of Europa* was moved to the imposing two-storey Grand Salon, which was the culmination of an enfilade facing the garden. The gallery was conceived as a grand vestibule, with Ionic pilasters, large mirrors and oval medallions, aligned on a great mirrored and gilt fireplace. This was a suitably grand setting for the best Venetian paintings in the Orléans Collection: masterpieces by Titian and Veronese, alongside works by Rubens.

Philippe took a keen interest in his collection and liked to re-hang paintings, so it is difficult to make a firm opinion about his taste. The grouping of colourists in the Grand Salon, works by Venetian masters and Rubens, seen as their heir, would indicate his preference for hanging paintings in particular schools. On the other hand, he also liked to mix them up, so that Georges Le Rouge, who wrote a guidebook to Paris in 1718, noted that versions of *The Finding of Moses* by Poussin and Veronese were hung side by side. The same occurred with versions of the *Flight into Egypt* by Pietro da Cortona and Jacopo Bassano. Subjects were also mixed up so that the lawyer

Mathieu Marais, who wrote an account of the regency of Louis XV, was shocked that religious paintings were placed next to erotic nudes.

For most visitors the total effect was quite overwhelming. Masterpieces by the finest Old Masters hung alongside gilded sculptures and martial trophies, above commodes by Boulle, the greatest cabinet maker of the day, and lacquer cabinets filled with oriental porcelain. These splendid works of art were set against a sumptuous backdrop of panelling and crimson silk hangings. The overall impression was one of overwhelming luxury, with the stools and benches covered in gold-embroidered Gobelins tapestries, and a rock crystal chandelier illuminating the tables made of green Campagna marble.

In the Alcázar the *Rape of Europa* had been hidden from view, but the Palais-Royal, as splendid as any palace in Baroque Rome, was designed to proclaim Philippe's dynastic status and was open to the public. Like the Spanish Habsburg kings, the Duke of Orléans was a great admirer of Titian's paintings (he was to own three of the artist's *poesie*: the two Diana paintings as well as the *Rape of Europa*), choosing his portrait of *Philip II* to hang in his bedchamber. His attitude towards collecting was more eclectic and he wanted to acquire the greatest paintings on the art market, regardless of their particular school.

A few years after acquiring the Titians, the regent began using Pierre Crozat, a prominent financier and passionate lover of the arts, as his agent. Crozat himself was to form one of the greatest art collections of the early eighteenth century. Crozat managed to acquire the best paintings that were available. There were an extraordinary number of works by the leading artists: 12 each by Raphael and Poussin, 25 by Annibale Carracci and 16 by Guido Reni (these artists were regarded as supreme practitioners of the classical school or the art of *disegno*). The collection was equally strong in the Venetian School (the art of *colore*), with 28 Titians, including the three paintings from his set of *poesie*, 16 works by Veronese and 12 by Tintoretto, as well as 19 by Rubens, the seventeenth-century artist most strongly influenced by the Venetians.

To acquire these masterpieces, Philippe was prepared to pay vast prices. The canons of Narbonne Cathedral were persuaded to part with the *Resurrection of Lazarus* by Titian's Venetian contemporary Sebastiano del Piombo (National Gallery, London) for 24,000 livres, Raphael's *St John in the Desert* (Uffizi, Florence) was purchased for 20,000 livres, the same sum paid for his Bolognese follower Annibale Carracci's *St Roch and the Angel* (Fitzwilliam Museum, Cambridge). Outside France Crozat purchased Poussin's *Seven Sacraments* (National Gallery, Edinburgh) from the Chantelou collection in Holland for the enormous sum of 120,000 livres. Many of the most important works from the collection of Charles I, sold after his execution in 1649, had returned to France, where they were acquired by the regent, including Giulio Romano's *Infancy of Jupiter* (National Gallery) and Rubens' romantic *Landscape with St George and the Dragon* (Her Majesty the Queen), where St George bore the features of Charles I and the princess those of his Queen, Henrietta Maria.

Crozat's greatest coup, however, was the purchase for Philippe of the collection of Queen Christina of Sweden, including masterpieces by Raphael, Correggio, Titian and Rubens. The queen had benefited from the extraordinary success of the Swedish armies in the Thirty Years' War, when they had sacked Prague and looted the collection of the Emperor Rudolph II, the most compulsive collector of the late sixteenth century. After Christina's abdication from the Swedish throne in 1654 and her conversion to Catholicism (as the daughter of Gustavus Adolphus, the champion of Protestantism during the Thirty Years' War, this event sent shock waves through Europe), she took her collection of paintings with her to Rome, where she continued to acquire works by the great Italian Old Masters, notably the *Colonna altarpiece* (Metropolitan Museum, New York) by Raphael. To celebrate her conversion, Archduke Leopold William of Austria, ruler of the Spanish Netherlands, gave the queen Titian's *Death of Actaeon* (National Gallery), a late mythological work similar in style to his *poesie*. After Christina's death in 1689 her collection was bought by Don Livio Odescalchi, nephew of Innocent XI (Louis XIV had

also been interested in acquiring it), whose heir the Duke of Bracciano sold it on to the Duke of Orléans for 358,000 francs.

The actual purchase of the collection was a long drawn-out affair, with Crozat competing with the Emperor Charles VI and Prince Eugene of Savoy. There was also the complication of securing a papal licence to export the works of art. When it seemed that Crozat might fail to secure the whole collection, Philipppe indicated that the paintings he most desired were the nudes by Titian and Correggio. Crozat was, however, successful, and the sale for the whole collection finally went through in 1721, the paintings on canvas were carefully rolled on to cylindrical drums and packed on board ship before sailing from Rome to the south of France. They finally reached Paris in December.

Visitors were astonished at the magnificence of these paintings. Such was the quality of the Old Masters that it is scarcely surprising that Joachim Nemeitz, in his guidebook published in 1727, should have contrasted 'the new gallery, with various rooms embellished by rare paintings', with the Louvre, the main place of the Bourbon royal family in Paris, which he thought all but inaccessible, the paintings being 'today in very poor condition'. Nemeitz was probably referring to the Grand Salon, giving on to the Rue de Rivoli, which was decorated by Oppenord with the finest furniture, Gobelins tapestries and the prize sculpture from the collection of Cardinal Richelieu. Philippe was less interested in contemporary art apart from Coypel's Gods of Olympus in the Gallery of Aeneas, though he collected a few works by Watteau, who often frequented the palace, and his followers Pater and Lancret, who specialized in light-hearted scenes of sexual dalliance and intrigue.

It was at this period that the Palais-Royal acquired its reputation for scenes of debauchery. The regent was a true sybarite, who was notoriously unfaithful to his wife Francoise-Marie de Bourbon (she was a Princess of the Blood in her own right), whom he nicknamed Madame Lucifer, and enjoyed a succession of mistresses. He resembled his cousin Charles II of England in his mixture of charm, natural grace and intelligence

combined with a veneer of idleness and world-weary cynicism. Indifferent to religious orthodoxy and conventional morality, and endowed with a keen sense of humour, the sybaritic lifestyle of the pleasure-loving Philippe gave rise to lurid rumours. People suspected him of using his laboratory to indulge in black magic, holding séances and attempting to communicate with the devil. When a large number of Louis XIV's descendants: the dauphin, two of his three sons, his daughter-in-law and the little Duke of Brittany, all died within a few years, Orléans was rumoured to have poisoned them all to enhance his claim to the French throne.

Once he had been appointed regent, Philippe was able to indulge to the full his dissolute habits. During the day-time he dealt with affairs of state, receiving ministers and ambassadors and visiting the king, but the evenings were devoted to debauchery. Philippe's friend the Duke of Saint-Simon, whose *Historical Memoires* give such an insight into life at court during the Regency, was shocked by the regent's behaviour. He was scandalized by how the duke spent the evening 'in shocking bad company, with his mistresses or girls from the Opera, often with Mme la Duchesse de Berry [his dissolute daughter] and some dozen young men, not always the same, whom he invariably spoke of as his *roués* ... the wine flowed, the company became heated; they talked filth and out-rivalled one another in blasphemy; and when they had made sufficient noise and were all dead drunk, they were put to bed, and on the following day began all over again.'

Gossips at Court provided even more lurid descriptions of scenes of gross depravity. Supper parties were held in the palace in a room known as the *Cabinet Bleu*, where erotic paintings such as the *Judgement of Paris* by the Dutch genre painter Adrian van der Werff were hung on walls covered in blue silk damask. No servant was allowed entry into the regent's private apartments, to spare their blushes. Each guest was given a *nom de guerre* and served with a plentiful supply of champagne, three bottles per person being the normal consumption. Supper was eaten on a Sevres service specially

designed for the duke, decorated with obscene motifs. After supper there was often an indecent magic lantern show, before the party set off for a masked ball in the palace theatre. For those unable to contain their amorous intentions, there was ample opportunity to indulge their needs in the bedroom strategically sited off the regent's box.

On returning to the Palais-Royal, accompanied by a group of chorus girls, an impromptu ballet might be staged, the dancers performing stark naked. A leading participant in these activities was the regent's favourite daughter, Marie Louise Elisabeth, Duchess of Berry, with whom Philippe was supposed to have had illicit relations, alternating in the contrasting roles of a prostitute and a nun. Parties normally broke up when the guests were incapable of understanding one another, and footmen removed those incapable of walking out of the palace. Even Peter the Great, notorious for his drunken and lecherous behaviour, visiting Paris in 1717, refused a second invitation to supper with the regent.

The scandalous behaviour of Philippe was part of a general reaction to the austerity of the last years of Louis XIV. There was a feeling of liberality that characterized Regency society, epitomized by the light-hearted exuberance of the new Rococo style. It stands in marked contrast with the excessive formality of the Alcázar in Madrid where every aspect of Philip IV's life was rigidly controlled and the *Rape of Europa* was hidden behind a curtain when Philip was visited by the queen.

However this liberality could, at times, lead to excess. The most spectacular example of this prodigality was the career of the Scotsman John Law, a convicted murderer, speculator and gambler who organized the most successful financial swindle of the eighteenth century. France was heavily in debt on Louis XIV's death in 1715 and the regent was desperate to raise revenue. He was completely taken in by Law who devised a scheme whereby the newly-created Banque Generale would issue interest-paying bank notes, thereby reducing government debt. These bank notes could then be used to buy shares in a joint stock trading company, called the Compagnie des Indes, controlled by Law,

which consolidated the trading companies of Louisiana, the large French colony on the banks of the Mississippi, into a single monopoly, later extended to include all France's colonial trade. Law was now an incredibly powerful figure and was appointed Controller General of Finances, with the right to collect taxes. Profits from the venture were issued in shares which rocketed from an initial price of 500 livres to the astronomical price of 18,000 livres per share.

It seemed that everyone would profit from this windfall but when the Prince de Conti, one of the leading French nobles, in March 1720 decided to send three wagons to the bank, demanding that he redeem his 14 million shares in gold, it started a run on the banks and it rapidly became apparent that the shares were worthless. The subsequent collapse of the company not only bankrupted large numbers of Frenchmen, but also led to the collapse of the Banque de France itself. Although the regent, as head of the government, was heavily implicated in what became known as the 'Mississippi Bubble', ironically it was at exactly this moment, when his reputation was so low, that the city of New Orleans, at the mouth of the Mississippi, was named after him.

Philippe's involvement in Law's recklessness tainted his reputation and seems to mirror the debauched lifestyle that he enjoyed in the Palais-Royal. His son Louis, however, who succeeded in 1723, was a very different character. Despite his proximity to the throne, he was heir to Louis XV until he produced a son in 1729, and stood proxy for the king at the marriage ceremony with the Polish princess Marie Leszczynska in Strasbourg in 1725, the new duke showed little interest in politics. Instead, he devoted himself to performing works of charity. Louis's custom of distributing bread to the poor outside the door of the Palais-Royal ensured that the House of Orléans retained widespread popularity among Parisians, something that eluded the royal family (once Louis XV had attained his majority he had followed his predecessor and moved back to Versailles).

Orléans was of a strong religious disposition. He was devastated

when his young wife Johanna of Baden-Baden died in 1726 at the Palais-Royal after just three years of marriage, and turned for solace to religion, devoting himself to the translation of the Psalms and the Epistles of St Paul. His neurotic religious sensibility meant that he strongly disapproved of the erotic paintings collected by his father. Louis's wrath was directed in particular at the works of Correggio: his *Jupiter and Io* and its companion *Leda and the Swan*, two of the greatest paintings in the entire collection, descending from the Duke of Mantua to Charles V, the Emperor Rudolph II and Queen Christina of Sweden.

Louis violently objected to their lascivious subjects and cut out Io's head with a knife. The mutilated painting was then given to the painter Charles-Antoine Coypel, curator of the Orléans collection, to restore it, which he did with great skill. *Leda and the Swan* suffered an even more ignominious fate, being cut into four pieces by the incensed duke, and Leda's head destroyed. After the duke's death, the two Correggios were sold to Frederick the Great of Prussia, and installed in his gallery in Sanssouci, his pleasure palace in Potsdam. As a measure of their importance, they were brought back briefly to Paris after Napoleon defeated Prussia in 1806, before returning to Berlin following the emperor's fall in 1814. Considering Orléans's violent reaction to these mythological scenes, depicting the lusts of the Gods, it is a miracle that Titian's paintings of their amours, also based on Ovid's *Metamorphoses*, were spared.

Louis's distaste for the erotic paintings in his collection reflected his antipathy to the Rococo style, epitomized by luscious nudes by Francois Boucher (his version of the *Rape of Europa*, painted in 1749, was a typically suggestive work, with the princess' half-naked maidens tenderly stroking the bull). By this date, however, taste had changed and Boucher was no longer the most fashionable artist in Paris. The author of an anonymous pamphlet attacked the artist for his irrelevant themes: 'The *Rape of Europa*, isn't that a bit worn out?' Among the paintings in the Orléans Collection there was increasing praise for Poussin's *Seven Sacraments*, with their high-minded and moralizing classicism, harking back to ancient Rome. Jean-Baptiste-Simeon Chardin's

simple, naturalistic subjects, showing the influence of Dutch and Flemish genre painting, were also immensely popular.

Despite Louis' neglect, however, the Orléans Collection continued to attract visitors. Every knowledgeable Grand Tourist from Britain wanted to make a visit. Robert Taylor, in 1728, shared the general view that it was 'a cabinet of the finest pictures I ever yet saw'. Two years later, William Mildmay echoed his sentiments: 'Strangers commonly pay a visit to the ... Palais Royal. This last is enriched with the greatest collection in Europe of the most famous Italian and Flemish masters.' Bishop Douglas, who had been enlisted by the Marquis of Bath to accompany his son Lord Pulteney on the Grand Tour, visited the palace in 1748 and counted 30 paintings by Titian, more than any other artist. He lamented the religious devotion of the Duke of Orléans which had led him to destroy works he owned by that master as 'indecent'.

A year after the bishop's visit, the writer of the *Voyage Pictoresque de Paris* gave a very complete account of the collection. The pictures were hung in the palace much as they had been in the regent's day. Although the Flemish and Dutch paintings were kept separately in the Cabinets Flamands, there was no particular logic in the way that the Italian and French paintings were displayed, and Titian's set of *poesie* was not hung together as a group. The *Rape of Europa* was still displayed in the Grand Salon, together with a number of other works by the artist, while *Diana and Callisto* was in the Salle du Billard, and *Diana and Actaeon* in a room referred to as the Quatrieme Piece.

There was no systematic attempt by collectors at this date to hang paintings, either in individual schools or chronologically (this was only to occur at the end of the eighteenth century). Spectators liked variety, with a painting by a major artist from the Bolognese School (the school of *disegno*) placed next to one by a Venetian painter (the school of *colore*) so that viewers could make a comparison between the merits of the two schools.

The Orléans paintings in the Palais-Royal were much better displayed than the royal collection, either at Versailles or in

the Luxembourg Palace in Paris where they were open to the public by appointment on Wednesdays and Saturdays. La Font de Saint-Yenne's *Reflexions sur quelques causes de l'état présent de la peinture en France*, published in 1747, advocating the creation of a royal gallery, preferably in the Louvre, criticized the way that the royal collection in Versailles was 'hidden away in small, darkly lighted rooms ... ignored by foreigners owing to their inaccessibility'. He lamented that, even if the royal paintings 'surpass in number and quality those [of the Duke of Orléans] ... what a loss their imprisonment is for the talented artists of our nation'.

The hanging of the paintings at the Palais-Royal was probably not the decision of the duke, since he was so rarely seen in the palace. Orléans had become increasingly obsessed by religion, and eventually retired to the Abbaye Sainte-Genevieve outside Paris, near the family seat of Saint-Cloud, where he devoted himself to the study of natural science and ancient philosophy, mastering the archaic languages of Aramaic, Hebrew and Syriac. The duke adopted some very strange beliefs, and became convinced that death was just an illusion. In addition, he was convinced that his son was incapable of fathering an heir and therefore refused to acknowledge his grandson Louis Philippe Joseph, whom he regarded as an imposter. Nevertheless, Louis was not without artistic sensibility, remodelling the gardens of the Palais-Royal and the Chateau de Saint-Cloud.

The highly religious Louis, who died in 1752, was succeeded by his lazy and unprincipled son Louis Philippe, another member of the Orléans family prone to debauchery. Known as 'Philippe the Fat', he was rarely to be seen in the Palais-Royal, preferring to indulge his passion for hunting by day and gambling and enjoying his mistresses by night. Nevertheless, despite the duke's foibles, the House of Orléans continued to be held in high regard among the people of Paris. Louis Philippe served in the French army in the Seven Years' War (a conflict waged by France and Austria against England, Prussia and Russia) and when he led his troops to victory at the battle of Hastenbeck in 1757, the news was announced by his wife, Louise Henriette de Bourbon,

another Princess of the Blood, from the balcony of the Palais-Royal, to cheering crowds gathered in the courtyard beneath.

The Orléans' marriage, however, soon collapsed on his return from the war (the duchess had taken full advantage of her husband's absence to entertain a series of lovers in the Palais-Royal). In 1769 Louis Philippe made a morganatic marriage to the attractive and witty Charlotte Jeanne Béraud de la Haye, Madame de Montesson, with whom he had been having an affair for a number of years. His new wife exerted a strong influence on her husband and, in contrast to his earlier debauched lifestyle, the couple held salons attended by leading playwrights, scientists and intellectuals. Notable among the guests were the mathematician and philosopher Jean le Rond d'Alembert, the German writer and philologist Melchior Grimm, the chemist Claude Louis Berthollet, the composer Pierre-Alexandre Monsigny and the comic playwright and landscape gardener Louis Carrogis de Carmontelle. Perhaps conscious of the Palais-Royal's colourful recent history, Louis Philippe and his wife preferred to entertain their distinguished guests at the Château de Saint-Cloud and seldom stayed at their Parisian residence.

It was in the Palais-Royal, however, that the duke chose to bring up his son and heir Louis Philippe Joseph. The life and career of this young prince was to be one of the most extraordinary in French history. Born to a life of unimaginable privilege, cousin of Louis XVI, he was to become the promoter, paymaster and figurehead of the French Revolution.

The future Duke of Orléans was given a strict if highly privileged upbringing in the palace. In his early childhood, on his father's instructions, he was allowed no familiarity with servants or dogs, but, once he reached adolescence, Philippe soon acquired the dissolute habits of his ancestors. At the age of 15, the Duke of Chartres, as he was known, was introduced to the attractive Rosalie Duthe, one of the most alluring young courtesans in Paris, who had been painted in the nude by Jean-Honoré Fragonard, renowned for his playful and erotic paintings. Rosalie was soon a regular visitor to the Palais-Royal, eagerly anticipated by Philippe, and he was spotted, as Louis

XV's spy Marais reported to his master, going round to her house every day, carried in a sedan chair. Once he had acquired a taste for the fair sex, Philippe progressed to spending the night with three dancers, Emilie, Zelmire and La Guérin. They were seen leaving at day-break, each clutching six gold Louis, a fortune even for courtesans at the height of their profession.

Although his parents had neglected his upbringing, they were determined that their high-born son should make a suitable match. Philippe was soon courting Louise Marie Adelaide de Bourbon, a tall, slender beauty, with translucent skin, blue eyes and golden hair. More importantly she was also the richest heiress in France and grand-daughter of Louis XIV (her father, the Duke of Penthièvre, was the bastard son of the Sun King and Madame de Montespan). Within a few months of their initial meeting, Philippe and Louise were engaged to be married. Contemporaries were astonished at the scale of the dowry that the fabulously wealthy Penthièvre bequeathed on the fortunate couple: 6 million livres in cash, a further 4 million in rents on land and chateâux, and an annual income of 240,000 livres, later increased to 400,000. When the Duke and Duchess of Chartres returned to the Palais-Royal from their magnificent wedding in Versailles in 1769, the audience celebrated their position at the pinnacle of society by greeting them, as they entered their box at the Comédie Française in Paris, with the cry: 'Long live the royal family'.

The design of the palace gates, with their ironwork tracery, allowed passers-by to gaze into the forecourt. For those who wished to explore further, it was permitted to visit the interior of the palace and to wander through the gardens. Performances at the palace theatre were extremely popular and, when it was burnt down in 1763, it was rapidly rebuilt by Victor Louis, who had made his name as architect of the magnificent neo-classical theatre in Bordeaux. Philippe and Louise were keen patrons of the arts and had new apartments designed for them within the palace. The palace had a magnificent entrance, with an oval staircase designed by Pierre Contant d'Ivry and decorated with palm trees and putti made of wrought iron and bronze. The duke held court here daily, and his position as President of the

Parlement of Paris (the most important legal body in the capital), meant that there was a constant stream of visitors.

Foreigners flocked to see the remarkable collection of paintings in the Palais-Royal. In 1781, Henry Ellison, in a letter to his brother Robert, compared them favourably with all he had seen on his Grand Tour in Italy. Six years earlier Samuel Johnson visited Paris. The eccentric doctor refrained from speaking French, preferring Latin instead, for 'it was a maxim that a man should not let himself down by speaking a language which he speaks imperfectly', but was determined to see all the sights. Discarding his brown coat, plain shirt and black stockings in favour of a new hat, white stockings and a handsome, French wig, he ventured forth.

One of Johnson's first ports of call was the Palais-Royal. Although he did not mention Titian by name, he was very appreciative of 'a very great collection of pictures'. Johnson then strolled through the Tuileries gardens, noting the way that the fashionable, upper classes were to be seen 'dripping powder and paint' on to their embroidered clothes. As a major literary figure in Georgian London, the doctor inspected the libraries of the king, the Sorbonne and Saint-Germain, together with the Ecole Militaire, the Observatory, the courts of justice and a number of churches. He admired the statue of Louis XIV in the Place Vendôme, the Gobelins tapestry factory, the Sèvres porcelain works, and enjoyed the egg-and-rope dancing on the boulevards. Johnson also went to Versailles to see the king and queen dining in public.

The formality of life that the doctor witnessed at Versailles contrasted with the free-thinking ways at the Palais-Royal. This included giving women a prominent role. The duchess' favourite friend was Félicité de Genlis, niece of his father's paramour Madame de Montesson. Pretty and cultured, equally adept as an actress and musician, Félicité soon attracted the attentions of the duke, who installed her as his mistress. He relished the sight of her bathing in milk strewn with rose petals, which he regarded as 'one of the most agreeable things in the world'. But once fully clothed, often in trousers, Félicité was a formidable intellectual

presence, holding salons in the palace which attracted the most intelligent figures of the age.

These men and women were noted for the brilliance of their conversation, none more so than Charles Maurice de Talleyrand-Perigord, bishop of Autun (Talleyrand was a born survivor and was to play a major role in coming events as foreign minister of Napoleon and later of the restored Bourbon monarchy). Another liberal aristocrat who attended was the orator, writer and politician Henri Gabriel Riquéti, Comte de Mirabeau. A more exotic figure was the Chevalier de Saint-Georges, son of a French aristocrat and a black slave, renowned as a swordsman, who was to become the leading French abolitionist. Many of the habitués at the salons were freemasons, a body that encouraged the dissemination of radical ideas. Philippe was Grand Master of the Grand Orient de France, the governing body of the Masonic Order. These masons included the Montgolfier brothers, pioneers of ballooning, and the firebrand Camille Desmoulins, soon to become a leader of the extreme left-wing Jacobin party.

One of the subjects much discussed at the salons was the nature of beauty and the part that art could play in the transformation of society. These conversations on aesthetics were held in rooms decorated with the most magnificent collection of art in all France. Since the 1730s there had been regular exhibitions in Paris, known as the Salon, and numerous reviews were written about them. Many of the most perceptive of these reviews were penned by the philosopher Denis Diderot. Diderot was the editor of the monumental *Encyclopedie*, a key work of the Enlightenment, and a regular attender at Félicité's salons. The playwright Carmontelle, wit and intimate of Philippe, for whom he designed the beautiful Anglo-Chinese garden at Parc Monceau on the outskirts of Paris, felt that art could play a crucial role in the foundation of a new, liberal social order. Jean-Paul Marat, another habitué of the Palais-Royal and soon to become one of the leaders of the extreme Jacobin faction (his death in a bath, stabbed by Charlotte Corday, and painted by Jacques-Louis David as a martyr, was to become one of the iconic images of the French Revolution), shared Carmontelle's ideals.

Jacques-Pierre Brissot, a brilliant, subversive journalist, thought that society constrained artists but that the greatest of them overcame these constraints. Brissot, future leader of the moderate Girondin party, had a key role to play at the Palais-Royal. He was employed by Philippe to transform the duke's image from an arrogant, cynical and womanizing prince, notorious for his piercing blue eyes and sardonic smile, into a thoughtful liberal, devoted to improving the lot of his fellow citizens. Brissot was remarkably successful, and Philippe was widely perceived as a democratic king in waiting, surrounded by a circle of able and ambitious advisers.

The progressive thinking at the Palais-Royal extended to education, and the Orléans children were taught core academic subjects – Latin, Greek and moral science, as well as six European languages – but also architecture, carpentry and gardening. The star pupil was Philippe's eldest son, the future King Louis Philippe. As a further example of Philippe's progressive thinking, he put the formidable Félicité in charge of the children's education, a highly unusual move at the time, and one much to the chagrin of the duchess, who held less liberal ideas than her husband. She was, not surprisingly, extremely jealous of the attractive blue-stocking who exerted such a strong influence over her family.

It is, however, too simplistic to praise the free-thinking ideals of the Orléanist party, as it was known, promoting the role that art would play in the establishment of a new society, and dismiss the reactionary ideas of Louis XVI and his ministers. The able and energetic Comte d'Angivillier, director general of the royal buildings, aimed to transform the Grand Gallery of the Louvre, the main royal palace in Paris, into a magnificent museum of art, a source of national pride and a way to enhance the prestige of the Bourbon monarchy. Ironically, the left-wing Jacques-Louis David, soon to play a leading artistic role in the French Revolution, was so keen to study the paintings that he was invited by Louis XVI to stay in the palace. Throughout the 1780s d'Angivillier bought a large number of French paintings to demonstrate the supremacy of France in the arts, together

with Old Masters to fill gaps in the royal collection. Like the progressive party in the Palais-Royal, d'Angivillier saw the arts as playing a crucial role in shaping society.

Meanwhile, although Philippe enjoyed a life of incredible privilege, he longed to achieve something in his own right. In 1775 he applied to join the French navy, hoping to succeed his father-in-law to the office of Grand Admiral, which earned a salary of 400,000 livres. Although he was denied this office, three years later the duke served at the battle of Ushant against the British fleet under Admiral Keppel (during the American War of Independence France had allied with the American colonials against Britain). The battle was scarcely a French victory, indeed d'Orvilliers, the French admiral in command, blamed the duke for refusing to engage the enemy, but such was Philippe's status in Paris that, on his return to the Palais-Royal, he was given a 20-minute standing ovation at the opera.

Louis XVI, who had succeeded his grandfather Louis XV in 1774, was unimpressed, and supported his admiral's verdict, much to the duke's annoyance. The king's decision may have been based on personal animosity; there was no love lost between Philippe and Queen Marie Antoinette (daughter of the Austrian Empress Maria Teresa) whom the duke scorned for her frivolous and spendthrift lifestyle. The queen, in return, despised Philippe for his treachery, hypocrisy and selfishness. The duke had been regarded with suspicion by his sovereign since 1771 when he had been banished to his country estates for counter-signing letters of protest at Louis XV's decision to raise taxes without consulting the Estates General. This was composed of the First Estate, representing the nobility, the Second Estate the clergy, and the Third Estate the rest of the population.

Even at this early stage, despite the income from his estates of 800,000 livres per annum, Philippe's extravagant habits and his love of gambling were leading him into serious financial trouble. As an example, in 1777 he lost a large but entirely frivolous bet with the Comte de Genlis that he could prick 500,000 holes in a piece of paper in one hour. The duke's financial position improved when he was given the Palais-Royal in 1780 by his

father as a way of healing the rift between father and son over Louis Philippe's morganatic marriage, though the old duke was careful not to hand over the contents of the palace, fully aware of his son's extravagant habits. Philippe now proceeded to make substantial alterations to the palace which cost the extraordinary sum of 12 million livres. To pay for this, he disposed of a number of properties in Paris which raised 3 million livres, and sold the Château de Saint-Cloud to Marie Antoinette, whom he affected to despise, for 6 million livres. He also set up a lottery, with the permission of his estranged cousin Louis XVI.

The duke's most successful way of raising money, however, was to develop the gardens of the Palais-Royal by commissioning Victor Louis, who had already laid out the court of honour and rebuilt the theatre, to design a splendid colonnade. Beneath this colonnade, enclosing three sides of the gardens, were situated shops, cafés and commercial premises, with a covered promenade lit by 188 street lamps. To keep down costs, the fourth side was constructed of wood decorated with *trompe l'oeil* architecture.

Although Philippe's cousin the Comte d'Artois, younger brother of Louis XVI and the Comte de Provence, commented disdainfully: 'We don't see our cousin any more since he has become a shopkeeper', the venture proved a great success, and d'Artois and the Comte de Provence, the future Charles X, were soon to follow suit, developing their properties in the Faubourg Saint-Honoré and the Luxembourg Gardens. Parisians of all classes flocked to the Tartars' Camp, as it was known, to sample the shops filled with luxury goods, and frequent the excellent restaurants and cafes situated in the arcades. They discussed politics in the Café du Caveau, philosophical and artistic matters in the Salon des Arts, or boasted of their exploits fighting in America alongside the Marquis de Lafayette, commander of the French forces against the British in the American War of Independence, in the Café des Americains (Frenchmen who fought with the Americans often returned to France imbued with the colonials' liberal views which they expressed in the Palais-Royal). They took refreshments at the kiosks situated on the lawns before stopping to watch the puppet theatre or

visiting the new museum devoted to the science of aeronautics (this had become a passion in Paris following the successful ballooning exploits of the Montgolfier Brothers). The gardens were even more vibrant at night, when a less salubrious throng of gamblers, prostitutes, cheats and swindlers frequented the arcades, preying on visitors to the theatres, gambling clubs, wine shops and brothels.

The Palais-Royal, a haven for free thinkers of all persuasions, was a major focus for dissent against the government, and Parisians came here to express their dissatisfaction with the regime. They were welcomed by the duke, who was encouraged in his liberal ideas by his frequent visits to England, where he witnessed the passionate involvement by the aristocracy in politics, involving outspoken criticism of the government and even the monarchy. Louis XVI and Marie Antoinette were horrified by this criticism and their strong anglophobia was strengthened by the publication of scurrilous publications in England such as *The Pleasures of Antoinette*, which accused the French queen of rampant lesbianism.

Since the Palais-Royal belonged to the first Prince of the Blood, it was exempt from government censorship, and a flood of vitriolic propaganda was directed at Marie Antoinette. Ironically, one of the most stringent criticisms of the government was over taxation, and the blatant inequality between the exemption enjoyed by the aristocracy and the taxes that the bourgeoisie and the peasantry were obliged to pay. Considering the lavish lifestyle enjoyed by the Orléans family, it is remarkable that vociferous, left-wing figures such as Brissot, Marat and Desmoulins should have ignored the reckless extravagance of the duke when attacking the royal family.

During the 1780s efforts by the government to reduce the national debt by attempting to raise new taxes merely increased its unpopularity. In 1787 Louis XVI summoned an Assembly of Notables (a consultative body, like an expanded King's Council), something no King of France had done since 1626, to help to achieve this. The obvious candidate for President of the Assembly was the Duke of Orléans (Philippe had succeeded to the title on

the death of his father in 1785). But when the Assembly met at Versailles on 22 February the deputies were amazed to discover that their new president, displaying extraordinary fecklessness, had gone hunting instead. Despite this aberration, Philippe played a prominent role in expressing liberal anti-royalist, views in the Assembly and the duke was thought by his opponents to be plotting to replace Louis XVI.

When the Estates General met at Versailles in the autumn of 1787, summoned by Louis XVI on the advice of his finance minister, Charles-Alexandre de Calonne, to try to persuade the nobility and clergy to pay their share in tax, the Duke of Orléans, a major beneficiary of the exemption, shocked the royalist party by his willingness to challenge the rights of Louis XVI, declaring: 'Sir, allow me to lay at your feet the illegality of your orders.' This was an act without precedent, coming from a Prince of the Blood, but proved immensely popular with the Parisian populace and led to Philippe returning in triumph accompanied by a vast crowd to the Palais-Royal. Although he was temporarily exiled once again to his estates outside Paris by the enraged king, Orléans reconciled himself with Louis XVI on condition that he refrain from political activity. Considering that he was President of the First Estate of the Estates General, and that the animated political discussions continued daily at the Palais-Royal, this was all but impossible. In an attempt to avert the growing political pressure the king agreed to double the number of deputies in the Third Estate.

Orléans's champion Brissot now departed for America, but his place was taken by the equally ambitious radical Pierre Ambroise Choderlos de Laclos, author of the seductive and subversive novel *Les Liaisons Dangereuses*. Like Brissot, Laclos's mission was to promote his patron as the champion of individual liberty. His efforts were similarly successful and Philippe's popularity among Parisians was greatly increased by the free food distributed at the gates of the Palais-Royal during the freezing winter of 1788–9 following the failure of the harvest that summer. By late 1788 Laclos was being employed by the duke on a salary of 6,000 livres per annum. Laclos was also

given the honour of helping to educate the precociously bright 15-year-old Duke of Chartres, the future King Louis-Philippe, replacing Madame de Genlis, much to her chagrin.

Like his master Philippe, Laclos was one of many left-wing thinkers who revered the philosopher Jean-Jacques Rousseau, and he wished to follow his ideas in the creation of a more moral and democratic form of government. In his *Social Contract*, Rousseau argued that there was an agreement between the ruler and the people whereby the people accepted the rule of government as long as their rulers respected their rights, property and happiness. If this did not happen, the people were free to choose a new set of rulers. This radical idea, adopted by the Americans in their War of Independence, was to be used by the French Revolutionaries to justify the violent overthrow of the *Ancien Régime*, and was particularly popular among the extreme Jacobins, led by Desmoulins and his friends Georges Danton and Maximilien Robespierre. They stood in contrast with the more moderate views espoused by Voltaire and Montesquieu (Charles Louis de Secondat, Baron de Montesquieu), two leading *philosophes*, who advocated constitutional monarchy based on the British model.

During the summer of 1789, the political situation continued to deteriorate. With law and order breaking down, Paris became an increasingly dangerous place. On 9 June Arthur Young, who had travelled extensively through France noting how superior British agriculture was to its French counterpart (he was an authority on the subject, about which he had written several books), recorded how the mood in the gardens of the Palais-Royal had turned, against not only the monarchy, but also the clergy and the nobility. He noted how every coffee-house contained 'orators, who from chairs and tables harangue each his little audience. The eagerness with which they are heard, and the thunder of applause they receive for every sentiment of more than common hardiness or violence against the present government, cannot easily be imagined.' No wonder Simeon Hardy, a bookseller with a shop in the palace's arcades, wrote:

'An air of discord hangs over the city. All it needs is a single spark to ignite some terrible conflagration.'

That spark was to be lit the very next day. On 20 June the Third Estate, now calling themselves the National Assembly, were locked out of the chamber of the Estates General at Versailles, and, at the instigation of a certain Dr Guillotine, inventor of the famous execution machine, soon to become symbolic of the Revolution, reassembled in a nearby tennis court, from where they issued their famous Tennis Court Oath, pledging themselves not to separate 'until the constitution of the kingdom is established'. Philippe had already openly aligned himself as closely as possible with the Third Estate, voting with that body against the king to show his opposition to the government. Now the Assembly voted overwhelmingly for the Duke of Orléans as its first president, but Philippe, once again, refused the honour. This did not stop his opponents from suspecting him of harbouring greater ambition, either to become regent or lieutenant-general of the kingdom, the key posts controlling the government and the army respectively. And the ambitious clique that had formed around the duke, led by Laclos, continued to plot against the royal family, with Marie Antoinette as the focus of their dissent. When a rioting crowd attacked the Abbaye prison in Paris, and rescued some soldiers who had refused to fire on the crowd in the Reveillon riots earlier in the year (an attack in April by hungry workers on Jean-Baptiste Reveillon's factory after he had offered the workers lower wages), the soldiers were carried in triumph to the Palais-Royal.

In answer to these demonstrations, and under the influence of the queen, who opposed his attempts to reform the nation's finances, Louis XVI dismissed his popular chief minister Joseph Necker. On 12 July, suspecting that the king was about to order troops into Paris to arrest his opponents, the young lawyer Camille Desmoulins, pistol in hand, leapt on to a table outside the Cafe Foy, in the gardens of the Palais-Royal, with the cry: 'To arms! To arms! There's not a moment to lose, I've just come from Versailles. Necker has just been dismissed. This will be another Feast of St Bartholomew [the Massacre of the Huguenots by Catholics in Paris in 1572], comrades. This evening the Swiss

and German guards will be marching along the Champs de Mars to massacre us. Come on, this is a call to arms.'

Seizing a cluster of leaves from a chestnut tree, he urged his comrades to adopt this cockade as a symbol of liberty, soon to be replaced by the red and blue colours which represented both the city of Paris and the House of Orléans. When the colour white was added to the cockade it was transformed into the famous *tricolore*. The spontaneous action of Desmoulins showed how ordinary people rather than leading politicians could influence key events, something that was to assume greater importance as the *Ancien Régime* collapsed in the forthcoming months.

On 14 July, the Bastille prison was captured by the Parisian mob and the governor and his Swiss guards brutally murdered. Many suspected Orléans of involvement, and the behaviour of his supporters in the gardens of the Palais-Royal, where the event was celebrated in a semi-hysterical orgy of obscenity and drunkenness, seemed to bear out their fears. Philippe, meanwhile, was nowhere to be seen, and Grace Elliott, one of his mistresses, was later to assert that he was on a fishing excursion while these momentous events were taking place. Dr Edward Rigby, an ardent English Whig who supported the aims of the French reformers, had taken rooms in the Palais-Royal. On 14 July he and his companions were swept along with the crowd, and warmly embraced as freemen and brothers when they were recognized as Englishmen. His feelings of delight turned to disgust, however, when a mob appeared, carrying the bloody heads of two murdered Swiss guards on pikes. They were impaled on spikes in the gardens of the Palais-Royal, a highly provocative gesture.

On 5 October the situation finally exploded. A large crowd, dominated by angry women demanding bread, and inflamed by the fiery oratory of Danton, Marat and Desmoulins, all supporters of Orléans, marched from Paris past the Palais-Royal where the duke, attired in a grey riding coat, watched them from the balcony, heading for Versailles. On arrival, the mood of the mob soured, and, after breaking into the royal apartments, the lives of the royal family were only saved by the prompt action of Lafayette, commander of the National Guard, whose status

as a popular hero, celebrated for his passion for liberty and his unimpeachable honesty, gave him the stature to defy the mob.

Lafayette was, however, unable to prevent the royal family from being taken back in captivity to Paris by the triumphant mob, where they were imprisoned in the Tuileries Palace. It is still unclear exactly what role Philippe played in the day's events, and many people thought he was implicated in a plot to overthrow the royal family. When a report was published the following year, exonerating Orléans from any involvement in the events of the preceding October, Marie Antoinette is reputed to have said to her husband: 'If you really want to see who is the real King of the French, just take a drive to the Palais-Royal.'

Orléans's supporters had worked tirelessly to promote him as a potential regent, but the duke, at this critical juncture, chose to spend the period between October 1789 and July 1790 in England, ostensibly on a diplomatic mission. He was persuaded by his opponent Lafayette, who regarded him as a disloyal trouble-maker, that his removal would scotch persistent rumours that he wanted to become regent or even seize the crown for himself. When the king also appealed to his cousin to leave France, Philippe felt unable to refuse. For his supporters, leaving France at this critical juncture was tantamount to cowardice. Mirabeau commented derisively: 'The coward! He has the appetite for crime, but not the courage to execute it.' Talleyrand was even more scathing. 'He is the slop-pail', he declared, 'into which is thrown all the filth of the Revolution.'

In fact, Philippe had a more pressing reason to go to England, to contact friends who would help him to solve his disastrous financial position. Despite Orléans's popularity, he had many opponents in the National Assembly, which had now moved from Versailles to Paris, and they passed a vote in August to exclude the two minor branches of the royal family, the Bourbon kings of Spain and the House of Orléans, from the royal succession. More importantly, the Assembly ordered the sale of all land belonging to the Duke of Orléans and to Louis XVI's two brothers, the Counts of Provence and Artois, the future Louis XVIII and Charles X (despite Philippe's left-wing

credentials, it was indicative of the growing hostility to the aristocracy as a whole that he should have been bracketed with two of his main opponents). Since the total rents from all his properties, agricultural land and forests, covering the equivalent of three French departments, amounted to the vast sum of just over 5 million livres, far more than that of the king's brothers, this was a devastating financial blow.

Philippe had visited England several times in the 1780s, he was a firm anglophile, owned a house in London and numbered the Prince Regent among his close English friends (like the prince he was a member of Brooks's Club, a centre for francophile Whigs). He was a great admirer of the security of the country's political system and had deposited large sums of money in English banks. Philippe also knew that if he was to raise substantial sums of money to pay his debts, rich English aristocrats were the most likely buyers of his magnificent art collection. Two years earlier, in 1787, he had been compelled to raise money by selling his priceless collection of precious stones, cameos and medallions to the acquisitive Catherine the Great of Russia. They were soon on display in the Hermitage in St Petersburg, including a wonderful agate-onyx of Nero's mother Agrippina, which bore a remarkable likeness to the Russian empress.

On his return to Paris in July 1790 Philippe instructed his agent Nathaniel Parker Forth, an old friend with whom he shared a passion for horse racing, to contact James Christie, head of the reputable firm of auctioneers in England, regarding the sale of his paintings. During the autumn, after considerable negotiations, a contract was drawn up stating that Christie would offer a deposit of 100,000 guineas for the paintings. However, although the well-connected auctioneer persuaded the Prince of Wales to put up £7,500, and his brothers the Dukes of York and Clarence £5,000 each, he found great difficulty in attracting further backers. This may have been due to the perception that the lion's share would go to the royal princes. In the event Christie's bid was unsuccessful. Shortly after negotiations broke down the duke was declared bankrupt. He now had little alternative but to sell.

A second Englishman, Thomas Moore Slade, formed another consortium. The lure of acquiring the famous Orléans Collection was so great that he was prepared to risk visiting Paris in the middle of a Revolution. On 8 June 1791 Slade set off for Paris with the backing of Lord Kinnaird and Messrs Morland and Hammersley (the three men were partners in the banking firm Ransom, Morland and Hammersley in Pall Mall), carrying letters of credit for £50,000. Slade arrived on 20 June to discover that the royal family had just escaped from the capital. The king was persuaded that his family was in grave danger if it remained in Paris in the hands of the revolutionaries, who were proving more and more hostile, and that his best hope lay in joining the Austrian army massed on the border at Metz (France had declared war on Austria in April). Unfortunately, the carriage known as a *berline*, travelled very slowly, and the royal party, although in disguise, was recognized by a postmaster who persuaded the local guardsmen at Varennes to apprehend the king and queen. They were brought back in disgrace to Paris.

Slade described his experiences:

I arrived in Paris the very day the king fled: the city was in the greatest confusion and under martial law; however, the keepers of the gallery [of the Palais-Royal] had orders to let me have free access at all hours, and to take down any pictures which I wished to inspect ... After two or three days that I had been in Paris, I was requested on the part of the Duke of Orléans to make a valuation of all the pictures in the collection, and to make an offer.

Slade was reluctant to do this, since he expected Orléans to have fixed a price, but the duke insisted that he do so. He continued:

I was therefore compelled to make a valuation, which I presented to the Duke; but when he saw it, he got into a rage, and said he was betrayed, and that I was in league with Monsieur le Brun, the director of His Royal Highness's

gallery, as there was only 20,000 livres difference between his valuation and mine. I most positively assured the duke that such could not be the case as I was not acquainted with Monsieur le Brun; had never spoken to him in my life; and only knew him by reputation. This casualty, however, gave a check to the affair.

In fact Philippe's reputation was in the ascendant following the Flight to Varennes, as it was known, and he felt less need to sell. He therefore felt that he no longer needed Slade, who recorded:

The Orléans party at this time became every day stronger at Paris, and the duke so popular, that he flattered himself he should speedily be elected regent – he suddenly, therefore, resolved not to sell that collection, on the credit of which he had already borrowed considerable sums of money for the purpose of influencing the public mind: thus was this first, and most important negotiation broken off, to my great mortification, and I returned to England, having accomplished nothing.

But the vacillating duke changed his mind and his rejection of the Regency, partly due to the robust opposition of Lafayette, effectively ended his role in the French Revolution. And Philippe still desperately needed to raise money. Slade was once more in the frame:

I had not long left France, when Lord Kinnaird informed me that the Italian part of the Orléans Collection [the *Rape of Europa* and other valuable masterpieces] had been disposed of; that the duke had lost a large sum of money at billiards to Monsieur la Borde [another example of Philippe's fecklessness], and that the bankers were so pressing upon him that he was compelled to let them have the Italian pictures [the most valuable part of the collection], to pay his debt; that the Flemish and Dutch pictures still remained, but there was

not a moment to be lost in endeavouring to secure them for his country.

Although Slade would have loved to handle the Italian paintings – there were five so-called Titians hanging in his house in Rochester – he was determined to acquire the remainder of the collection and set off post-haste for Paris, where he made a new valuation. This was accepted, a memorandum of agreement signed, only for the fickle duke to change his mind yet again, as Catherine the Great, who had already bought his collection of cameos, had made a rival offer. After an argument about exchange rates, Slade's offer of 350,000 livres was restored but now he had to deal with Orléans's creditors who had their eyes on the Palais-Royal. His account continued: 'The numerous creditors, to whom he had pledged various parts of the palace, rose up and claimed the pictures as part of the furniture, and refused to let them be removed.'

The enterprising dealer now consulted an advocate, and, following a meeting with some 30 claimants in the great hall of the Palais-Royal, he enforced the legality of his claim and the next day removed the paintings discreetly to a warehouse adjacent to the palace. Aware of potential objections to the paintings leaving France, and keen to avoid the duke's many creditors, he informed anyone who asked questions that they were going down the Seine to Le Havre, but instead transported them secretly by night to Calais. He had hired the sloop *Grace*, and informed the skipper Thomas Cheney to sail from Chatham, with one Thomas Aldridge, an expert on paintings, on board. The *Grace* sailed across to Calais, where Cheney, Aldridge and some of the crew disembarked and headed for the house of a Monsieur Dessein, who had in his possession 15 crates, filled with paintings from the Orléans Collection. Having brought them aboard, the sloop was then delayed by a gale for several days, before crossing the Channel and sailing up the Medway to Chatham where Cheney waited until dark before unloading the crates and carrying them to his house. This stealthy operation meant that Slade avoided paying any duty on an immensely

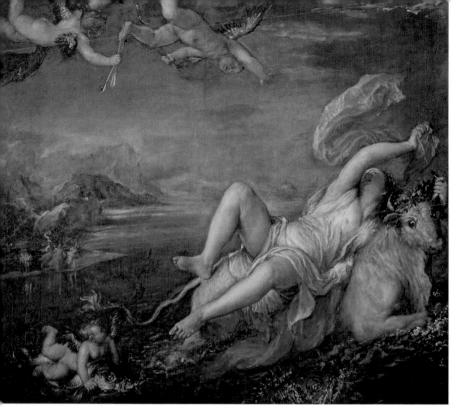

Two of Titian's *poesie*: 'The Rape of Europa', (c. 1560–2), Isabella Stewart Gardner Museum, Boston (above) and 'Danae Receiving the Shower of Gold', (1553), Prado, Madrid (below)

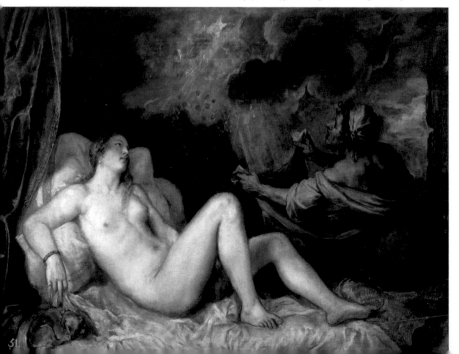

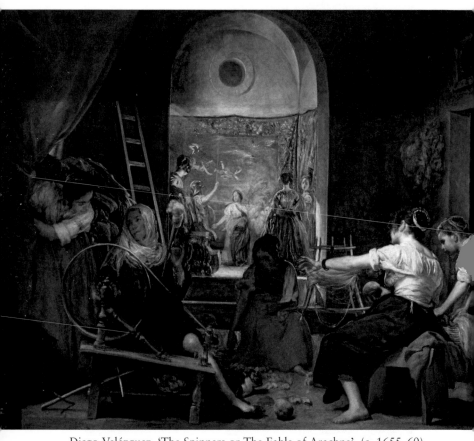

Diego Velázquez, 'The Spinners or The Fable of Arachne', (c. 1655–60), Prado, Madrid

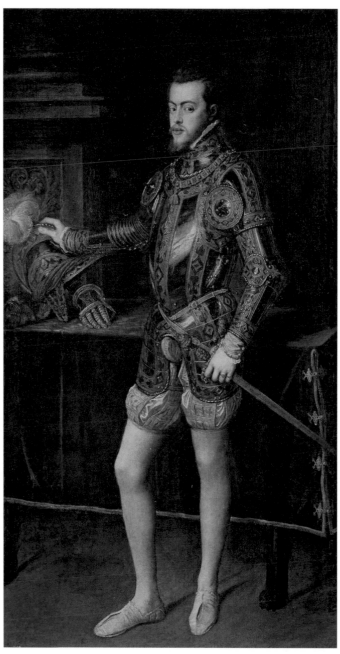

Titian, 'Portrait of King Philip II', (1551), Prado, Madrid

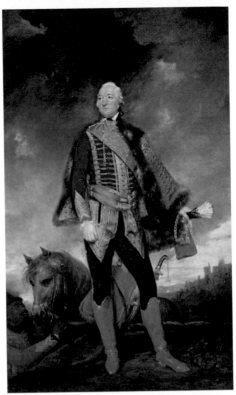

Sir Joshua Reynolds P.R.A., 'Portrait of Louis-Philippe-Joseph d'Orléans,
Duke of Chartres, later Duke of Orléans', (1779), Musée Condé,
Chantilly (above); The Palais-Royal, Paris (below)

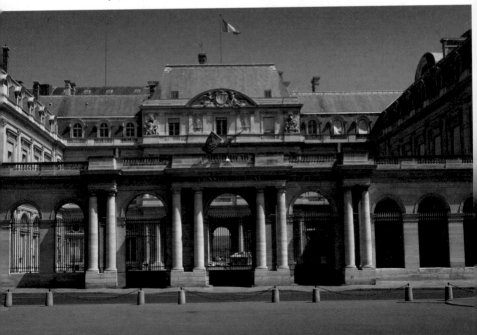

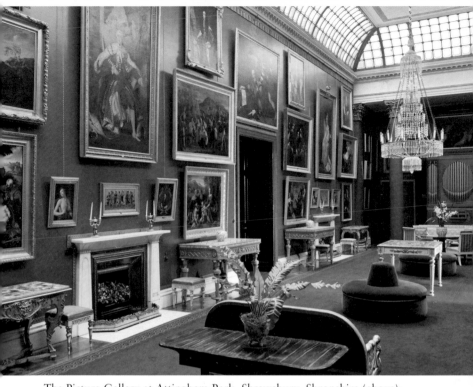

The Picture Gallery at Attingham Park, Shrewsbury, Shropshire (above);
Cobham Hall, Cobham, Kent (below)

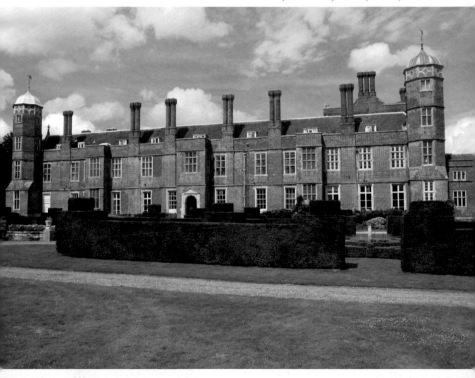

Art historian Bernard Berenson at his home outside Florence, *Villa I Tatti*, 1903

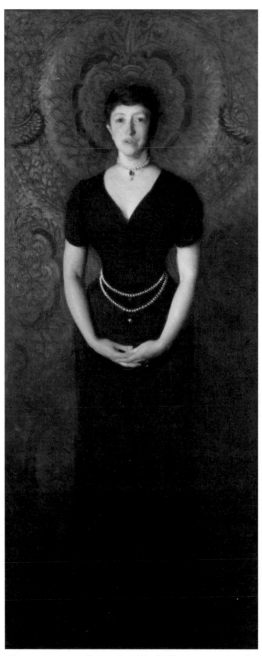

John Singer Sargent, 'Portrait of Isabella Stewart Gardner', (1888),
Isabella Stewart Gardner Museum, Boston

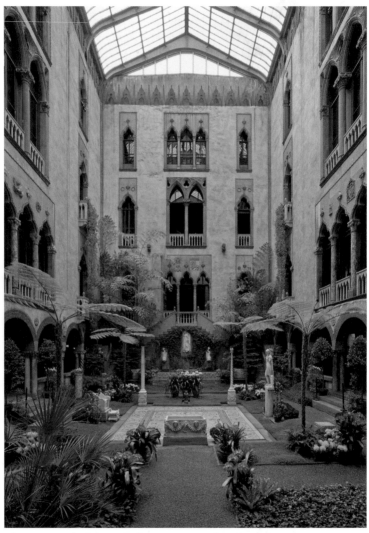

The courtyard of the Isabella Stewart Gardner Museum, Boston, Massachusetts

valuable cargo. Within a few days they were on view in the Old Academy Rooms in Pall Mall.

Slade cashed in on the Dutch and Flemish paintings but it was a banker from Brussels, Edouard Walckiers, who scooped the pool by acquiring the Italian and French pictures from the collection in 1792 for 750,000 livres, more than double what Slade had paid for the Dutch and Flemish paintings. He immediately sold them on for a handsome profit to his cousin François Louis Jean-Joseph de Laborde-Mereville, who acquired them, with the help of a mortgage from the banker Jeremiah Harman, for 900,000 livres (£40,000). The paintings were briefly exhibited at Laborde-Mereville's house in the Rue d'Artois but, in an increasingly dangerous political situation, the aristocratic banker fled from Paris to England in the spring of 1793, bringing the paintings with him (his father, a former minister in Louis XVI's government, was to be executed in Paris in the Reign of Terror the following year).

There was surprisingly little comment in Paris on the dispersal of one of the finest art collections in Europe. This was due to the worsening political situation. On 10 July 1792, the National Convention voted for the abolition of the French monarchy. On the same day 600 Swiss Guards were massacred at the Tuileries Palace (Orléans's former protégé Jerome Pétion, as Mayor of Paris, was instrumental in allowing the mob to ransack the palace and insult the royal family). The population of Paris waited fearfully for news of the invading Austrian army advancing on the capital, accompanied by numerous émigrés intent on extracting revenge. This climate of fear led to the decision to slaughter 1,400 defenceless royalist prisoners in September.

The destruction of the *Ancien Régime* included a transformation of the arts. The leading revolutionaries wanted to get rid of images of the hated royalty and aristocracy, and encouraged the destruction of the royal tombs in the Abbey of Saint-Denis. There was no place for the Palais-Royal, dismissed by the painter-turned-politician Gabriel Bouqier for its 'luxurious apartments of satraps and the great, the voluptuous boudoirs of courtesans, the cabinets

of self-styled amateurs'. But the revolutionaries also wanted the
Louvre Museum to be a show-case for Paris as a worldwide
capital of the arts. Parisians turned out in their thousands to
witness an extraordinary Festival of Unity on 10 August 1793,
organized by the painter David, which demonstrated the themes
of national unity and the regeneration of the people. The French
Revolutionaries were ruthless in pursuit of their idea that art
represented the new order, and throughout the 1790s looted
the finest works from the countries they conquered. They were
brought to the Louvre, which now housed the most magnificent
collection of art France had ever seen, and the Orléans Collection,
representative of the *Ancien Régime*, was quietly forgotten.

The Duke of Orléans, despite his left-wing credentials, had
no place in these events. During 1792 he continued to sit
among the Jacobin faction in the National Convention, but this
only attracted derisive comments about why a Bourbon prince
was sitting 'among the sans-culottes'. Marat, a former close
supporter, was even more scathing, denouncing Orléans as 'an
unworthy favourite of fortune, without virtue, soul or guts,
whose only merit was the gibberish of debauch'. When not at
the Convention, Philippe was to be found sitting disconsolately
in the Palais-Royal. In September 1792 he was informed that
his family name was now to be Egalité and the gardens of the
Palais-Royal were to be known henceforth as the Garden of the
Revolution. *Citoyen* Philippe Egalité, as he was now known,
had been one of the most powerful and richest men in France
but had contrived to lose both his political power and his vast
fortune.

Now he was to lose his reputation. On 11 December, Louis
XVI was brought to trial before the National Convention.
Among those sitting in judgement was his cousin Philippe. On
16 January 1793, he voted the king guilty. Although his family
and his household urged the duke not to attend the following
evening when the Convention was to take the crucial vote
on whether the king was to be sentenced to imprisonment or
death, he felt it was his duty. When his name was called, he
descended to the bar of the court in utter silence and proceeded

to proclaim: 'Motivated solely by my duty, and convinced that those who threatened or will threaten the sovereignty of the people deserve the ultimate punishment, I vote for death.' Even his former supporters were stunned that the First Prince of the Blood, first cousin of the defendant, could have voted in this way, and he returned to his seat amid a cacophony of catcalls, insults and boos.

That evening his son the Duke of Montpensier found him, sitting at his desk in the Palais-Royal with his head in hands, weeping, some indication of the depth of the shame he felt in betraying his cousin. His former mistress, the Scottish courtesan Grace Dalrymple Elliot (she numbered George, the Prince of Wales among her many lovers), later recorded her reaction on hearing the news: 'I never felt such horror for anybody in my life as I did at that moment at the Duke's conduct.' The behaviour of the Prince of Wales, a close friend and fellow libertine, was typical of many who felt that this was the ultimate betrayal. Leaping up from his chair in Carlton House, he tore down the portrait of the duke that he had commissioned from Sir Joshua Reynolds.

Philippe's action did little to regain his position among the Jacobins. He fell under suspicion when his eldest son the Duke of Chartres, serving in the French army under General Dumouriez, followed his commander in changing sides and joining the Austrian army. On 9 April 1793 officials from the Committee of Public Safety, dominated by the fanatical Robespierre, known as the Sea-Green Incorruptible, arrived at the Palais-Royal with warrants for the arrest of Philippe and his younger sons the Dukes of Montpensier and Beaujolais. They were sent to a prison in Marseilles. After six months' captivity, Orléans was brought back to Paris and finally committed to trial on 6 November. Although he mounted a spirited defence, the verdict of guilty was inevitable. Returning to his cell, where he consumed a final dinner of oysters and lamb cutlets, washed down by a bottle of Bordeaux, Philippe Egalité, having powdered his hair and put on a green frockcoat, in the style of the *Ancien Régime* he had so affected to despise, was led to the guillotine.

It is still difficult to make an assessment of Philippe without the benefit of hindsight, in particular his role in the death of Louis XVI. He possessed many admirable traits in his character: he was a cultivated, liberal reformer, a devoted and enlightened father, and genuinely concerned for the welfare of his fellow Parisians, who reciprocated by showing a real devotion to the House of Orléans. And the leading radicals who supported his cause, making the Palais-Royal a key place in the early stages of the French Revolution, were some of the most talented men in France, though they often acted purely to further their own political agenda.

Certainly Philippe must have been aware of, even if he did not originate, the numerous plots and intrigues based on the Palais-Royal, but his vacillation verged on cowardice as he appeared, on several occasions, to lose his nerve just as he was about to seize power. Ultimately, it is difficult to feel much sympathy for someone blessed with unbelievable privilege, the richest man in France and a royal prince, who managed to lose his fortune and to earn the opprobrium of supporters and opponents alike by the time of his death. Thomas Carlyle, writing his famous *The French Revolution: a History* in 1837, summed up the ambivalence of Orléans's career: 'For he was a Jacobin Prince of the Blood: consider what a combination.' Despite his efforts to prove himself a man of the people, Philippe, Duke of Orléans, was part of the *Ancien Régime* and his demise was symptomatic of the passing of the old order in France as much as the execution of the king. The sale of his art collection in England, however, can be seen in a wider context.

Although the duke was a committed anglophile, France and Britain had been on opposing sides in every major conflict throughout the eighteenth century and the victories of Robert Clive at the battle of Plassey in 1757 and James Wolfe's capture of Quebec two years later during the Seven Years' War (1756–63), resulting in the loss of India and Canada, had destroyed French dreams of a worldwide empire. The wealth the British gained, particularly from their Indian possessions, the way that country used its maritime power to promote trade within the empire, together with the many inventions that vastly increased its

ability to manufacture goods, gave Britain enormous prosperity. France's effort to extract revenge by supporting the American colonials in the American War of Independence (1775–83), though it played a crucial role in the colonials' success, virtually bankrupted the state.

Louis XVI's finance ministers struggled to introduce much-needed financial reforms and to increase the crown's revenues in order to reduce the enormous government debt. Earlier efforts under Louis XV to levy the tax on revenue known as the *vingtième* had been only partially successful owing to the refusal of the nobility and the clergy to contribute. This intransigence continued into the following reign, with a succession of finance ministers attempting, with limited success, to increase taxes which invariably fell on the poorer sections of the population, thus provoking bitter resentment.

This failure to reform the system contrasted with the success of the British economy in the late eighteenth century, caused by a combination of financial reform, overseas trade and the development of a series of manufacturing techniques that were to transform British society. The *Rape of Europa* was brought across the Channel just as Britain was becoming the most prosperous nation in Europe. Her new-found economic strength was, however, to be tested to the limit by a resurgent France and the most brilliant figure to emerge from the French Revolution: Napoleon Bonaparte.

6

The Taste for Titian in Nineteenth-Century Britain

From 1793 to 1815 Britain was almost constantly at war with France, a country with almost three times the population and far superior military resources. The fact that she survived this unprecedented period of warfare and emerged victorious over a nation led by the greatest general of the age and one of the most brilliant men in European history, demonstrates the tenacity of the British and the country's underlying economic strength. The fleets of Nelson and later the armies of Wellington played a crucial role, but what is equally impressive is the way that Britain had the financial resources to cope with the expense of a war lasting almost without interruption for over 20 years. It was this capacity for survival and the role that the country played as paymaster to France's many continental enemies that ensured Napoleon's ultimate defeat.

Unlike the French government, whose inability to reform the nation's finances had been a major cause in the downfall of the *Ancien Régime*, in Britain William Pitt the Younger, the most able prime minister of the century (1783–1801 and 1804–6), introduced far-sighted financial reforms. His most important success was to increase the collection of much-needed revenue. Pitt had three methods of doing this: by increasing taxation, notably through the introduction of Income Tax in

1798; by reducing import duties, which led to the decrease in smuggling; and by cutting government spending by the abolition of numerous profitable sinecures.

These financial reforms, together with Britain's maritime supremacy, which enabled trade to be maintained throughout the British Empire during the Napoleonic Wars, greatly strengthened the economy. At the same time a series of inventions in generating new manufacturing processes was transforming industrial production. It came to be called the Industrial Revolution and was to make Britain the richest nation on earth. England possessed plentiful, natural resources, with rich coal and iron ore deposits and swiftly flowing rivers. A series of new spinning and weaving machines, using these natural resources, initially powered by water and later by steam (James Watt invented a highly efficient steam engine), meant that the dramatic increase in the production of textiles gave Britain a significant advantage over her economic rivals.

The Agricultural Revolution in the early eighteenth century, improving crop production, had resulted in an increase in population, and a gradual migration from the countryside into urban centres. The construction of canals, improved roads and railways (George Stephenson built the first railway line to use steam locomotives), enabled manufactured goods to be moved to the cities where there was a ready market. Many of the increased population lived in the new industrial cities in the north of England, where they worked in mills mass-producing textiles which were distributed, using the new forms of transport, both at home and abroad. For most of the nineteenth century it was be British industry, British ships, British capital and British financial institutions that dominated world trade. It was not until the end of the century that other nations, in particular Germany and the United States, which had also, belatedly, enjoyed their own Industrial Revolutions, began to catch up and then overtake Britain's economic output.

It is fascinating to look at the link between industry and art during the heyday of Britain's economic supremacy. Magnates such as Coke of Norfolk, a great patron of the arts, had

pioneering new agricultural methods, but the profits he made from increased agricultural output bore no comparison with those generated by the Industrial Revolution. The grandee who benefited most was Francis Egerton, Third Duke of Bridgewater. Following an Act of Parliament the duke had commissioned the construction of the Bridgewater Canal in 1759 to transport coal from his mines at Worsley to Manchester. He followed this by commissioning a second canal in 1762 from Liverpool to Manchester, thus beginning what was to be known as Canal Mania. Barges on canals could transport goods more effectively than packhorses or horses and carts on badly-maintained roads (Thomas Telford, 'the Colossus of Roads', was to revolutionize road-building in the early nineteenth century). The Bridgewater Canal cost a staggering £168,000, almost four times the £43,000 the consortium led by Bridgewater paid for the Orléans paintings over 30 years later, but Bridgewater was far-sighted enough to take the risk. From the moment the canal opened, the price of coal in Manchester halved, and the duke was soon earning himself a fortune, reputedly as much as £80,000 a year, and became the richest nobleman in England.

Bridgewater was not known for his interest in art but he sensed a wonderful business opportunity in the sale of the Orléans Collection. The Dutch and Flemish paintings purchased by Thomas Moore Slade had soon found ready buyers. The Italian and French paintings, on the other hand, remained for several years in the hands of Laborde-Mereville, who had brought them over to England, while various attempts were made by leading collectors to buy them. King George III, who had observed that 'all his noblemen were now picture dealers', was himself interested and tried to purchase 150 paintings for the nation with the help of his prime minister, William Pitt, and the President of the Royal Academy, the American painter Benjamin West. In the event, it was the art dealer Michael Bryan who acquired them in 1798 for £43,500 on behalf of a syndicate composed of three leading noblemen: the Duke of Bridgewater, the principal investor, his nephew and heir Earl Gower (later Second Marquess of Stafford and First Duke of Sutherland), who knew the Orléans

Collection from his time as ambassador in Paris in 1790–2, and
Gower's brother-in-law the Fifth Earl of Carlisle.

Under Bryan's guidance, the sales made by the syndicate
were spectacularly successful. Having purchased the whole
collection, the paintings were then valued independently which
almost doubled their value to £72,000. Bridgewater, Gower
and Carlisle retained 94 pictures for themselves and disposed of
the rest. Bridgewater's eclectic taste echoed that of the Duke of
Orléans who had formed the original collection, and included
two *Madonnas* by Raphael, the two paintings of *Diana* from
Titian's *poesie*, as well as Poussin's *Seven Sacraments*. Gower
and Carlisle had more classical taste and preferred the works
of Annibale Carracci, the chief seventeenth-century Bolognese
painter working in the style of Raphael.

Regardless of the duke's motives, which were regarded merely
as a matter of commercial speculation, in the opinion of a
writer on the *Notice Historique* in Paris, this was a wonderful
opportunity for British art collectors. The Italian paintings that
the Bridgewater Syndicate purchased were of better quality
than anything seen in England for many years. Grand Tourists,
on the whole, had had few opportunities to buy major Italian
Old Masters and had tended to purchase works by contem-
porary painters instead: views of Venice and Rome by Canaletto
and Giovanni Paolo Panini, and portraits by Pompeo Batoni.
Now Bridgewater and his fellow aristocrats were being offered
examples by the greatest masters of the Renaissance and the
Baroque.

Of the remaining Orléans paintings, 135 were sold immedi-
ately, and a further 66 at auction, for a total of 41,000 guineas.
They were exhibited in Bryan's Galleries in Pall Mall and the
Lyceum in the Strand from December 1798 to July 1799, with
the public being charged 2s. 6d for admittance, compared with
the normal 1s. Public exhibitions had been held in London since
1760, notably at the Royal Academy, but few people attended,
and still fewer had access to the major collections in grand
country houses, so the public had very little knowledge of great
Old Master paintings.

The exhibition created a sensation. The essayist and critic William Hazlitt, already an admirer of Titian, was quite overcome by the Orléans Collection, in particular the group of works by the Venetian master, and wrote in the London magazine: 'I was staggered when I saw the works there collected and looked at them with wondering and longing eyes. A mist passed away from my sight: the scales fell off ... We had heard the names of Titian, Raphael, Guido, Domenichino, the Carracci – but to see them face to face, to be in the same room with their deathless productions, was like breaking some mighty spell – was almost an effect of necromancy.' Mary Berry, who had formed a circle including the leading literary figures of the day (similar to that of Félicité de Genlis in the Palais-Royal), put it more succinctly: this was 'by far the finest, indeed the only real display of the excellency of Italian school of painting that I ever remember in this country'. The prices these paintings fetched demonstrate this enthusiasm. Raphael's *Holy Family*, known as *La Belle Vierge*, went to the Duke of Bridgewater for 3,000 guineas, while Annibale Carracci's *Lamentation over the Dead Christ* fetched an astonishing 4,000 guineas.

The sale was not, however, universally successful. On entering the Lyceum, the viewer was confronted on the right-hand wall by the *Raising of Lazarus* by Sebastiano del Piombo, a Venetian contemporary of Titian, flanked by Titian's *Diana and Actaeon* and *Diana and Callisto*, with the *Rape of Europa* and *Perseus and Andromeda* as companion pieces. The Sebastiano was immediately purchased by John Julius Angerstein for £3,500 on 26 December, the opening day of the exhibition (Angerstein was to be one of the founders of the National Gallery and the Sebastiano is listed as no. 1 in the inventory), and the Duke of Bridgewater kept the two Diana paintings at the asking price of 2,500 guineas each, but neither the *Rape of Europa* nor *Perseus and Andromeda* attracted a bidder.

There were a number of reasons for this. Britain had been at war with Revolutionary France since 1793, but this does not seem to have been a major factor, particularly after Nelson's recent, decisive victory at Aboukir Bay, at the mouth of the

Nile, at the beginning of August 1798, destroying the French navy and leaving the French army stranded in Egypt (its ruthless commander Napoleon sailed home to France shortly afterwards, leaving his soldiers to their fate). A more prosaic reason for the lack of bidders was the distance of the Lyceum from the clubs and fashionable shops of the West End (the organizers eventually halved the entry price to encourage buyers). Amabel Lucas, who had admired Titian's *poesie* in Paris, complained that their 'colouring [which] looked so fine at the Palais Royal, did not appear so beautiful here'. Contemporary artists were worried that the amount of Old Masters would affect prices for their own work. The Irish painter James Barry was to be seen lingering at the Lyceum, loudly criticizing the works on view while privately writing to the prestigious Dilettanti Society recommending that it should purchase Titian's *Diana and Actaeon*.

The most likely reason, however, was simply that there was a glut of top quality art on the market and consequently buyers were spoilt for choice. There were 27 works by Titian in the Orléans Collection (modern expertise has downgraded these to 11), including the *Rape of Europa* and three other of Titian's *poesie*, plus the *Death of Actaeon* which relates closely to the series. There were also other important collections coming on to the market. The impact of the French Revolution had led to the dispersal of art collections, both within France itself and in the countries that the French armies had conquered. In Italy Napoleon's defeat of the Austrians in Northern Italy in 1796 was followed by the overthrow of the Venetian Republic, and the subjugation of the Papal States.

At the Treaty of Tolentino in 1797 between France and the Papacy, the French took many of the finest paintings and sculpture from the Vatican back to France, where they were installed in the Louvre Museum. They formed part of one of the most extraordinary collections of art ever seen, organized by the dynamic director of the Louvre, Dominique Vivant Denon, who displayed works taken from countries the French had conquered in Europe and beyond, notably Egypt. However, when Napoleon was finally defeated in 1815, the most important paintings and

sculpture were returned to their countries of origin. It was now the British collectors which were to be the envy of European connoisseurs, and they were to prove the main beneficiaries from the sale of the Orléans Collection.

The noble families of Italy, who had watched these developments with horror, and had been reduced to near penury by the French invasion, were compelled to sell the priceless masterpieces they still owned to raise money. In Britain unscrupulous dealers such as William Buchanan, William Young Ottley, Alexander Day and Andrew Wilson were only too happy to take advantage of this opportunity to buy, and were soon busy organizing the export of paintings from Italy. As Anna Jameson, a pioneer female art historian of the Italian Renaissance, wrote in her *Companion to the Most Celebrated Private Galleries of Art*: 'Carraccis, Claudes, Poussins, arrived by ship-loads. One stands amazed at the number of pictures introduced by the enterprise of private dealers into England between 1795 and 1815, during the hottest time of the war.'

For the wealthy connoisseur it was a marvellous time to collect paintings, with some truly superb examples appearing on the market. To give an example, the treasures on offer at Alexander Day's exhibition in 1800 included two Titians and a Gaspard Poussin from the Colonna Gallery, sold jointly for 6,000 guineas, a Leonardo da Vinci and an Annibale Carracci from the Aldobrandini Cabinet valued at 3,000 and 2,000 guineas respectively, another Carracci from Genoa valued at 2,500 guineas, and a Raphael from the Borghese Gallery, also valued at 2,500 guineas.

In the case of major artists like Titian, however, there were simply too many works attributed to the master. The Orléans paintings had an established provenance but the attribution of other paintings was much less certain. Anna Jameson was very scathing, commenting:

We must take it for granted, that in many cases, a Titian, a Paul Veronese, etc. means simply a Venetian picture, of the style and time of Titian or Veronese. I firmly believe, for instance, that half the pictures which bear Titian's name, were

painted by Bonifazio [Veronese], or Girolamo de Tiziano, or Paris Bordone, or some other of the *Capi* of the Venetian school, which produced such a swarm of painters in the sixteenth century.

In addition, the prevailing neo-classical taste preferred works by the leading classical artists, strongly influenced by the art of antiquity. There was nothing available by Michelangelo, who had painted almost exclusively in fresco, i.e. directly on to the wall, so it was Raphael who was the most sought after artist (his *Sistine Madonna* was reputed to have been bought by the King of Saxony in 1754 for £8,500, by far the highest price paid for any work of art at that date). Coincidentally, in November 1798, a number of important works by Raphael, which had been brought back by the French from Italy, were unveiled at the Salon in Paris. These works, including his late masterpiece the *Transfiguration*, cemented Raphael's reputation as the supreme master. The catalogue of the exhibition waxed lyrical over 'the immortal Raphael' and 'the perfection we see in the Transfiguration'.

Unless a collector was as rich as William Beckford, whose family had made a fortune from sugar plantations in Jamaica, or the Duke of Bridgewater, it was extremely unlikely that he would be able to acquire a genuine Raphael. Most collectors had to content themselves with works by seventeenth-century Bolognese masters such as Annibale Carracci, Guido Reni and Domenichino, all strongly influenced by the master. Alternatively, paintings by the two leading French artists of the classical school, Nicholas Poussin and Claude Lorraine, both working in Rome in the seventeenth century, were much sought after. Poussin's austere compositions were deeply influenced by the art of antiquity while Claude's Arcadian landscapes were filled with classical ruins. Two Claudes from the Altieri Collection caused a sensation when they were brought back to England by Admiral Nelson, and were purchased by William Beckford for the staggering price of £6,825 in 1799. He was to resell them less than a decade later for 10,000 guineas (they now hang in Anglesey Abbey).

These classical artists were highly regarded by Sir Joshua Reynolds, first President of the Royal Academy, and his championship of the art of Michelangelo, Raphael and Carracci, chief representatives of what he regarded as the 'three great schools of the world [the Roman, Florentine and Bolognese]', formed the central thesis of his influential *Discourses on Art*, delivered in the 1770s. In his own painting, however, Reynolds strove to emulate Titian's technique; his portraits were strongly influenced by Van Dyck, who took so many of his ideas from Titian, and he owned 29 works attributed to the Venetian artist, including a copy of the *Rape of Europa*, now in the Wallace Collection.

Reynolds, like other late eighteenth-century British artists, had copied a number of works by Titian when visiting Italy on the Grand Tour (his works in the Spanish royal collection were virtually unknown). It is interesting to note those contemporary British artists' view of Titian. Many of them made copies of his work, choosing those that dated from the middle stages of the painter's career, particularly the 1530s and 1540s, when his style was most receptive to the Roman and Florentine idea of *disegno*, as championed by Reynolds (and indeed Vasari back in the sixteenth century) rather than the much freer, late style characteristic of the *Rape of Europa*. The words these artists most commonly used to describe these works by Titian were balance and harmony.

The Irish painter James Barry dismissed Titian's late *St Sebastian* in the Palazzo Barbarigo in Venice: 'to me [it] appears nothing more than a most disorderly mass of colours, jumbled together by the jumbling and slobbering of a pencil'. For William Hazlitt, however, it was precisely this subtle use of colour that gave these late works their unique quality, which he characterized as *gusto* (the Italian for taste). The colours in the Bridgewater *poesie* were:

> dazzling with their force but blended, softened, woven together into a woof ... and then a third object, a piece of drapery, an uplifted arm, a bow and arrows, a straggling weed, is introduced

to make an intermediate tone, or carry the harmony. Every colour is melted, impasted into every other.

With so much disagreement, it is not surprising that it was not until several years after its arrival in England that the *Rape of Europa* finally found a buyer. The Fifth Earl of Carlisle, a major stake-holder in the Bridgewater consortium, and a notable collector in his own right on the Grand Tour, expressed an interest in acquiring the painting, but withdrew from the sale, and it was not until 1804 that it was acquired for 700 guineas by the Second Baron Berwick, a fraction of the valuation of £5,250 for *Diana and Actaeon* and *Diana and Callisto* paid by the Duke of Bridgewater. Berwick's interest may have been stimulated by reports brought back by tourists who had flocked to Paris following the Treaty of Amiens in 1802–3 between Britain and France. Visitors were astonished by the quality of works on display in the Louvre Museum, created by its director Vincent Denon as a temple to the arts, and featuring a number of Titians looted by the victorious French from Italy.

Berwick had inherited a fortune from his father, who was ennobled by Prime Minister William Pitt the Younger for his help in restructuring the immensely profitable East India Company, a source of seemingly limitless wealth in the fast-expanding British Empire. The baron proceeded to employ the architect George Steuart to remodel Attingham Park in 1782 in the neo-classical style. Steuart produced a formal design for the house with two sets of apartments for Berwick and his wife, an idea often used for royal palaces, where the king and the queen would live separately. At Attingham the two apartments were united in an Entrance Hall with a top-lit staircase, providing a grand effect.

Berwick died in 1789 and the baronetcy and his estate were inherited by his 18-year-old son Thomas Noel Hill, who had just gone up to Jesus College, Cambridge. Three years later, on leaving university, the Second Baron Berwick pursued his artistic studies by going on the Grand Tour to Germany, Switzerland and Italy, taking as his travelling companion the knowledgeable

Edward Daniel Clarke, later to become a brilliant scientist, professor of mineralogy at Cambridge and one of the founding members of the Cambridge Philosophical Society. As soon as the two men reached Rome in November 1792, Berwick began to commission works of art, relying on his friend for advice. He 'is employing Angelica Kauffmann [a popular female artist later to work extensively in England] in painting,' wrote Clarke, 'and I am now selecting passages from the poets for her to paint for his house at Attingham, he has left me to follow my own taste in painting and sculpture.'

Clarke made Berwick aware of the perils of the art market, drawing his friend's attention to the unscrupulous dealers and salesmen who profited from the naivety of rich English Grand Tourists: 'The greatest of these Romans carry cheating to such a degree of ingenuity that it becomes a science; but in baking legs, arms, and noses, they really surpass belief.'

Clarke took full credit for the purchases Berwick made, commenting: 'I have ordered for him two superb copies of the *Venus de Medicis* and the *Belvedere Apollo* [famous Roman statues in the Uffizi Gallery and the Vatican], as large as the originals; they will cost near £1,000.' Berwick and Clarke continued their Grand Tour to Naples where they were to spend over a year. Grand Tourists often used their time abroad, far from parental discipline, to sow their wild oats, and the baron combined his efforts to buy works of art, acquiring a set of fine views by Jacob Philipp Hackert, with an attempt to seduce Lady Plymouth. The success of his Grand Tour led Berwick to revisit Italy in 1797, where he purchased 'some very fine statues' in Rome. In recognition of his knowledge of the arts, Berwick was made a Fellow of the Society of Antiquaries in 1801.

Many of Berwick's early purchases had been works of sculpture, but his acquisition of the *Rape of Europa* showed his intention to make a serious collection of Old Master paintings. The subject was a serious one, taken from Ovid's *Metamorphoses*, but the voluptuous princess lying astride the bull must also have appealed to the racier side of his lordship's character. Berwick was soon to become infatuated with the

17-year-old Sophia Dubouchet, one of four sisters, all of whom were courtesans. At first Sophia showed little interest in his advances, describing Berwick as a 'very nasty, poking, old, dry man'. But this did not prevent her from following the baron to Brighton in 1811, rendered fashionable by the Prince Regent, where she was described as parading 'the remains of her rather shaky virtue'. On returning to London shortly afterwards she was soon comfortably installed by Berwick in a house in Montague Square and, within a year, had become his wife.

Swiftly adapting to her new, respectable lifestyle, Sophia retired to Attingham Park, Berwick's splendid house in Shropshire, where she followed her husband's instructions and refused to see her sisters. Her behaviour may account for the unflattering account of the Berwicks by Sophia's sister Harriete, who was to become the leading courtesan of the Regency period, practising her trade under the name Harriete Wilson and numbering among her clients the Prince of Wales, the Lord Chancellor and four future prime ministers. Harriete described Berwick in her *Memoirs* as 'a nervous, selfish, odd man, and afraid to drive his own horses'. But she saved up her real venom for Sophia, who had set her sights at a cobbler at the tender age of 13, before throwing 'herself into the arms of the most disgusting profligate in England aged fourteen, with her eyes open, knowing what he was; then offers herself for sale at a price to Colonel Berkeley, and when his terms were refused with scorn and contempt, she throws herself into the arms of age and ugliness [Lord Berwick] for a yearly stipend, and at length, by good luck, without one atom of virtue, becomes a wife.'

Harriete used the same racy style in her *Memoirs* to describe her famous clients, or 'protectors' as she preferred to call them. She determined to publish her *Memoirs* despite efforts by one of her more notable clients to prevent this. Arthur Wellesley, Duke of Wellington, victor of Waterloo and the most famous soldier in Europe, was used to giving orders. When Harriete refused his request, the Iron Duke is said to have uttered his famous comment: 'Publish, and be damned.' Harriete duly went ahead, ignoring the duke's objections, and her *Memoirs*

appeared in a broadsheet in 1825. Each week crowds would gather outside her publisher John Stockdale's shop, which had become a salon for the political classes (Stockdale's was frequented by Tories, while Whigs preferred Debrett's). Londoners would pretend to express their strong disapproval while on tenterhooks to find out the graphically described sexual peccadilloes of the rich and the famous in the current issue. The enduring popularity of the *Memoirs* has ensured that they remain in print to this day.

Since going on the Grand Tour Lord Berwick had determined to make his country seat one of the most splendid in England, a worthy place to house his magnificent collection of works of art. As well as the *Rape of Europa* (referred to as *Jupiter and Europa* in Bryan's sale catalogue), he acquired other masterpieces from the Orléans Sale: *St John in the Wilderness* and the *Vision of Ezekiel* by Raphael, purchased for 1,500 and 800 guineas respectively, and Annibale Carracci's *Toilet of Venus* and Rubens' *Continence of Scipio* for 800 guineas each. Berwick's taste was eclectic, and his purchases included Van Dyck's *Balbi Children* (National Gallery) and works by Poussin, Claude, Cuyp and other masters of the Dutch School. The most expensive of these, showing the growing interest in the Spanish School, was Murillo's *Virgin and Child*, was bought for £2,500, more even than Raphael's *St John* at 1,500 guineas, and over three times the price paid for the *Rape of Europa*.

To house his collection, Berwick employed John Nash, the most fashionable architect of the day, to remodel Attingham. Berwick had already employed Humphrey Repton, the leading landscape gardener, on his park, to provide a worthy setting for the house, and it seems probable that Repton, who was in partnership with Nash, introduced patron and architect. Although Nash described himself as a 'thick, squat, dwarf figure, with a round head, snub nose and little eyes', he had great charm. In the words of Repton: 'He had the power to fascinate, beyond any man in England.' Like Berwick, he aspired to a place in the elite of Regency society, working for the Prince Regent at Brighton Pavilion and Buckingham

Palace. In 1805 Berwick gave Nash the commission to build a grander staircase off the Entrance Hall. The most original feature was a top-lit Picture Gallery to display Berwick's collection of Old Master paintings. The architect was not afraid to use new technology, and the roof of the Gallery had curved cast iron ribs supporting continuous glazing, a highly original feature.

Nash's use of cast iron demonstrates the willingness of architects and their aristocratic patrons to make use of new technology. The cast iron came from nearby Ironbridge Gorge, one of the key pioneering points of the Industrial Revolution. This was where the iron-founder Abraham Darby had successfully set up a coke-fired blast furnace in the village of Coalbrookdale in the early 1700s, using coal from the mines in the sides of the valley. The iron ore that Darby produced by a process of smelting was of very high quality and was used to produce cast iron cooking pots, kettles and domestic articles. By the late eighteenth century, the technology was considerably more sophisticated and Coalbrookdale was producing structural ironwork. Following Abraham Darby III's construction of Iron Bridge, the first cast iron bridge in the world, in 1780, the Scottish civil engineer Thomas Telford, soon to become the greatest engineer and road-builder of the day, began the Longdon aqueduct, which carried the Shrewsbury Canal over the River Tern on cast-iron columns.

However, despite Nash's originality in the use of cast iron, the material was very expensive, costing Berwick £13,000. In addition, Nash tended to be slap-dash in his architectural projects and his workmanship was often shoddy. The small panes of glass in the roof were soon leaking and Berwick found himself paying for their repair and to the scagliola (imitation stone) columns which had been damaged by the water. This rather ruined the magnificent effect of the interior, with its walls in the Chinese style, porphyry scagliola columns and marbleized door-cases, and a white marble fireplace in the Egyptian style. Lady Berwick, now happily ensconced at Attingham, was keen that her quarters should be designed in the latest style. In 1812

her husband commissioned the fashionable firm of Gillows of Lancashire to fit out a suite of rooms on the first floor.

Keeping Berwick and his wife in the lifestyle to which they were accustomed came at a hefty price. As early as 1810 the baron wrote to his brother William Hill, later Third Lord Berwick and himself a passionate collector, lamenting: 'I can not afford to retain a seat [country house] in Salop ... blame me for not living more prudently, and not having the resolution to abstain from Building and Picture buying'. There is a certain irony in this letter, as William was also deeply in debt due to all the works of art he had been purchasing. A year later Richard Williams, a rich lawyer based in London's Lincoln's Inn, was offering Berwick £1,000 for his Rubens, or £3,000 for the Rubens and his Raphael. The majority of Berwick's collection was sold in the 1820s but it appears that the *Rape of Europa* was sold before 1816, when J. Watton's *A Stranger in Shrewsbury* gave a very complete account of Attingham, but omitted any mention of Titian. Having described the position of the house, and the 'lofty and spacious hall', the author continued with a detailed description of the paintings in the Picture Gallery:

> The picture gallery is a spacious room 78 feet and 6 inches long, by 25 feet 6 inches wide, and 24 feet high. It contains many chef d'oeuvres of the old masters, particularly some valuable ones by Raffaello – Parmigianino – Paolo Veronese – Annibale Carracci – Rubens – Vandyck – Poussin – Kuyp – the Ostade's – Murillo – Salvator Rosa – Berchem. The walls of this elegant room are of a deep lake colour; the ceiling supported by porphyry columns of the Corinthian order, the capitals and bases of which are beautifully gilded. Underneath the cornice of this extensive room is a gold fringe of great depth. The floor is inlaid with rich Mosaic work, and the grand staircase is finished in a corresponding style of magnificence.

Watton continues with a detailed description of the rest of the interior, showing why Berwick's costly passion for collecting and

his determination to decorate Attingham in the best possible taste led him into acute financial trouble:

> The suite of drawing rooms is superbly furnished with immense plate glasses and burnished gold furniture, and the ceilings are richly gilt. The boudoir is a beautiful small circular room, the panels of which are decorated by the pencil of one of our first artists. The library is in the west wing, and is a very extensive and lofty room, the cornice is supported by rich Corinthian pilasters; and besides a very valuable collection of books, it contains several rare specimens of art from the antique. Among those most worthy of notice will be found a font from Hadrian's Villa; on the basso relievo on its exterior the story of Narcissus is beautifully told. A rich candelabra from the antique, of exquisite workmanship, near ten feet high – a fine colossal statue of Apollo Belvedere [a notable purchase on Berwick's Grand Tour] – a beautiful small Esculapius – with a splendid collection of Etruscan vases from Herculaneum, busts, chimeras, & c. The rooms on the first floor correspond in the grandeur and magnificence of their furniture with those on the ground floor.

By this date it appears that John Bligh, Fifth Earl of Darnley, was already the owner of the *Rape of Europa*, for which he paid considerably less than Berwick had paid for it just a few years earlier, when it was exhibited at the British Institution (most of the main beneficiaries of the Orléans Sale were directors of the Institution). The Institution had been set up in 1805 with the aim of encouraging native talent, with the idea that it should show both living artists and great works from the past, with the latter, it was hoped, providing inspiration for the former. The idea proved a great success and artists flocked to display their paintings. Some contemporary artists felt that too many works by 'Dead Artists' were hung in the exhibitions, and this may account for the ironic comment made about the *Rape of Europa* by one critic: 'When a lady is permitted to exhibit herself in this pickle, it would be indecent to insist on her putting on clean linen.'

The British Institution was a private society but its success was instrumental in the founding of the National Gallery in 1824. One of the initial subscribers had been the Russian émigré, banker and collector John Julius Angerstein (most of the money he spent on his art collection was made from his slave estates in Grenada), and it was the acquisition of his 38 paintings for £57,000 that formed the core of the National Gallery. Angerstein believed that early sixteenth-century Italian painting marked the apogee of taste, and his collection included three works by Titian: the *Concert*, *Venus and Adonis* and the *Rape of Ganymede*. His paintings were installed at his London house at 100 Pall Mall, where they were hung frame to frame, from floor to ceiling. Two years later the gallery managed to buy Titian's *Bacchus and Ariadne*, the finest of his early mythological works painted for the Duke of Ferrara. The paintings continued to be exhibited at these premises until the new building in Trafalgar Square was opened to the public in 1838. In the following year the new gallery attracted 768,244 visitors.

Darnley's important collection of paintings was housed in his country house at Cobham Hall in Kent and contained a number of works by Titian. As well as his *Rape of Europa*, Darnley owned Titian's *Portrait of Ariosto* (National Gallery, where it is called *Portrait of a Man with a Blue Sleeve*, possibly a self-portrait), and two further works from the Orléans Collection: *Venus admiring herself* and a version of *Venus and Adonis*. They hung alongside Rubens' *Continence of Scipio* and Annibale Carracci's *Toilet of Venus*, which Darnley had acquired from Lord Berwick for 800 guineas each. Other major works were Annibale Carracci's *Martyrdom of St Stephen*, Rubens' *Thomiris*, Giorgione's *Milon*, Pordenone's *Hercules* and Ribera's *Democritus*.

The Bligh family originated in Ireland where they had extensive land holdings. They came to prominence in the eighteenth century when John Bligh was awarded the earldom of Darnley in 1725 and acquired large estates in Kent, based around his seat of Cobham Hall. The house had a distinguished history, playing host to a series of royal visitors including Elizabeth I in 1559 and Charles I and his new bride Henrietta Maria in 1625 (whom he had married instead of the Spanish Infanta – see Chapter 4). Later in the seventeeth

century the Duke of Richmond lived here with his beautiful wife Frances Stuart, a great favourite of Charles II and the model for Britannia when the image was chosen to adorn British coins.

In the late eighteenth and early nineteenth centuries the fourth earl carried out extensive additions and alterations to the existing Elizabethan house, which had been remodelled in the seventeenth century. Like Berwick at Attingham, he chose a fashionable architect, James Wyatt, who designed a Picture Gallery in 1806–9 to replace the Tudor Long Gallery. It consisted of two vestibules with a connecting gallery. The windows in the vestibules and those in the north side of the gallery were blocked out by screen walls to provide wall space for the display of Darnley's collection of paintings.

An early nineteenth century guidebook to Kent gives a detailed description of 'this ancient baronial mansion taken from a late publication'. Surprisingly, the *Rape of Europa* does not appear to have hung in the picture gallery. The author praised the sculpture in the vestibule and music-room, which he described in some detail, before continuing:

Thence you proceed to the picture-gallery, 134 feet long, lined with paintings by the first masters. The four chimney-pieces, in common with all the rest in the old parts of the house, are beautifully wrought in white and black marble, bearing the Cobham arms, and date 1587. In an adjoining chamber Queen Elizabeth was lodged, during her visit to William, Lord Cobham, in the first year of her reign, and her arms are still on the ceiling ... In the apartments of the south wing are many fine pictures, by Titian, Sir Joshua Reynolds, Salvator Rosa, &c. and a particularly fine and valuable one by Rubens, representing the death of Cyrus.

There is a tantalizing dearth of accounts of the *Rape of Europa* by visitors to Cobham Hall in the nineteenth century. One distinguished visitor was the Duchess of Kent in May 1819. Lord Darnley (the fourth earl) described her stay in a letter to his second son who was up at Oxford: 'Our Royal Visitors [the

Duchess of Kent and her doctor] have just set off in a continual pour of rain in the phaeton, after having eaten and drunk and slept well ... and with every prospect that HRH will speedily produce a healthy heir to the throne.' A week later the nation was celebrating the birth of Princess Victoria. She was to become queen aged just 18 in 1837.

In the 1820s Prince von Pückler-Muskau was a regular visitor, and gave a comprehensive account of his visits to Cobham Hall, but was more interested in the way Humphrey Repton had landscaped the park noting that 'nothing can exceed the incomparable skill with which the walls of wood within the park are planted in masterly imitation of nature'. Doubtless used to a more formal way of life in his native Germany, the prince was surprised by the manner of eating, the guests appearing for breakfast in 'neglige'. He was even allowed into his hostess' boudoir on departure: 'I took leave of Lady D[arnley] in her own room; a little sanctuary furnished with delightful disorder and profusion:– the walls full of "consoles", surmounted with mirrors and crowded with choice curiosities: and the floor covered with splendid camellias, in baskets, looking as if they grew there.'

Even more tantalizing is the house's association with Charles Dickens. The writer spent a lot of time in the vicinity, staying at the *Leathern Bottle* in the village, and Cobham features in a number of his works, particularly the immensely popular *Pickwick Papers*, published in 1836–7, where Pickwick, Winkle and Snodgrass liked to walk in the neighbourhood. Lord Darnley gave Dickens keys to the gates to the park, and the two men obviously got on well. To quote Percy Fitzgerald, in his *Memories of Charles Dickens*: 'We then walked over to Cobham, when he [Dickens] told me a good deal about Lord Darnley, whom he said he liked, and showed me the chain drawn across the avenue never removed except for a funeral.' Dickens made numerous references in his letters to the beauty of the trees in the park, with deer grazing beneath them, and described the house as 'displaying the quaint and picturesque architecture of Elizabeth's time', showing his appreciation of one

of the best examples of Elizabethan architecture in the country, with additions made in the seventeenth century by John Webb to designs by Inigo Jones.

However, sadly, Dickens left no description of the interior of the house. The writer was surprisingly knowledgeable about painting. He had been to Italy and written up an account of all he had seen, particularly in Rome, and one can only suppose that he was never invited in by Lord Darnley or he would almost certainly have left some description of the beautiful paintings in the interior. The only direct reference he made to the interior is in a ghost story related by the character of Mary Weller in *Pickwick Papers*.

One of the few visitors to Cobham to comment on the collection of paintings was the German art historian Dr Gustav Waagen, Director of the Royal Picture Gallery (later the Kaiser Friedrich Museum) in Berlin. The doctor had already published a series of clear, concise and highly informative catalogues of the Berlin collection, the first major picture gallery where the paintings were hung systematically according to their individual schools. To increase his knowledge, he made frequent study tours abroad which he recorded in meticulous notes, letters, diaries, official reports and sketches. Waagen ranged far afield, visiting the main art centres in Europe: Italy, France, England, the Netherlands, Spain and even Russia, as well as his native Germany.

The small, bespectacled doctor visited England for the first time in May 1835. Already a noted connoisseur, with an acute visual memory, Waagen availed himself of a mass of contacts with the owners of the great collections throughout the country. He had, with typical Germanic thoroughness, drawn up a list of the most notable art collectors in England, ranking them in order, starting with the three main beneficiaries of the Orléans Sale: the Duke of Bridgewater, the Marquis of Stafford and the Earl of Carlisle, with the Earl of Darnley, owner of the *Rape of Europa*, in fifth place.

On a peregrination lasting six months the doctor discovered that the English were using their great wealth, gained from their possessions overseas and their participation in the Agricultural

and Industrial Revolutions, to form unrivalled collections of art, exceeding anything on the continent. As he commented: 'Scarcely was a country overrun by the French when Englishmen skilled in the art were at hand with their guineas.' The description of Waagen's journey was published in three volumes by John Murray in *Works of Art and Artists in England* in 1838. He noted how the British were unique in their desire to live among their possessions, unlike other countries, where art was more usually confined to special cabinets and galleries.

In eighteenth-century France, nobles such as the Dukes of Orléans, although they owned châteaux all over the country, chose to live entirely in Paris and Versailles, the centre of power which was based on the king. It was therefore natural that the Orléans Collection should have been housed in the family's main Parisian residence. In Britain, in contrast, the aristocracy divided their time between their town and country houses. Political power was centred on Parliament, rather than the royal court, and since Parliament sat for less than half the year, this allowed nobles considerable time on their country estates. These land holdings were also a source of much of their wealth, and so they preferred to hang many of their finest works of art in their country houses.

Waagen needed endless perseverance in his attempts to visit these houses, overcoming the problems of absentee landlords, grudging housekeepers reluctant to admit a foreigner into their domain, and poor viewing conditions. This was a perennial handicap for curious sightseers, especially if they were foreign. Even as distinguished a visitor as the exiled Comte d'Artois, the future Louis XVIII (as the younger brother of Louis XVI he had prudently fled to England during the French Revolution), was treated with scant civility. W. T. Whitley recorded the count's visit to Blenheim Palace:

> The Cicerone performing this delicate task was the ordinary showman dressed out in the tawdry livery of his office; flippantly sporting his 'Mounsheers', his 'Lewis's' and other John Bullisms, and vaunting about the thousands of Mounsheers who were killed, taken prisoners, etc, in every

battle. In vain did I take him aside and appraise him that the decencies of hospitality and the quality and intelligence of the visitors rendered fewer explanations necessary. 'I likes it', he said, 'I likes to tell him the truth', winking his eye at the same instant and smiling excessively.

Problems such as dealing with obnoxious servants were not enough to put off an indefatigable sightseer like Waagen in his quest to discover the masterpieces hidden in country houses. He returned to England throughout the 1850s, and the summary of his painstaking research, entitled *Treasures of Art in Great Britain*, was published in 1854 (a supplementary volume was entitled *Galleries and Cabinets of Art*). Waagen was highly regarded in England and was appointed a juror for the Great Exhibition in 1851, partly at the instigation of Prince Albert, who fully appreciated the good doctor's devotion to hard work and his high-minded principles.

It was on his tour that year that Waagen visited Cobham Hall in the company of Charles Eastlake, soon to be Director of the National Gallery, who shared the doctor's scientific approach to art history. They were probably the two greatest connoisseurs in Europe, both perceptive and immensely scholarly, while Eastlake, in addition, was also a distinguished painter in his own right. Waagen described the *Rape of Europa* as 'unquestionably the pearl' of the Darnley collection, although 'the great warmth and power of the colouring is somewhat lost in the present neglected state of the picture'. At the end of his tour the earl presented him with a copy of *A Day's Excursion to Cobham*, a guidebook written by Felix Summerly, the *nom-de-plume* of Sir Henry Cole, Director of the fledgling South Kensington Museum (funded with the proceeds of the Great Exhibition and soon to become the Victoria and Albert Museum). Waagen was less than appreciative of this gift, commenting loftily that it 'was the more acceptable to me in that I find the writer agreeing in most of my conclusions'.

Waagen had a high opinion of his own talents, but he was not always right. In view of his complimentary description of the *Rape*

of Europa it is fascinating to record his impression of *Perseus and Andromeda,* the pendant to *Europa,* which he saw in Hertford House, the home of Sir Richard Wallace (now the Wallace Collection), illegitimate son of the Fourth Marquess of Hertford. The painting was stored in a crate and, when it was produced for the great man's approval, he pronounced it to be the work of Veronese. Having been downgraded by the great connoisseur, it subsequently languished for years above a bath in Wallace's dressing room. The Third Marquess of Hertford had acquired the painting in 1815, and it seems probable that the Fourth Marquess, whose extensive collection today forms the basis of the Wallace Collection, bought a reduced copy of the *Rape of Europa* in 1857 to hang alongside *Perseus and Andromeda* (the two *poesie* by Titian had been paired together during the time of Philip II).

The marquess's copy of the *Rape of Europa* had been owned by the neo-classical painter Gavin Hamilton, and by the notable collector William Young Ottley, and was generally considered to be a sketch for the *Europa* in Darnley's collection. Hertford's agent Samuel Mawson described it as 'much finer than the finished picture' when it appeared for sale in 1857, and Hertford concurred, writing that 'the Titian is only a study but I dare say very desirable.' The marquess, like Philip II before him, seems to have much enjoyed the subjects chosen by Titian, with their highly charged erotic content, since he also bought a late eighteenth-century copy of *Danae with Cupid* (another of the *poesie*) in 1856.

Waagen selected Darnley's *Rape of Europa* for the Manchester Art Treasures Exhibition of 1857, in which he played a key role. The city was an ideal choice, representing the new-found wealth that had transformed Britain. A century earlier the Duke of Bridgewater's canal had begun the process by dramatically lowering the price of coal transported from Worsley into the city. But the true wealth of Manchester relied on the manufacture of cotton, which was mass produced in the city's water-powered cotton mills. Entrepreneurs such as Richard Arkwright, who owned the first of these mills, made fortunes on the proceeds. The cotton was then taken by railway to Liverpool from where it was distributed in British ships all over the world.

By the 1850s Manchester was one of the most prosperous cities in Europe. Visitors to the exhibition had the chance to see a magnificent display of art in a setting that summed up the extraordinary success of Victorian Britain, though they had little idea of the poverty and squalid lifestyle of many of the workers whose hard labour had created this urban metropolis. One of those who noticed this exploitation of the working classes was Friedrich Engels, but it was for aesthetic pleasure, rather than the plight of the proletariat, that he urged his friend Karl Marx to visit Manchester: 'Everyone up here is an art lover just now and the talk is all of the pictures at the exhibition ... Among the finest is a magnificent portrait of Ariosto by Titian [belonging to Lord Darnley] ... you and your wife ought to come up this summer and see the thing.'

The exhibition proved to be one of the most extraordinary gatherings of art ever recorded in England, with over 16,000 works of art on display, including 1,173 Old Master paintings and 689 works by contemporary artists, a unique chance for the public to see what collectors had been buying over the previous 50 years. The Prince Consort, in his high-minded way, hoped that the public's response to seeing these great works of art would both be educational and help to raise the standard of design in manufacture (Manchester being at the heart of the Industrial Revolution).

Buyers at the Orléans Sale were predominantly a small circle of aristocratic collectors, whose preference of Renaissance and Baroque Old Masters broadly echoed that of Philippe, Duke of Orléans, who had formed the collection. At Manchester, traditional Old Masters were still much in evidence, with 27 paintings by Titian including the *Rape of Europa*, and numerous works of the Eclectic School, as the great Bolognese artists of the seventeenth century were known, but there was an increasing number of viewers prepared to admire other schools of art.

The exhibition featured a number of Italian Primitives, many of them lent by Prince Albert, who had proved an enthusiastic collector of early Florentine painting. Popular and influential books such as John Murray's *Handbook for Travellers in North*

Italy, Lord Lindsay's *Sketches of the History of Christian Art* and Anna Jameson's *Sacred and Legendary Art* had persuaded their readers of the merits of Giotto, Fra Angelico and Botticelli, stressing the religious feeling imbuing their works. Now they were able to see the works in the flesh.

Botticelli, in particular, had been virtually ignored in the early nineteenth century, but now, following the lead given by Eastlake at the National Gallery, he was about to become the most sought after of all Florentine artists of the *Quattrocento*. One of the most perceptive scholars to view the exhibition was the American Charles Eliot Norton, who was particularly taken with paintings by the Italian Primitives, which related to his life-long love of Dante. Norton was to exert a profound influence on the artistic and literary taste of Isabella Stewart Gardner, who was to purchase the *Rape of Europa* from Lord Darnley some 40 years later.

Other schools were also well represented, showing the diverse interests of the leading collectors. French paintings by Watteau and his followers appealed to the Third and Fourth Marquesses of Hertford, the tenth Duke of Hamilton (the dispersal of his collection at the Hamilton Palace Sale was to be greatest sale of the 1880s), and the Rothschilds, who lived in great splendour at Mentmore Towers and Waddesdon Manor (the latter a neo-French Renaissance chateau). Following the Duke of Wellington's lead (a grateful Spanish government gave him magnificent Spanish paintings for his part in defeating the French in the Peninsular War of 1808–12), a number of collectors had acquired works by Velázquez, Murillo and Goya. Sir Robert Peel, prime minister (1834–5 and 1841–6) and one of the founders of the National Gallery, had formed perhaps the finest collection of Dutch and Flemish paintings in England, which was to be purchased en bloc by the Gallery in 1871.

But perhaps the most interesting aspect of the exhibition was the prominence given to contemporary British art. Turner and Constable had earned a European reputation for the brilliance of their landscape painting, and there were 100 works by Turner on view. In Britain, Victorian genre painting was all the rage and

works such as *Life at the Seaside, Ramsgate Sands* by William
Powell Frith had been bought by Queen Victoria (his *Derby Day*,
painted immediately after the exhibition, was so popular that a
rail had to be installed at the Royal Academy to hold back the
crowds that flocked to admire it). Apart from a few exceptions,
however, such as the Third Earl of Egremont, a great patron of
Turner, most of the aristocracy tended to ignore native talent.
The most original school of painting was the Pre-Raphaelite
Brotherhood, formed in 1848, whose members, as their name
indicated, were looking for a new, purer form of art inspired by
preceding those works of the High Renaissance and the Baroque
that represented the prevailing taste.

It was leading Victorian industrialists from the Midlands
and Northern England who broke new ground. Their wealth
encouraged them to purchase works by contemporary British
artists. Figures such as the textile manufacturer Thomas Coglan
Horsfall from Manchester, Andrew Kurtz, a Liverpool industri-
alist, James Gillot, a manufacturer of steel pens in Birmingham,
and James Leathart, a lead manufacturer from Newcastle, were
all very active collectors. The politician Sir Thomas Fairbairn,
had played a key role in fixing the exhibition. He had commis-
sioned Holman Hunt's *Awakening Conscience*, a moral fable
where a fallen woman suddenly sees the light, which was promi-
nently displayed in Manchester. Owing to their support, there
was a growing movement to create a national collection of British
art, and wealthy collectors such as Robert Vernon, a former
horse dealer, the sculptor Sir Francis Chantrey and the clothing
manufacturer John Sheepshanks left their collections to the South
Kensington Museum with this intention (they were to join the
sugar magnate Sir Henry Tate's legacy when the Tate Gallery was
opened in 1897).

The most persuasive advocate of contemporary British art
was the art critic, social thinker and philanthropist John Ruskin,
whose *Modern Painters*, published in five volumes between 1843
and 1860, argued that contemporary British artists were superior
to the Old Masters, particularly in their accurate documentation
of nature. Ruskin was a great champion of Turner, but also of the

Pre-Raphaelites, despite the fact that John Everett Millais, one of the founders of the Brotherhood, eloped with his wife Effie.

Ruskin's other great passion was Venice, and he published his magisterial three-volume *Stones of Venice* in 1851–3. Although he professed to prefer Tintoretto to Titian, like so many others Ruskin found the beauty of Titian's paintings irresistible, and his memorable evocation of the *Serenissima* attracted thousands of his fellow countrymen to go to see the Titians in the painter's native city (few travellers went to see the much superior collection of works by the artist in Madrid and the Escorial).

In the introduction to his work, Ruskin drew his readers' attention to the parallel between Venice and Britain, two of the greatest maritime empires in history: 'Since the first dominion of men was asserted over the ocean, three thrones, of mark beyond all others, have been set upon its sands: the thrones of Tyre, Venice and England.'

After describing Tyre, Ruskin launched into one of his most famous passages, a magical description of the fragile, evanescent beauty of Venice:

> Her [Tyre's] successor, like her in perfection of beauty, though less in endurance of dominion, is still left for our beholding in the final period of her decline: a ghost upon the sands of the sea, so weak – so quiet, – so bereft of all but her loveliness, that we might well doubt, as we watched her faint reflection in the mirage of the lagoon, which was the City, and which the Shadow.
>
> I would endeavour to trace the lines of this image before it be for ever lost, and to record, as far as I may, the warning which seems to me to be uttered by every one of the fast-gaining waves, that beat, like passing bells against the STONES OF VENICE.

Many British tourists were inspired by Ruskin's words to visit Venice, and returned home determined to build houses for themselves in the Venetian style. Although not all the buildings they erected were always successful, and these pastiches of Venetian Gothic were dubbed by critics as 'streaky bacon',

there was a growing interest in Venetian art. People wanted to learn more about the major artists. At Manchester, Waagen had provided a description of the *Rape of Europa* in his *A Walk through the Art-Treasures Exhibition*: 'The action of Europa is very animated, the landscape very poetical, the colouring very warm and clear; the treatment, equally broad and spirited, indicates the later period of the master.'

But this was not enough for the reviewer of the exhibition in the Athenaeum magazine, looking for something more perceptive, who objected to Waagen's verbiage, as he put it, 'his use of phrases such as "graceful motives", "juicy colour", "silvery tone", "warm and clear in the chiaroscuro", "full body", "juicy in golden tones" abound. This is the true dead language of the old time of the Georges, and which still abounds in Germany. These phrases save all thinking and apply to anything.' George Scharf, the Art Secretary to the exhibition, in contrast, provided a more detailed technical analysis of Titian's use of glazes in his *Handbook*, comparing his coat of transparent colour to the opaque paint used by an artist such as Frans Hals.

Scharf's analysis was indicative of a growing interest in art history. There was widespread dismay among collectors at the large numbers of school pictures (paintings by artists working within the circle of a major master) masquerading as works by important artists, and this led to much confusion (not least over the price for these works). This was soon to change with the publication of a number of scholarly works by art historians, carefully discriminating between works by major masters and the far greater output of their followers.

In the case of Titian, James Northcote, a pupil of Sir Joshua Reynolds, produced a *Life of Titian* in 1828, which recorded a series of anecdotes of the painter's life. A much more interesting monograph appeared a year later, written by the MP Sir Abraham Hume. Hume's family had made a fortune in the East India Company, and the baronet had purchased Titian's *Death of Actaeon* at the Orléans Sale, a painting he described as 'unfinished but very beautiful'. He therefore had an intimate knowledge of the artist's work. In his monograph he provided a

topographical catalogue of Titian's major works, some of which he had seen (the works in British collections and those he saw in the Musée Napoleon in Paris in 1802), an essay on Titian's use of colour, a list of his pupils and a catalogue of engravings after the master.

Since Hume's monograph, little had appeared in print on Titian in English, but this was to change with the advent of two leading art historians: the English consular official Sir Joseph Archer Crowe and the Italian writer and art critic Giovanni Battista Cavalcaselle. The two men became lifelong friends on a visit to Italy in 1846–7. They collaborated on two major works: *Early Flemish Painters* and *the History of Painting in Italy* before publishing *Titian: His Life and Times* in 1877. Crowe and Cavalcaselle were strongly influenced by Cavalcaselle's fellow Italian Giovanni Morelli, who had created a new form of connoisseurship by making a careful comparison between individual paintings of a particular Old Master in order to ascertain their authenticity. This approach was to be of major importance in transforming the study of Old Master painting, and in the prices that discriminating collectors were willing to pay for paintings which had been authenticated by this process. Both Morelli and Cavalcaselle advised Eastlake on the purchase of Italian paintings for the National Gallery, with outstanding success.

Crowe and Cavalcaselle's entry on the *Rape of Europa* shows their scholarship and sensitivity to the painting. The two art historians began with a very full description of *Europa*, comparing 'the silvery light and deep brown shadows of the Europa' with Veronese:

> but the scene is depicted with much more elevation than Paolo [Veronese] was capable of feeling, and composed with much more thought than he usually bestowed on pictorial labours. Nothing betrays the aged character of Titian more than the inevitable looseness of drawing and the coarse delineation of realistic extremities, to which we must fain plead guilty in his name. But these defects are compensated by startling force of

modelling and impaste, by lively effect of movement apparent in every part, by magic play of light and shade and colour, and a genial depth of atmosphere.

There follows a description of the 'imposing and triumphant' bull, with Europa 'on the back of the beast whose seat she dare not leave, holding on with her left to one of his horns, parted from his white side by an orange cloth, of which a fold is waved by her outstretched right arm. As her face is thrown back it catches a shadow from her arm, and her glance may reach to the shores far away where her companions have been left ... Eros clinging with expanded wings to a dolphin, and sporting along in the course of the bull, is a lovely fragment of Titianesque painting, representing, as finely as the two Cupids with their bows and arrows in the air, the idea of rapid going, already suggested by the swimming fishes and the surge of the bull's breast.'

For Crowe and Cavalcaselle, 'nothing can be more vigorous or brilliant than the touch which has all the breadth of that in the "Jupiter and Antiope" or the "Calisto," without the abruptness of Paolo Veronese, the broader expanses of tinting being broken effectually with sparkling red or grey or black, toned off at last by glazing and calculated smirch to a splendid harmony.'

Almost as important as this detailed and poetic description of the Titian is the authors' dismissal of various versions of *Europa*. In a footnote the authors make detailed reference to the painting owned by Sir Richard Wallace, which the owner regarded as a genuine sketch by Titian: 'This copy is no doubt that which belonged to Dawson Turner, Esq, of Yarmouth (Waagen, Treasures, iii, 18), and has been characterised by some critics as a genuine sketch by Titian. It is, however, but a copy, and probably by Del Mazo [a follower of Velázquez]. A poor copy of the Cobham Hall *Europa* is in the Dulwich Gallery.'

Crowe and Cavalcaselle may have been united in their praise for the *Rape of Europa* but its owner, Lord Darnley, was not to enjoy his painting for much longer. Darnley, like so many English aristocrats, had suffered acutely from the effects of the agricultural depression of the 1870s, and was considering

selling the painting. Badly in need of funds, the earl's holdings in Ireland had been affected by successive Land Acts which enabled tenants to buy their land from the owner. Darnley had also spotted the opportunities offered by the Settled Land Act of 1882, which permitted the break-up of entailed estates, allowing art and land to be turned into cash provided that the proceeds were held on trust for the heirs of the estates. The Act led to a series of major sales in the 1880s, beginning with the extensive 17-day Hamilton Palace Sale in 1882, and continuing with the great Old Master sale at Blenheim Palace in 1884–5. The pressure on owners to sell was increased by the introduction of death duties in 1894.

The trustees of the National Gallery were determined to try to buy the best paintings appearing on the art market. In 1884 they scored a major coup in raising £70,000 to purchase Raphael's *Ansidei Madonna*, showing that, in monetary terms, he continued to be the artist against whom all others were measured. Six years later they bought a number of Venetian paintings belonging to Lord Darnley: the *Origin of the Milky Way* by Tintoretto for £1,310.10s, and the four *Allegories of Love* by Veronese for £5,000. All of these paintings had been exhibited in Manchester in 1857. In 1904 the National Gallery was once again successful in acquiring Titian's superb *Portrait of a Man with a Quilted Sleeve*, thought to be a portrait of Ariosto, for the much greater sum of £30,000.

But, between those two dates, the trustees turned down the chance to buy the most important painting in Darnley's collection: the *Rape of Europa*. In 1894 the owner's uncle, the eminent art historian Lionel Cust, wrote to Lord Carlisle (whose ancestor had turned down the chance to buy the painting some 90 years earlier), a trustee of the National Gallery, informing him in confidence that Lord Darnley was prepared to offer the Gallery the painting for £15,000 to be paid in three instalments of £5,000 each. Carlisle passed on this information to the other trustees but, at a meeting held on 1 May, they decided that they were unable to pursue this offer, presumably judging the price to be too high.

This may seem surprising, considering the popularity of Titian in England. However, the gallery already possessed a good collection of works by the artist, including the *Tribute Money*, *Noli me Tangere* and *Bacchus and Ariadne*, the latter belonging to his first *poesie* series. In addition it appears that by the time the *Rape of Europa* appeared on the market the director and trustees favoured the artist's earlier style, and showed little appreciation of what the former director, Dr Nicholas Penny, Director of the National Gallery (2008–15) has described as Titian's 'interest in rough and smudgy handling and deliberately blurred form'.

Darnley therefore determined to offer the painting elsewhere. The most likely candidate was Dr Wilhelm Bode, the extremely knowledgeable and acquisitive Director of the Kaiser Friedrich Museum in Berlin (a post that had been held by Waagen until 1868). Bode had begun working for the picture department of the museum in 1872 and his abilities were soon spotted by the director, Julius Meyer, who authorized him to search out suitable paintings to add to the museum's collection. In this he was outstandingly successful. Bode had joined the museum just one year after Berlin had become an imperial capital, following the defeat of France and the creation of the German Empire, dominated by Prussia. This triumph, aided by high indemnities which the French were forced to pay, resulted in an unprecedented economic boom.

The self-assured Bode was determined to take advantage of this and make the collection of the Kaiser Friedrich Museum the greatest in Europe. Coolly calculating and single-minded in his pursuit of great Old Masters, the doctor soon made a number of major acquisitions, at first concentrating on Italian Renaissance paintings (later on he was to form an extraordinary collection of works by Rembrandt, Durer and the Early Flemish Primitives), including Titian's *Portrait of the Daughter of Roberto Strozzi*. Bode's professional advice was much sought after by collectors throughout Europe, which he was willing to give, providing that these collectors were willing to donate paintings to the museum.

It was Bode to whom William McKay, senior partner of Colnaghi's, an old, established firm of art dealers in London,

turned when he heard that the *Rape of Europa* was coming on to the market. He wrote to the director on 1 June 1895: 'Dear Dr Bode. I think I ought to let you know that Lord Darnley has approached me through a relation with a view to sell the famous picture of Europa by Titian. I understand that you have had the picture under consideration for some time.' McKay was keen to offer Bode the painting, but was anxious that he should have a cut in any deal Bode was likely to make, adding: 'I can certainly assist you greatly ... I have no doubt I could buy it much cheaper than you'.

Later that month Dr Bode visited Cobham Hall with McKays' junior partner Otto Gutekunst who had learned his trade dealing in art in Paris before joining Colnaghi's in 1894. He was to play a major role in transforming the firm into a leading picture dealer in Old Masters. A restless opportunist and not one to waste any time, Gutekunst wrote the following day to thank the earl and, at the end of the letter, requesting an interview at Darnley's earliest convenience. His next letter was designed to pave the way for the opening of negotiations but this was unsuccessful, probably because Bode, who was very careful in his use of his museum's funds, like the National Gallery, baulked at the price.

Despite the fact that Darnley and other owners felt compelled to sell due to financial constraints, the mood in Britain in the 1890s was generally upbeat. London remained a great imperial capital, and the industrial cities in the Midlands and the north of England continued to benefit from the enormous wealth accrued during the Industrial Revolution. Queen Victoria's Diamond Jubilee in 1897 was a chance for the nation to celebrate its success over the 60 years since the queen had ascended the throne, reigning over an empire that extended to every corner of the globe and included Canada, most of the islands in the Caribbean, great swathes of Africa, Hong Kong, Australia, New Zealand and India, where Victoria had been proclaimed empress in 1877. These far-flung territories were protected by the Royal Navy which had had undisputed control of the seas since Nelson's victory at Trafalgar in 1805.

Nevertheless, other nations were catching up. In the late nineteenth century, as economic growth slowed in Britain, with arable farming, textiles, iron and steel, engineering, and consumer goods all facing difficulties, other nations, now enjoying increased economic production, were keen to compete. Germany and the United States enjoyed more abundant and cheaper supplies of energy and raw materials, and had erected tariff barriers to protect their trading interests, unlike Britain, which was still a believer in free trade.

Germany had enjoyed its own Industrial Revolution and had overtaken Britain by the end of the century in economic production. The country had also become the dominant military power in Europe, led by Kaiser Wilhelm II (1888–1918) and his domineering Chancellor Otto von Bismarck, the architect of German Unification in 1870 and the driving force in promoting the German economy. Outside Europe, Germany belatedly sought to compete with Britain in acquiring an empire in Africa. More importantly, the Kaiser and Admiral von Tirpitz began to build a navy with the clear intention of challenging the hegemony of the Royal Navy.

The United States provided a less immediate threat to Britain but the sheer size of the country meant that it possessed far greater potential economic strength. In addition to the development of more competitive and advanced manufacturing processes, the building of railways across the continent meant that America began to take full advantage of her vast natural resources. Millions of the poorer working class throughout Europe emigrated to the New World, hoping to make their fortunes; it has been estimated that during the years 1875–1900 the United States doubled in population and trebled in wealth. Fortunes were made and a number of self-made millionaires sought to invest some of their new-found wealth in art.

The movement of the *Rape of Europa* had pursued a historical path, passing from Venice to Spain, on to France, before coming to Britain. In each case its movement had followed the economic and political fortunes of the rising nation. In 1895 Dr Bode, representing a resurgent Germany, had tried and failed to

buy the painting. Now it was to fall to a representative of the new economic super-power across the Atlantic, a woman who had spent many summers living in a palace in Venice and had acquired a passion for Venetian art. She was also busy creating one of the finest collections of Old Master paintings in North America. Her name was Isabella Stewart Gardner.

7

Isabella Stewart Gardner, Bernard Berenson and the Creation of her Museum

Isabella Stewart Gardner was one of a breed of newly-rich American collectors who benefited from the economic boom the United States enjoyed in the late nineteenth century. The population had risen greatly, with mass immigration from Europe, but industrial production had increased still faster. By 1900 the country, which possessed half of the world's resources of iron ore and coal, was producing double the amount of iron and steel manufactured in Britain. Americans, like their counterparts in Britain who had created an Industrial Revolution a century earlier, produced a host of new inventions including Alexander Graham Bell's telephone, Thomas Edison's electric light and phonograph, Elisha Otis' elevator and C. Latham Sholes' typewriter. Even more important was the erection, at first in New York and Chicago, and subsequently all over the continent, of tall buildings, encased within a steel frame, which earned the nickname 'skyscrapers'. This astonishing outpouring of creative energy linked to industrial development is often called the Second Industrial Revolution.

One manifestation of America's new-found economic strength was the appearance of giant corporations, such as U. S. Steel,

General Electric and Standard Oil. The industrialists who ran these companies, men such as the oil magnate John D. Rockerfeller and the financier John Pierpont Morgan, became some of the richest men in the world. Morgan, like many of these industrialists, had begun his career making railways, which had spread across the whole continent following the Civil War, allowing the much more efficient transportation of manufactured goods and agricultural produce. These railroad pioneers were often referred to as 'robber barons' on account of their ruthless pursuit of success. Having made their fortunes, they wanted to invest their wealth in art; many of them proceeded to create museums to house their collections.

J. P. Morgan had set up U. S. Steel in 1901, the first billion-dollar company in the world, buying Carnegie Steel, the creation of Andrew Carnegie and Henry Clay Frick, for $480 million on the way. Morgan a great art collector and the Pierpont Morgan Library in New York (opened to the public in 1924) is his legacy (Morgan also bequeathed over 4,000 works of art to the Metropolitan Museum in New York). Other railroad barons followed suit. The Walters Museum in Baltimore (opened in 1934), the Huntington Art Museum in Los Angeles (opened in 1928), and the delightful Frick Museum in New York (opened in 1935) all house the collections of these 'robber barons'.

Railways were not the only way to amass a fortune. The retailer Benjamin Altman and the sugar magnate Henry Osborne Havemeyer were both major benefactors of the Metropolitan Museum. Havemeyer's lawyer John G. Johnson left his collection of Old Masters to the Philadelphia Museum of Art. The retailer Samuel Kress, the banker and industrialist Andrew Mellon and the wealthy businessman Peter Widener were instrumental in founding the National Gallery in Washington in 1937, to which they bequeathed their collections.

The most spectacular artistic coup was made by Mellon, then Secretary to the Treasury, who made a secret purchase in 1930–1, for $7 million, from the Soviet government of 20 paintings, including Raphael's *Alba Madonna*. This is a classic example of the effect a rich nation can have on the art market. Stalin urgently

needed foreign currency to finance his first Five-Year Plan, an attempt to promote the industrialization of the Soviet Union by the collectivization of agriculture (this policy was to fail spectacularly with the destruction of the *kulaks*, or independent farmers, leading to famine and widespread starvation), so he decided to sell some of the masterpieces from the Hermitage Museum in St Petersburg (then called Leningrad) to the richest buyer, namely the US government.

The ruthlessness these wealthy bankers and industrialists displayed in their pursuit of art was symptomatic of the way that they had made their fortunes. There were, however, other collectors who were less ruthless than these self-made men. Perhaps the most notable was Isabella Stewart Gardner, who was fortunate enough to form the bulk of her collection before the 'Robber Barons' began collecting in earnest. The museum she created opened to the public in 1903, long before those endowed by Morgan, Huntington or Frick.

Isabella was the daughter of David Stewart, a New Yorker who had made a recent fortune in Irish linen and mining investments. Her parents sent her to attend finishing school in Paris in 1856–8, where she met Jack Gardner, who came from one of Boston's grandest and richest families. On returning to New York, the couple began dating and were married in 1860. Morris Carter, first Director of the Isabella Stewart Gardner Museum, recorded that Boston ladies, up to Isabella's death, repeated the apocryphal story that 'Belle Stewart jumped out of a boarding-school window and eloped with Jack Gardner'.

Isabella entered into the intellectual life of Boston and, under the direction of Charles Eliot Norton, professor of the history of art at Harvard University, she developed a love for Dante and began collecting rare books and manuscripts. After the tragic loss of Jackie, her only child, in infancy, Isabella indulged in her passion for travel, making extensive trips with her husband to Europe, the Middle East, India, China and Japan.

A favourite destination was Venice, which the Gardners first visited in 1884, where they were guests of Jack's relation Daniel Curtis at the Palazzo Barbaro, a fifteenth-century Gothic palace

on the Grand Canal which was to serve as the inspiration for the Isabella Stewart Gardner Museum. Under the guidance of Daniel's son Ralph, a talented amateur painter, Isabella embarked on an intense study of Venetian art. She also had the opportunity to meet such luminaries as the writers Robert Browning, John Ruskin and Henry James, and the painters James McNeill Whistler, John Singer Sargent and William Merritt Chase, who were frequent visitors to the palace. The Gardners were very taken with this delectable lifestyle, and were to return regularly to the palace, which they rented for the summer months from the Curtises.

In this delightful setting Jack and Isabella entertained artists, writers and musicians. They commissioned views of Venice by Sargent and the Swedish painter Anders Zorn. Henry James, a frequent visitor, used the palace as the setting for *The Aspern Papers* and *The Wings of the Dove*. Isabella made an equally striking impression on the locals. She would later delight in relating a charming anecdote, as Carter recorded in his biography, of a Venetian girl meeting a friend at a railway station and asking why she was there.

'I'm waiting for the train.'
'Why are you waiting for the train?'
'Because Mrs Jack Gardner of Boston is coming on it, and I want to see her.'
'Why do you want to see her?'
'Because she is so wicked.'
'How wicked is she?'
(with awe) 'More wicked than Cleopatra.'

Returning to Boston must have seemed very tame after the excitements on offer in Venice. Impulsive, witty and reckless, with her almond-shaped eyes, her pale skin and dark hair, Isabella made a pronounced impression, with her provocative dresses designed by Charles Worth and her famous pearls, painted daringly by John Singer Sargent, encircling her waist. Isabella became notorious for her flouting of convention; she

rode around town in an open carriage, accompanied by two lion cubs, and was rumoured to receive guests seated in a mimosa tree in her conservatory.

Her every movement was followed with fascination by the press. In 1875 a reporter summed up her appeal:

> Mrs Jack Gardner is one of the seven wonders of Boston. She is eccentric, and she has the courage of eccentricity. She is the leader where none dare follow. She is 35, plain and wide-mouthed, but she has the handsomest neck, shoulders and arms in all Boston. She imitates nobody; everything she does is novel and original.

Despite her foibles, Isabella was intensely interested in art and had begun collecting in earnest following the death of her father in 1891, leaving her a fortune estimated to be worth between two and three million dollars. She was later to comment: 'I had two fortunes – my own and Mr Gardner's. Mine was for buying pictures, jewels, bric a brac etc. etc. Mr Gardner's was for household expenses.' Initially, Isabella and Jack showed little interest in buying major Old Master paintings, but this all changed at the Thoré Burger sale in Paris in December 1892 when they acquired Vermeer's *Concert*, an exquisite Dutch interior with two girls, one seated at the keyboard, the other singing, with a man seated between them. This little masterpiece, bought for FF. 29,000 (approximately $6,000), was the most tragic loss from the 1990 burglary at the Isabella Stewart Gardner museum.

By this date Isabella had already met Bernard Berenson. Berenson had been born Bernhard Valvrojenski in poverty in Lithuania in 1865, and had been educated by the local rabbi, who had a keen knowledge of literature. Ten years later Bernard (he actually spelt his name Bernhard until the outbreak of the First World War when he changed it to Bernard to show his preference for France over Germany) and his family emigrated to Boston. His father struggled to make a career and became a pedlar, selling his wares from a cart in the villages surrounding Boston. Berenson, however, had set his sights on higher things,

and, through extensive reading and hard work, earned himself a place at Boston University, from where he graduated to Harvard.

Harvard, founded in 1636, was the oldest and most esteemed university in the country. The university had entered a golden age under the presidency of Charles Eliot Norton. Norton had travelled widely in Europe, befriending the historian Thomas Carlyle and the art historian John Ruskin, and returned to America convinced that higher education should be designed to prepare undergraduates for economic and political leadership. Under his guidance the curriculum at Harvard included a wide range of subjects, giving students the best chance to discover their own particular bent in life. Undergraduates flocked to study under this enlightened regime. Businessmen were equally impressed and Harvard became the best-endowed university in America, with enormous sums set aside for research. As professor of the history of art and President of the Dante Society, Norton exerted a strong influence on Isabella Stewart Gardner. Berenson attended his lectures but Norton never seems to have liked him, possibly because the professor preferred the Middle Ages whereas his student was passionate about the Italian Renaissance. Certainly, Harvard undergraduates much enjoyed the story that Norton, on being admitted to heaven, recoiled in horror, exclaiming: 'Oh! Oh! Oh! So Overdone! So garish! So Renaissance!'

Berenson was introduced to Isabella and was highly impressed by this grand Bostonian lady, with her burgeoning collection of paintings, furniture, textiles and stained glass acquired on her extensive travels. Isabella was equally taken with the brilliant young aesthete and helped to pay for his travels to Europe. During his time abroad Berenson acquired his passion for paintings. He met leading scholars of art history on his travels, including Giovanni Battista Cavalcaselle and Giovanni Morelli in Rome, both men leading exponents of a new scientific method of analysing what constituted the characteristics of individual artists' style (see p. 153).

On his return to Boston, Berenson embarked on a dual career as an art historian and dealer. Realizing that he needed to renew his friendship with Isabella if he was to benefit from her

desire to collect Old Master paintings, he sent her a copy of his *Venetian Painters of the Renaissance* when it was published in 1894, a work that established Berenson as the leading authority on Italian Renaissance painting. He enclosed a note with the book stating: 'I venture to recall myself to your memory apropos of a little book on Venetian painters which I have asked my publishers to send to you. Your kindness to me at a critical moment is something I have never forgotten'. Berenson's praise for the Venetian masters, their 'love of objects for their sensuous beauty', and the way that their paintings 'seemed intended not for devotion … nor for admiration … but for enjoyment' was music to the ears of Isabella, who had spent so many summers studying their works in Venice.

The young art historian was to exert a decisive influence on the creation of Isabella's outstanding collection of Old Master paintings. They embarked on a correspondence which continued for many years, Isabella encouraging Berenson in his desire to become an art connoisseur, while BB, as he signed his letters, whetted Isabella's appetite with descriptions of all the great paintings he encountered on his travels. The correspondence is very revealing of the two conflicting strands in Berenson's character: the high-minded aesthete, unsurpassed in his knowledge of Renaissance painting, and the picture dealer, looking to make the maximum profit on any sale. It is clear from Berenson's correspondence that he was playing the role of a canny picture dealer from the moment he began offering his advice.

One of the reasons that Berenson was such a good salesman was his brilliant way with words. He could empathize with Isabella's love for Venice by writing: 'I know no pleasure equal to that I get from pictures, from great Venetian pictures. It is like the pleasure I have when I come across a wonderfully beautiful line or verse, or when I catch a strain of infinitely tender melody.' Isabella was flattered to receive such eloquent letters, and, in December 1895, she made a secret agreement with Berenson whereby he was to be paid five per cent of the purchase price of any painting Isabella bought on his recommendation, with first

refusal on anything he was offered. Isabella entered the contract in good faith, little realizing that Berenson was also receiving a commission from Colnaghi's in London on any sale he made for the firm. One of his first coups had been selling his new client Lord Ashburnham's the *Tragedy of Lucretia* by Botticelli for £3,200 ($16,000), the first major painting by the artist to enter a North American collection.

It was shortly after the sale of the Botticelli that Berenson heard that the *Rape of Europa* might be coming on the market. His informant was Otto Gutekunst of Colnaghi's:

> Lord Darnley's (whose name, by the way must not be mentioned, as he is a very touchy and peculiar man) "Ariosto" is not to be believed. Out of the question! But the Europa is a picture for a great coup. There is *absolutely nothing* against it, except, perhaps, for some scrupulous fool, the subject, which is very discreetly and quietly treated. You will find all about this in Crowe and Cavalcaselle page 317 etc and chiefly 322 and 323. 'Tis one of the finest and most important Titians in existence. Condition is *perfect*, not considering the dark varnish, and the landscape alone is a masterpiece of the 1st order. The price is £18,000 but we ought to get 20,000, if anything at all, and will divide whatever he might in the end be willing to take for cash. It would be jolly if Europa came to America?

This letter, from a master dealer, is an excellent example of the chicanery of the art world. Gutekunst was anxious to assure Berenson that he was offering him the genuine article, and therefore carefully quoted the page reference from Crowe and Cavalcaselle, who had written an important monograph on Titian. Gutekunst also knew that Berenson was no respecter of tradition. He had reduced his list of attributions to Titian in *Venetian Painters* from almost a thousand works to just 133 paintings. He had also launched a devastating attack on the *Exhibition of Venetian Paintings* held recently at the New Gallery in London's Oxford St in February 1895. This had been

in the form of an alternative catalogue, published two days after the opening of the exhibition, and commenced with an attack on the Titians on view: 'Of these,' wrote Berenson,' one only is by the master ... of the thirty-two that remain, a dozen or so have no connection with Titian and are either too remote from our present subject or too poor to require attention.' The rest were dismissed as obvious copies, or by Titian's followers and later imitators.

Gutekunst may have deferred to Berenson's expertise but he showed his skill as an art dealer in dismissing Titian's *Portrait of Ariosto* as 'not to be believed'. This may seem all the more surprising, considering that it was one of Lord Darnley's most treasured possessions and Colnaghi's had attempted to buy the portrait just a year previously (he was soon to sell it to the National Gallery for the colossal sum of £30,000). But Gutekunst reasoned that he was much more likely to achieve a sale of the *Rape of Europa* if it was the only top-quality Titian on the market. And he felt he had his hands full dealing with the 'touchy and peculiar' Lord Darnley.

What Gutekunst had not realized was that Berenson was also playing a double game. He had heard that the Duke of Westminster was intending to sell his *Blue Boy* by Gainsborough, perhaps the most glamorous of all eighteenth-century English portraits. Bernard therefore calculated that he could earn considerably more if he offered the Gainsborough to Isabella, together with a lesser work by Titian, and sold the *Rape of Europa* to another client. His choice was Mrs Warren, a wealthy Boston society hostess and rival of Isabella, who had helped to fund his early travels in Europe, and whose husband was President of the Trustees of the Museum of Fine Arts in Boston.

On 26 April he wrote to Isabella offering her two paintings: Titian's *Portrait of Maria of Austria and her daughter* for £10,000 and the *Blue Boy* for the much greater sum of £35,000 ($150,000). Berenson made his best sales pitch, claiming the painting as Gainsborough's masterpiece, and urging Mrs Gardner 'BE BOLD', and was gratified to find that his client at once cabled back her acceptance. She did, however, question the price,

writing, with a touch of melodramatic humour, that 'although the price is huge, it is possible. *Now*, you see me steeped in debt – perhaps in Crime – as the result!' She then added that it would mean that she would 'have to Starve and go naked for the rest of my life; and probably in a debtor's prison'.

There was a slight hiccup in Berenson's master-plan when Gutekunst struggled to produce an adequate photograph, but eventually he managed to acquire one by late April, writing triumphantly 'and now my friend, three cheers, for I've got the *Europa* photo at last', unaware that Berenson was going to send it to Mrs Warren, not to Mrs Gardner. Fortunately, the late appearance of the photograph saved the day for Berenson. The Duke of Westminster had decided to keep the *Blue Boy* and Berenson realized that his offer of the *Rape of Europa* to Mrs Warren risked alienating his best client. Anxious to make amends, he determined to offer the *Rape of Europa* to Isabella instead. Sitting in the Hotel Hassler in Rome, he composed a long letter to her on 10 May, a masterpiece of the epistolary art. The letter begins with a long preamble, ending with characteristic Berenson flattery: 'and what sincerely I value most, the opportunity of supremely pleasing you.'

The failure to acquire the *Blue Boy* was laid fairly and squarely on the shoulders of the owner: 'What happened was this. The owner of the Blue Boy seems to have wanted to see what serious offer would be made for his picture, and this having been made – £30,000 – he then firmly said that he had not the remotest intention of selling, and that no price could possibly tempt him. There the matter stands. Do forgive my having excited you in vain. Your disappointment can not be greater than mine. The only consolation is that in our life-time the Blue Boy will not leave its present owner, without its going to you, if you continue to want it. Of that much I trust I can assure you [not true, as it was bought by Joseph Duveen in 1921 who promptly sold it to Henry Huntington for £182,200 ($728,800) – 90,000 people queued up to see it in the National Gallery, where it was put briefly on display before its departure for California].'

The central part of Berenson's letter dealt with his near-fatal error in offering the *Rape of Europa* to Mrs Warren. Having

congratulated Isabella on the purchase of Titian's *Portrait of Maria of Austria and her daughter*, he continued in his very best style:

> Now, on bended knee I must make a frightful confession. Just a week ago I thought The Blue Boy so certainly yours that I did something stupid in consequence. 'Tis a tale with a preface, and this you must briefly hear. One of the few great Titians in the world is the Europa – which was painted for Philip II of Spain, and as we know from Titian's own letter to the king, despatched to Madrid in April 1562. Being in every way of the most poetical feeling and of the most gorgeous colouring, that greatest of all the world's amateurs, the unfortunate Charles I of England had it given to him when he was at Madrid negotiating for the hand of Philip the Fourth's sister. It was then packed up to await his departure. But the negotiations came to nothing, and Charles left Madrid precipitately. The picture remained carefully packed – this partly accounts for its marvellous preservation – and finally came in the last century into the Orléans collection. When that was sold some hundred years ago, the Europa fell into the hands of a lord whose name I forget, then into Lord Darnley's, and now it is probably to be bought for the not extraordinary price of £20,000 (twenty thousand pounds). This is my preface. Now listen to my doleful tale. Of all this I became aware just a week ago when I had no doubt I could get you The Blue Boy. I reasoned that you would not likely want to spend £20,000 on top of £38,000. But the Titian Europa is the finest Italian picture ever again to be sold – I hated its going elsewhere than to America, and if possible to Boston. So in my despair I immediately wrote to Mrs S. D. Warren urging her to buy it.

Berenson's intention was to excite Isabella with his description of the Titian, and its wonderful history, hoping that she would then overlook the way that he had deceived her by offering it to her society rival Mrs Warren. His attempt to excuse himself by stating that he had done this because he wanted, above all, for

the painting to come to Boston was less than honest. Berenson continued by denigrating the *Blue Boy* (Isbella was never to buy another major British painting) and included a wonderfully effective piece of flattery, linking her surname with Charles I: 'Now as you can not have The Blue Boy I am dying to have you get the Europa, which in all sincerity, personally I infinitely prefer. It is a far greater picture, great and great tho' The Blue Boy is. No picture in the world has a more resplendent history, and it would be poetic justice that a picture once intended for a Stewart should at last rest in the hands of a Stewart.' This flattery was particularly effective and Isabella was to claim a special relationship with Mary, Queen of Scots and was later to commemorate Charles I's death with a service annually in the chapel of her house.

Berenson now proceeded to dismiss Mrs Warrren's claim on the painting, and ended with the code he liked to employ on offering Isabella a work of art:

Cable, please the one word YEUP=Yes Europa, or NEUP=No Europa, to Fiesole as usual. I am sending a poor photograph which will suffice if you look patiently to give you an idea.

And now, dear Mrs Gardner, I have told you my doleful tale. Forgive me. Get the Europa, and if you decide to get her – by the way she is on canvas, 5ft 10 high, 6ft 8 broad, signed TITIANUS PINXIT – please do not speak of her to any one until she reaches you, so as to spare me with Mrs Warren. Please address Fiesole until June 3.

Very sincerely yours Bernard Berenson

Won over by Berenson's persuasive skills, Isabella agreed to pay him on 15 June. Isabella had been an avid reader of Berenson's *Italian Painters of the Renaissance*, and the volume on the Venetian School had only recently appeared in 1894. Berenson's writing was so eloquent and she, like so many others, had been entranced by his description of the artist's late style:

Titian's real greatness consists in the fact that he was able to produce an impression of greater reality as he was ready

to appreciate the need for a firmer hold on life. In painting, as has been said, a greater effect of reality is chiefly a matter of light and shadow, to be obtained only by considering the canvas as an enclosed space, filled with light and air, through which the objects are seen. There is more than one way of getting this effect, but Titian attains it by the almost total suppression of outlines, by the harmonizing of colours, and by the largeness and vigour of his brushwork.

What makes Berenson so fascinating is that the eloquent and scholarly aesthete, unsurpassed in his ability to write so eloquently about art, was also capable of the most venal skulduggery. With the sale of the *Rape of Europa*, he managed to hoodwink both the readily susceptible Isabella but also the much more wily Otto Gutekunst. Gutekunst had offered Lord Darnley £14,000 for the Titian, and had recommended his colleague to lower the asking price from £20,000 to £18,000. But Berenson held out for the £20,000 without telling Gutekunst, and when he received the full amount from Isabella, send Gutekunst a cheque for £2,000 i.e. 50 per cent of the balance between the £14,000 Darnley received and the £18,000 that the Colnaghi's dealer thought Isabella had paid. This sharp practice enabled him to pocket an extra £2,000 as well as the commission he received from Isabella.

The acquisition of the *Rape of Europa* gave Isabella a focus for her collection, a confirmation of her lifelong passion for Italian paintings. She was to build her house at Fenway Court on the outskirts of Boston in the Venetian style, strongly influenced by the Palazzo Barbaro, with a room specifically dedicated to her prize. Berenson shared his patron's desire to promote their home town of Boston as an artistic and intellectual centre. Though Boston's great days as a political centre were long past, Bostonians still took great pride in the part she had played in the American War of Independence: the Boston Tea Party, and the battles of Lexington and Concord, the first military actions in the Revolutionary War. Her leading citizens included John Adams, second President of the United States.

This was Boston's heritage and now Berenson wanted the city to build on this and become a great art centre like the cities of Renaissance Italy, with Isabella filling the role of her namesake Isabella d'Este, Duchess of Ferrara, patron of Andrea Mantegna, Pietro Perugino, Giovanni Bellini and, most important of all, Leonardo da Vinci. He eulogized:

> If we are to build up on American soil cities like Florence, world-renowned for art and science even more so than commerce, we must breed merchant princes, cultured like Rucellai [Giovanni di Paolo Rucellai, a Florentine banker and one of the greatest patrons of the arts in the Quattrocento] and become deeply imbued with his maxim, that it is pleasanter and more honourable to spend money for wise purposes than to make it.

Isabella had spent her money 'for wise purposes' in buying the *Rape of Europa*. Now she was keen to see her purchase. Berenson sympathized with his patron's impatience, adding: 'Why can't I be with you when the Europa is unpacked?' and describing how honoured he was to help her in creating a museum which 'shall not be the least among the kingdoms of the earth'. He described the painting as 'the finest picture that would ever again be sold', not the first or last time that he would use this phrase.

When the picture still failed to appear, Berenson attempted to distract Isabella by tempting her with other paintings: a Van Dyck portrait, the splendid *Earl of Arundel* by Rubens and a Rembrandt. At the same time he continued to congratulate her on her purchase, writing from North Berwick, on a trip to Scotland, on 2 August: 'What a beauty ... No wonder Rubens went half mad over it. I beseech you look at the dolphin, and at the head of the bull. There is the whole of great painting!' Berenson even had the luck to come across a 'splendid atelier [studio] version' of the *Rape of Europa* at Rokeby in Yorkshire.

The original finally arrived in Boston, sailing from England via New York in the ocean liner *Lucania*, to be greeted ecstatically by its new owner. She cabled Berenson on 26 August: 'She

(Europa) has come! I was just cabling to you to ask what could be the matter, when she arrived safe and sound. She is now in place. I have no words! I feel "all over in one spot," as we say. I am too excited to talk.' Isabella was to acquire many great paintings in the following years, but she was never to show the same level of excitement over a purchase. For the first few months after its arrival in Boston, and despite her interest in other works offered by Berenson, notably a Giorgione and a Velázquez, the proud owner continued to wax lyrical over the Titian, eulogizing how 'every inch of paint in the picture seems full of joy'.

Isabella was much amused by the reaction of staid Bostonians when they visited her house on Beacon Hill, where the painting hung to the left of the fireplace in the living room: 'She has adorers fairly on their knees – men of course'. This reaction was as nothing compared with the owner's, who poured out her feelings to Berenson on 19 September, how she was still breathless about the *Europa*, describing her emotions as 'a two days' orgy. The orgy was drinking myself drunk with *Europa* and then sitting for hours in my Italian garden at Brookline [her country house outside Boston], thinking and dreaming about her'. She continued with a list of the notable aesthetes and collectors who had 'wallowed at her feet', one of whom, Edward William Hooper, a trustee of the Museum of Fine Arts, described Isabella as 'the Boston end of the Arabian nights'. The letter ended: 'Good night. I am very sleepy after my orgy.'

This outpouring of emotion was characteristic of Isabella. Berenson was very pleased that his fellow Bostonians should be so appreciative, and his letter from Ancona on 7 October was couched in a similar indulgent style to Isabella's: 'I rejoice for dear old Boston that it hath people who can appreciate *Europa*, and your own pleasure in her is like a sweet savour to my nostrils.' But he was soon back to business, anxious to appease Isabella's hunger to acquire more masterpieces to hang alongside *Europa*. Pandering to Isabella's passion for the Titian, his letters made frequent references to it in the context of other paintings he hoped to acquire for her.

In Van Dyck's *Lady with a Rose* 'the landscape was as fascinating as a Titian'. Rembrandt's *Mill* was 'the most famous landscape in the world ... It is a poem of solemnity and depth that would join in most symphoniously with that gayer gravity of *Europa*' (Isabella was not convinced and it was Widener who was to purchase the painting for $500,000 in 1911; it now hangs in the National Gallery in Washington). When drawing Isabella's attention to a Watteau, Berenson made a well-judged comparison: 'He [Watteau] is not Titian 'tis true, but Herrick [a minor seventeenth-century poet] is not Shakespeare, yet there are moods, and they come often, when one prefers the magician of sweetness to the enchanter of grandeur.'

There was more than an element of hyberbole in Berenson's description of the paintings he was offering Isabella: a *Music Lesson* by Terborch (a good but certainly not great Dutch seventeenth-century genre painter) who had 'the strength and simplicity of Manet at his best. In colour he rivals Titian and Giorgione'; a Correggio of a *Girl pulling a Thorn out of her Foot* (later dismissed as a school picture in poor condition) was 'the daintiest, most feminine, loveliest nude you ever saw ... an astounding masterpiece, by a painter surely ranked with Titian, Giorgione and Raphael among Italian artists'.

Berenson knew that Raphael ranked alongside Titian in Isabella's estimation and he was determined to acquire works for her by the artist. When nothing was available, he had warned her: 'Remember that Raphael is not a great painter in the sense that Titian or Veronese or Velázquez or Reubens are'. This did nothing to dampen Isabella's desire to acquire a work by Raphael and Berenson's derogatory verdict changed dramatically when his *Portrait of Tommaso Inghirami* appeared on the market.

He described the Raphael portrait, in a letter dated January 1898: 'Well, if I had been asked what in the whole range of art seemed hardest to acquire I should have said a portrait of *any* kind by Raphael.' Isabella was only too willing to oblige, and the portrait was to form the centrepiece of the Raphael Room on the second floor of the museum at Fenway. It was joined by

his *Pietà*, the predella panel to his Colonna altarpiece. Berenson argued: 'you can get the little gem for £5,000 ... There will be no other chance in our life-times if ever to acquire a first-rate Raphael, at such a price.' He was also happy to boast of his own good judgement, denigrating the Colonna altarpiece (Metropolitan Museum), purchased by the fabulously wealthy John Pierpont Morgan, 'the one I urged you *not* to buy – is exhibited in London at the Old Masters, and critics, I am happy to note, are pretty well agreed about its worthlessness'.

Isabella's passion for Raphael reflected the artist's continuing popularity as the most sought after of all Old Masters. The *Ansidei Madonna* was bought by the National Gallery at the Blenheim Palace sale in 1885 for £70,000 ($350,000), an incredibly large sum at that date. A generation later the *Cowper Madonna* was sold to Joseph Widener in 1914 for $565,000. But even this price was dwarfed by the sale of the *Niccolini-Cowper Madonna* to Andrew Mellon in 1928 for $875,000 (both paintings were sold by descendants of the Third Earl Cowper who bought them on the Grand Tour in Florence in the 1770s; they now hang in the National Gallery in Washington). Not content with this, when Mellon agreed to buy 20 paintings from Stalin in 1930–1, Raphael's *Alba Madonna* cost $1,166,400 out of a total of $7 million.

Berenson could now claim that Isabella was the proud possessor of a group of paintings that 'all the European collections could envy'. The Raphaels were exceptional paintings, but Isabella was, in general, becoming more discriminating in her taste. This was mainly due to financial reasons. As she described it in a letter to Berenson on 8 February 1897 when rejecting a portrait by George Romney: 'It is a question of money – I am now forced to buy only the *Greatest* things in the world, because they are the only ones I can afford to go into debt for ... *Europa* and *Philip* and Van Dyck have drowned me in a Sea of debt.' In rejecting the Romney, Isabella was going against the trend. Glamorous British portraits were becoming all the rage with American collectors and consequently fetching enormous prices. Morgan paid £30,000 ($150,000) for Gainsborough's

Portrait of Georgiana, Duchess of Devonshire in 1901 but confessed: 'If the truth [about the price] came out, I might be considered a candidate for the lunatic asylum'. Twenty years later British portraits were still in fashion, Henry Huntington paying $728,800 for Gainsborough's *Blue Boy* in 1921.

Isabella was unable to compete with these enormous prices; she lamented to Berenson the constrictions placed on her spending power:

> The income of mine was all very well until I began to buy big things. The purchase of Europa and the Bull was the 1ˢᵗ time I had to dip into the capital. And since then those times have steadily multiplied ... Probably much of the misunderstanding comes from the way I spend my money. I fancy I am the only living American who puts *everything* into works of art and music; I mean, instead of into show, and meat and drink.

She was, however, willing to forego some luxuries, writing in her most flirtatious fashion: 'You would laugh to see me. I haven't had one new frock for a year.'

Isabella was happy to joke about her financial affairs with Berenson but her husband Jack was less amused. He was suspicious of Berenson's financial probity, and it was under Jack's influence that she confided to her adviser: 'They say (there seem to be many) that you have been dishonest in your money dealings with people who have bought pictures.' The niggling feeling that Jack was right lingered on after her husband's death in December 1898. When Bernard offered her Holbein's portraits of *Sir William and Lady Butts* the next year, she wrote to him: 'Tell me exactly what you paid for the Holbeins. I have a most singular letter from the owners. I am afraid something is wrong with the transaction ... It looks as if it might be a question for the law courts.'

The sober tone of this letter convinced Berenson that he must be careful in future. When he contacted Isabella with news that another major Titian was coming on to the market, he offered to lower his 5 per cent commission. The painting in question was *Sacred and Profane Love*, widely considered the most

beautiful of Titian's early works, and a painting worthy to hang alongside the *Rape of Europa*. When Berenson heard news in July 1899 that the Borghese family in Rome was considering selling it, he hastened to convince Isabella that it would be 'a title of glory in one's life-time, and of immortality thereafter'. He then proceeded to tell her that the painting was on sale for 'about 818,169 dollars' (the word 'about' speaks volumes for Berenson's financial dealings as a picture dealer).

There were major obstacles to overcome, however, if the sale was to go through. There was a growing furore in Europe over the sale of so many artistic masterpieces to collectors in the United States. European governments appeared powerless to stem the flow of works of art crossing the Atlantic. A cartoon in the New York satirical magazine *Puck* in June 1911, with the simple title *The Magnet*, showed John Pierpont Morgan, with his characteristic top hat and carbuncled nose, moving his dollar magnet across the Atlantic towards Europe, with inevitable consequences.

The Italian government determined to issue export licences to prevent the unrestricted export of works of art. In the case of *Sacred and Profane Love* Isabella's trustees were reluctant to part with such a large sum of money but this was no bar to the Rothschild family who were determined to acquire the Titian at any price, offering the incredible sum of 4,000,000 lire for the painting (the Villa Borghese and the whole collection was only valued at 3,600,000 lire). In the event the Italian government stepped in, acquiring the whole Borghese collection for the nation, and *Sacred and Profane Love* remains at the Villa in Rome, where it has become the iconic symbol of the museum.

Isabella was no more successful in acquiring a second major Titian belonging to the Earl of Darnley, the so-called *Portrait of Ariosto* (as a major Italian Renaissance poet he was of particular interest to the literary – minded Isabella), which Gutekunst had mentioned to Berenson in the context of the *Rape of Europa* several years previously. The Eighth Earl (as the Hon. Ivo Bligh, he had captained the England cricket team to Australia in 1882 and reclaimed the Ashes – the term was coined by a cricketing columnist penning a mock obituary of

English cricket) had inherited Cobham Hall in 1900 and was soon in financial difficulties. In 1903 Robert Ross, friend of the disgraced Oscar Wilde, wrote to Herbert Horne, the art collector and Botticelli expert living in Florence, about a surprise visitor to the Carfax Gallery, which he was running in London. Ross was intrigued by the conversation that ensued and recorded: 'Lord Darnley came and paid us a visit. He was very nice but stupid. He said the picture [the *Portrait of Ariosto*] was not for sale in the ordinary way, but that he might consider an offer of £40,000 clear. Certainly not less.' Horne was well aware of the fabulous collection at Fenway Court in Boston, much of it bought through the services of his Florentine neighbour Bernard Berenson, but, before a deal could be done, the National Gallery intervened, paying £30,000 to acquire the portrait (now known as *Young Man with a Blue Sleeve*).

By now the professional relationship between Isabella and Berenson had cooled as the level of her acquisitions dropped. He had, however, played a vital role in creating one of the great art collections in North America, including works by Titian, Raphael, Botticelli, Rembrandt, Rubens and Velázquez. In doing so, Berenson may have been guilty of sharp practice, but Isabella herself was also capable of disreputable dealing. In November 1900 she wrote to Berenson about the Chigi Botticelli *Madonna and Child*: 'can it be sent to me *smuggled*, do you think, so that I may get it here now, as soon as possible, without any duties?'

In the event the sale caused a furore, and Prince Chigi was fined by the Italian government for selling it without an export licence. The fine was 315,000 lire ($63,000), the amount he received, though, once the fracas had died down, it was reduced on appeal to 20,000 lire, later still to just 10 lire. Berenson had originally told Isabella that the painting was over-priced at $30,000 but, a few months later, advised her to buy it at $70,000, making a handy profit of $7,000 on the deal. Such was the painting's fame that it was exhibited at Colnaghi's in London en route to Boston.

In addition, regardless of the money he was making from Isabella, Berenson was genuinely fond of her. He recorded his feelings in September 1897 in a heart-felt tribute:

Mrs Gardner grows on me from moment to moment. She is the one and only real potentate I have ever known. She lives at a rate and intensity, and with a reality that makes other lives seem pale, thin, and shadowy. What has she not done? Nothing I fancy that she has really wanted. Then she seems really fond of me, not of my petty repute, nor the books I have published, and that is charming.

Seven years later Isabella had become one of the wonders of the New World. Berenson gave a wonderfully flattering description of the transformation: 'You have become, here in Europe, a most marvellous American myth, and people repeat stories about you as they must have done about Semiramis or Cleopatra or Elizabeth or Catherine the Great of Russia.' Isabella responded to his flattery and loved the whole idea of creating something unique in America, writing in jest: 'Shan't you and I have fun with my museum'.

The flirtatious nature of their correspondence has led to suggestions that Isabella and Berenson had an affair, but there is no positive evidence of this and it must remain pure supposition. Isabella certainly treasured a youthful photograph Berenson gave her of himself in profile, his boyish face, full, curving lips and wavy dark hair curling down over the collar of his coat like some romantic poet. There was no love lost between Jack Gardner and Berenson, but this appears to have been based on Jack's well-founded suspicion of Bernard's underhand dealings in overcharging Isabella for paintings he bought for her. Jack was known to be touchy. He had made Isabella promise not to show Sargent's portrait of her, with a string of pearls round her waist, in public. He had also threatened to horsewhip anyone he heard telling the joke going round town that Sargent had painted Isabella 'down to Crawford's notch', a pun on a resort in New Hampshire and the name of Francis Crawford, one of Isabella's admirers.

Jack Gardner may have been over-suspicious of Berenson, but he was not alone in his view. The painter Mary Cassatt saw through him immediately. 'I don't care for Berenson,' she

wrote, 'he is a bit too commercial for me'. The art historian had written to his cousin, the lawyer Lawrence Berenson, in a letter dated 17 October 1922, a defence of his actions: 'I do not earn money by trade. I earn it by enjoying such authority & prestige that people will not buy expensive Italian pictures without my approval.' For Gutekunst, who knew the business activities of Berenson as well as anyone, this lofty attitude was not good enough. 'Business is not always nice', he reminded his colleague. 'I am the last man to blame you, a literary man, for disliking it. But you want to make money like ourselves so you must do likewise as we do and keep a watchful eye on all the good pictures and collections you know or hear of and let me know in good time ... If the pictures you put up to us do not suit Mrs G. it does not matter, we will buy them all the same with you or by giving you an interest in them – as you please. Make hay while Mrs G. shines.'

Following Jack Gardner's death Gutekunst, knowing that neither he nor Berenson would enjoy such a windfall again, wanted to know exactly how rich Isabella was. But he resented the fact that Berenson passed on the blame for any suggestion of financial impropriety in his dealings on Colnaghi's. This resentment increased over the years, as Berenson gradually acquired the status of a great aesthete, pontificating on the arts from his villa at I Tatti outside Florence. Much later, in 1934, Gutekunst, whose career never reached such exalted heights, wrote bitterly to his former colleague: 'are not you all, like us, just after money – we openly, you quietly & less candidly! ... We know too much of one another ... But I do mightily resent this high brow & superior attitude.'

By this date, however, Berenson was immune to criticism. He was basking in his reputation as the greatest connoisseur of his day, and numbered as his protégés Kenneth Clark, recently appointed as the youngest ever Director of the National Gallery in London. He was happy to brush over any hint of impropriety in his association with Joseph Duveen, the most successful dealer to cash in on the boom in American art collecting. A descendant of Jewish-Dutch immigrants who had settled in Hull, Duveen

entered a partnership with Berenson which lasted from 1912 to 1937 (Duveen was reputed to have paid him an annual retainer of £25,000 for his attributions). He was absolutely clear about his aims, which he summed up with admirable succinctness: 'Europe has a great deal of art, and America has a great deal of money'. A salesman of genius, Duveen managed to persuade his clients, including Henry Clay Frick, the newspaper baron William Randolph Hearst, Henry E. Huntington, J. P. Morgan, Samuel H. Kress, Andrew Mellon and John D. Rockerfeller, that purchasing works of art would buy them class. In particular buying Italian Renaissance art showed their discerning taste and aesthetic judgement.

The partnership was so successful that Berenson could later joke that most of the Italian paintings entering America in the early twentieth century had his visa on their passport. The fact that Duveen and Berenson were both Jewish, and some of their clients were almost certainly anti-Semitic, makes their achievement all the more remarkable. Duveen himself ended up as Baron Duveen of Milbank and his legacy is the Duveen Gallery of the British Museum, housing the Elgin Marbles, and the major extension to the Tate Gallery. In America he was instrumental in the building of the National Gallery in Washington. Between them, Duveen and Berenson succeeded in selling numerous Old Masters to the great collectors who then founded museums in which they were displayed. The first, and in many ways the most remarkable of these, opened in Boston in 1903.

Isabella had taken the decision to build a museum to house her ever-expanding collection in 1899. During a tour to Venice in 1897 the Gardners had spent a considerable time collecting architectural elements for the new building, which was to stand on a patch of land in the Back Bay Fens, recently landscaped by the architect Frederic Law Olmsted. But before work could begin Jack Gardner died of a stroke on 10 December 1898. Nevertheless, Isabella went ahead and acquired a suitable site for her 'Venetian palazzo', known as Fenway Court, using funds from his estate, valued at $3,600,000.

The marshy site resembled her beloved Venice, with the foundations of the house resting on piles driven into the mud, in the way Venetian palaces had been erected over the centuries. The centre of the building was a Venetian style courtyard modelled on Palazzo Barbaro, an oasis of greenery, with a Roman mosaic as its centrepiece. The walls were encrusted with pieces of inset sculpture and so successfully was this done that it is difficult, if not impossible, to distinguish between the old pieces, bought in Venice, and pastiches made in Boston. The Italianate feel of the courtyard was enhanced by the red tiled roof and overhanging cornice.

This Italian style was already in evidence in other Boston landmarks, such as the Public Library, and stood in contrast with the French Renaissance chateau style favoured by the Vanderbilts in the extravagant mansions they were building in Newport, Rhode Island, at the same time. To counter the cold of the Boston winter, Isabella intended to capture a Mediterranean feeling by roofing the court and surrounding the central mosaic with palm and mimosa trees. Isabella's friend Sylvester Baxter, writing in the *Century Magazine* in 1904, summed up the inspiration of Venice:

Yes, we are in Italy! Or at least, Italy has come to us. ... there are Venetian colonnades about the cloisters, Venetian windows looking upon the court, Venetian balconies, Venetian loggias, Venetian carvings embedded in the walls, Venetian stairs – all genuine, all ancient, all stones of Venice bearing the incomparable hue of age, touched with the friendly touch of time, weather-worn, smoothed and rounded by the centuries and here reverently placed to endure for a new lifetime in a new Renaissance for the new world.

The motto over the door, however, was French and read *C'est mon plaisir*. This light-hearted allusion to pleasure harked back to the palace of Sanssouci (without a care) built for Frederick the Great at Potsdam when he wanted to escape from the cares of office in his capital of Berlin. In fact, Isabella's motto is closer

in feel to Louis XIV's famous statement: *L'etat c'est moi*, and it was clear to all visitors to the museum that she was going to emulate the Sun King in controlling every aspect of the building and its collection. For Sylvester Baxter:

> Fenway Court was not only planned by its owner, in a way she was an actual builder of the house to an extent unprecedented in association with the execution of plans of such magnitude and scope. Virtually Mrs Gardner was her own architect.

The long-suffering architect William T. Sears must have lived to rue this motto, as he had to endure constant interference from his patron to bring the project to fruition. Sears' patience was sorely tested by his patron's insistence on involving herself in every detail of the design. He recorded his travails in his diary:

> Sullivan [one of the key workmen] said she called him a liar and he would not do any more work for her.

> She insisted one of the wood panels had been placed bottom end up, but later said it was all right.

When the local authorities failed to provide a permit for the Carriage Shed, Isabella, who regarded herself as above the rules, declared loftily:

> Go ahead and build it without a permit, if the City stops me I will not open my museum to the public.

Locals were amused by the palace rising on the edge of the park. Morris Carter recorded the reaction of the *Boston Herald* on 10 April 1901 to the 'huge structure ... going up before the astonished gaze of residents of the Back Bay district'. One stranger had asked if it was to be a warehouse and receive the reply: 'Begorra, it 'ud make a foine brewery', but it was generally referred to in the neighbourhood as 'Missus Gardyner's Eyetalian palace.'

The building was finally completed by the end of 1902 and a
spectacular inaugural party was held on New Year's Day 1903.
On a cold, clear evening the cream of Boston society alighted
from their carriages at the entrance to be greeted by a tall Italian
major domo, as Morris Carter recorded:

> On the landing at the top of the horseshoe stood Mrs
> Gardner, dressed in black, her diamond antennae waving
> above her head; up the stairs the representatives of Boston's
> proudest families climbed to greet their hostess, and then –
> except the chosen few, perhaps possessing less family pride,
> whom she invited to sit in the balcony – they climbed down
> the other side, some of them inwardly fuming, but most of
> them amused at the homage Mrs Gardner had exacted of
> them.

The select audience then listened to a performance by the Boston
Symphony Orchestra of Bach, Mozart and Schumann, presided
over by Isabella seated in a carved and gilded armchair. When
the music finished, the mirrored doors of the Music Room were
rolled back, and guests gasped at the sight of the court, illumi-
nated by Japanese lanterns and filled with the scent of flowers
and the sound of water.

'While the courtyard is yet in an unfinished state,' reported
the *Boston Advertiser*, 'it already gives promise of beauty
and picturesqueness even beyond that anticipated by those
who understand that Mrs Gardner executes her projects
in brilliant and inimitable fashion.' The guests were then
encouraged to wander through the rooms, admiring the
priceless works of art on display in hushed silence. They were
quite overwhelmed, 'the aesthetic perfection of all things', in
the words of Henry James' brother William, 'making them
quiet and docile and self-forgetful and kind, as if they had
become as children'.

Charles Eliot Norton, one of the few allowed into Fenway
Court before its official opening, took justified pride in his
former pupil's achievement:

I have been admitted several times to see Mrs Gardner's still unfinished palace and have seen her collection of art. Palace and gallery (there is no other word for it) are such an exhibition of the genius of a woman of wealth as never seen before. The building of which she is the sole architect is admirably designed. I know of no private collection in Europe which compares with this in the uniform high level of the works it contains.

At the heart of the museum was a Venetian *salone*, known as the Titian Room. The *salone* was designed around Isabella's greatest coup, the acquisition of the *Rape of Europa*. Every detail was carefully worked out, with the painter's great work placed beside the window on to the park, so that it would catch the maximum amount of sunlight flooding in. Isabella surrounded the painting with religious works by Titian's contemporary Paris Bordone and from the workshop of Giovanni Bellini, his first master, together with portraits by other sixteenth-century Italian artists, Baccio Bandinelli and Giovanni Battista Moroni, and a magnificent Velázquez of Philip IV, the owner of the Titian (it had been commissioned by his grandfather Philip II), which hung above a monumental bronze bust by Benvenuto Cellini. The Titian itself was placed above two Venetian end tables, a putto attributed to the French sculptor Francois Duquesnoy, mimicking the pose of *Europa*, and a watercolour attributed to Van Dyck after the copy Rubens had made of the Titian. The walls of the room were of red brocade, and below the Titian, to give a particularly personal touch, Isabella placed a section of green silk, part of one of her evening dresses designed by Charles Worth.

For Isabella this painting was the centrepiece of her '*Borgo Allegro* [happy place]', as she called her museum. It was the painting Henry James referred to when he commiserated with his friend after she broke her leg falling on the ice in February 1902: 'My imagination shoved rose leaves, as it were, under the spine of a lady for whom lying fractured was but an occasion the more to foregather with Titian. Seriously, I hope you weren't very bad – that it was nothing more than the "Europa" could

bandage up with a piece of that purple of which you gave me so memorable an account.'

Following the triumphant opening of the museum Isabella decided to allow 200 members of the public to enter the sacred premises on specific open days, initially for two weeks every year, in the spring and the autumn. They were to pay $1 each, tickets sold in advance. Remarkably, her collection of European art was superior to that of the Boston Museum of Fine Arts, which was to open to the public in 1909.

Isabella lived on the fourth floor of the museum, and would come downstairs to entertain the leading intellectual and artistic figures of the time: Henry James, Oliver Wendell Holmes (the most widely respected judge in America), Charles Eliot Norton, the Berensons, John Singer Sargent and James McNeill Whistler. She was a generous benefactor to talented young artists and musicians, giving a cello to the young Catalan cellist Pablo Casals. Isabella was becoming increasingly imperious, and was often seen seated on an ancient marble throne in the courtyard of the museum, gazing at the mosaic of Medusa in the centre, the Gorgon's head encircled by snakes.

Isabella loved to portray herself as a cultural icon. She was more than happy to entertain her friends, but tended to treat the public with regal disdain. One day one of the guardians, Corinna Putnam Smith, entered the Titian Room and spotted that 'a young woman, timid-looking, almost pathetic, was gazing' at *Europa*. 'On observing that [she] was about to jot something down in a minute notebook, I was about to inform her kindly that this was against regulations, when Mrs Gardner pounced on her like a fury, shouting 'Don't you know you are breaking a rule?' The unfortunate girl fled from the room in tears but was later invited to lunch by the repentant owner, with the chance to spend a whole day in the museum. Subsequently, Isabella's decision to enrol Harvard students to help oversee the rooms in the museum was a great success, the students taking great pride in their role. Girls brought in to help from Radcliff College were less complimentary, noting how Isabella's face was covered in powder and rouge, and that she sported an outrageous yellow wig.

The Isabella Stewart Gardner Museum was a truly remarkable institution and Isabella was anxious that people should understand the reasons for its creation. In 1917 she wrote to her friend Edmund Hill, describing why she had created the museum:

> Years ago I decided that the greatest need in our Country was Art. We were largely developing the other sides. We were a very young country and had very few opportunities of seeing beautiful things, works of art etc. So I determined to make it my life's work if I could. Therefore, ever since my parents died I have spent every cent I inherited (for that was my money) in bringing about the object of my life.

The writer Edith Wharton, descended from one of the grand old families of New York (her father was George Frederic Jones, and the expression 'Keep up with the Joneses' originated with her father's family) and a friend of Berenson's, compared the museum to the ones she knew so well in Europe. 'Of course I have seen Palazzo Gardner,' she wrote, 'her collection is marvellous, and looks beautifully in its new setting, but a spirit of opposition roused in me when I am told "there is nothing like it in Europe".' Henry James took the opposite viewpoint, taking 'an acute satisfaction in seeing America stretch out her long arm and rake in, across the green cloth of the wide Atlantic, the highest prizes of the game of civilization.'

Bernard and Mary Berenson had contrary views of Isabella and her museum. The art historian retained a real affection for his former patron. Although their business relationship had ceased in the early years of the twentieth century, he had loyally offered Isabella the magnificent *Feast of the Gods* by Bellini and Titian (National Gallery, Washington) when it appeared on the market in 1917, writing cynically: 'Bless the war, that you have the chance [to buy], for without it the *Feast* would never have left its old home, nor I be in a position to urge it upon you.' And visiting her late in her life, when she was 'a little "gaga" as the French so aptly say', he loyally took with him paintings by

Mantegna, Piero della Francesca, Vivarini and two Fra Angelicos, wrapped in bath towels (a wonderfully cavalier approach to the way that important Old Masters should be handled, though Berenson never treated the condition of paintings with the same seriousness as his attributions).

Mary had waxed lyrical when first visiting the museum: 'We were quite overcome, the whole thing is a work of genius', adding, in her diary: 'In beauty and taste it far exceeded our expectations, which were high … One room is more entrancing than another, and the great masterpieces of painting seem mere decoration in the general scheme. I thought there was remarkably little that was not of Bernhard's choosing, but that little annoyed him immensely and hurt him too.'

By the time of her visit with Berenson in 1920, however, she had changed her tune with a vengeance, possibly because she now thought of Isabella as a tyrant who may not have given her husband full credit for all the work he had done for her. Considering that Isabella had suffered a stroke, and that the Berensons lived a life of great privilege at I Tatti, entertaining the great and the good, in large part due to the money Berenson had made from his art dealings with Isabella, Mary's behaviour seems astonishingly mean-spirited. She began by launching a personal attack on Isabella:

> We went out to see Mrs Gardner today. She will soon die and she must know it, but she is unchanged in her egotism, her malice, her attachment to detail, to nonsensical things. All this, in the days of her vitality, when it seemed as if she couldn't grow old and die, was actually part of her. But now it is purely pathetic, and a little ugly.

Mary now moved on to savage the museum her husband had done so much to create: 'But the worst of all is that her great Palace, in spite of the marvellous pictures in it, looks to our now enlightened eyes, like a junk shop. There is something horrible in these American collections, in snatching this and that away from its real home and hanging it on a wall of priceless damask made

from somewhere else, above furniture higgledepiggled from other places, streamed with objets d'art from other realms.'

It was true that Isabella's heyday as a collector was long gone, but her prescience and good fortune meant that she had been ahead of the game. Though she often lamented 'Woe is me! Why am I not Morgan or Frick?', she had formed the bulk of her collection before they entered the art market. Now, in old age, she was increasingly preoccupied with what would happen to the museum after her death. She had always cultivated impressionable young men and had taken a shine to Morris Carter, a Harvard graduate who was librarian at the Museum of Fine Arts. By 1908 she was hard at work persuading him to come to live at Fenway Court. Carter tried to resist, commenting: 'shan't I, like a very poor person, be extravagant with other people's money?', but resistance proved futile. He was presented with a piece of land at Brookline, Isabella's country estate, on which he planned to build a house, but soon discovered that his benefactress intended to take control of the construction. Carter realized the real reason for Isabella's generosity: she intended him to be the first Director of the Isabella Stewart Gardner Museum.

Living in such proximity to this powerful lady, Carter was under no illusion of the scale of the task he was to confront. This was outlined by Isabella's cousin John Chipman Gray, who had drawn up a legal document enshrining his cousin's wishes: 'I direct that Morris Carter shall be director of the Museum. He shall have the power to make suitable rules for the conduct of employees and visitors ... He shall have the sole power of appointing and dismissing ... subordinate officers and employees.'

There were, however, stringent limitations to Carter's powers. Not only was he commanded to live on site, he was even told how much holiday he was allowed to take. On Isabella's birthday, 14 April, he was instructed to hold a memorial service in the chapel at the end of the Long Gallery, as though Isabella was a saint or a queen. More seriously, Carter was forbidden to move a single object in the museum. If he had the temerity to do so, the whole collection would be put up for sale by the President and Fellows

of Harvard. On 14 July 1924 Isabella died in Fenway Court. Like some Old World monarch she had left precise instructions: 'Carry my coffin high – on the shoulders of the bearers', adding, characteristically: 'They will have to be told exactly what to do'. A mass was to be said daily for her soul by the priests from the Society of St John the Evangelist. No doubt Philip II, who had commissioned the greatest work of art in her museum, would have approved.

Carter had been appointed to tend the Gardner flame, and he never really escaped the long shadow cast by his former employer. From beyond the grave it seemed that Isabella was watching his every move. The board of the museum, composed of the conservative old guard of Boston, approved of the policy of minimal change and it was not until the 1930s that electricity replaced gaslight in the museum. When Carter tried to introduce changes, he found his every move observed. Isabella had begun a tradition of filling the courtyard of Fenway Court at Easter with nasturtiums. But in May 1929 the nasturtiums were missing from the floral display. The *Boston Herald*, sympathetic to Carter's predicament, drew this faux pas to its readers' attention:

It is only when the word 'nasturtiums' is mentioned that a gleam of madness shines from his [Morris Carter's] mild eye. If it has been a hard day, he may even be heard to utter dark threats of murder by strangulation. It appears that during Mrs Gardner's lifetime, when the palace was open to the public in April, the small balconies above the courtyard were filled with brilliant nasturtiums ... Apparently no one who saw the court with the nasturtiums has ever forgotten them, and as a result the unfortunate curator is hounded – no matter what the season – with the remark: 'Mrs Gardner used to have nasturtiums growing from those balconies – don't you ever have them now?' ... Those who [have seen the nasturtiums in the courtyard] will realize why no one ever forgets them and also why the patience of the long-suffering curators will still continue to be tried by observant ladies who walk past the Titians but gasp with emotion over a few green tendrils covered with crimson blossom.

Since Carter's long tenure in office (1924–55), there have been only three directors of the museum. The first of these was George Stout (1955–70), a diligent and meticulous student of the art of restoration, who had learned his trade in the conservation department at the Fogg Art Museum in Boston. During the 1930s, with the help of the departmental chemist, John Gettens, he pioneered research into the raw materials of painting – the pigments, oils, gums, resins and glues – and studied the causes of deterioration in a painting and the ways of preventing this. Stout's meticulous attention to the principles of conservation (he established the conservation department at the Isabella Stewart Gardner Museum in 1933) were widely accepted and were adopted by the Boston Museum of Fine Arts, the Fogg Art Museum and the Worcester Art Museum, three of the most important museums in Massachusetts.

Stout himself, however, is best remembered for his extraordinary work in recovering works of art in Europe at the end of the Second World War. His heroic exploits have recently been dramatized in the film *The Monuments Men*, where the dapper restorer is played by the rather unlikely figure of the glamorous George Clooney. During the war the art of conservation, hitherto restricted to the dusty back corridors of museums, suddenly assumed much greater importance. The allies realized that they urgently needed to preserve world-famous works of art in the coming conflict. Nazi Germany had stolen millions of cultural objects from the countries it had conquered, including some of Europe's greatest art treasures.

Stout left his job in training museum curators in the art of conservation, and early in 1944 he joined the newly formed Monuments, Fine Arts, and Archives section of the Allied armies, shortened to MFAA or, as they came to be called, the Monuments Men. Following the D-Day landings this unit, initially consisting of just 15 men, eight American and seven British, and possessing no offices, vehicles or support staff, were assigned to the allied armies to try to mitigate damage to churches, museums and other important monuments between the English Channel and Berlin, a truly herculean task. In addition,

they were authorized to locate stolen or missing works of art. Stout and his colleagues could not even rely on allied generals to help them, since General Eisenhower, Supreme Commander of the Allied Expeditionary Force, had instructed his senior officers that if they had to choose between preserving a monument or protecting their troops, 'the lives of our men are paramount'.

Undaunted, the members of the MFAA set to work. The most impressive act that the unit performed during the campaign of 1944–5 was at the Merkers mine complex which the American army captured on 6 April 1945. This was one of the biggest salt mines in Thuringia, consisting of a total of 35 miles of tunnels. When Stout arrived five days later, he was amazed to discover an artistic treasure trove, consisting of some of the most important Old Masters from the Prussian royal collection, Albrecht Durer's original woodcuts for the Apocalypse series, priceless Egyptian papyri, Greek and Roman antiquities, Byzantine mosaics and Islamic rugs. It turned out that Dr Paul Ortwin Rave, a dedicated museum professional, had just organized delivery from Berlin of this irreplaceable collection of art at the very moment when the Russians were shelling the German capital.

This artistic cornucopia was stored deep underground and it was difficult and dangerous work trying to locate the works of art in such dark, cold and damp conditions, with minimal lighting, no maps, narrow and cramped corridors, with the perpetual threat that the next compartment might have been booby-trapped by the retreating Germans. The situation at the Merkers salt mine was made considerably more complicated by the fact that the Third Reich's gold reserve was also stored in the mine, and this had attracted the attention of the world's press. The mine was also in the Russian zone of occupation and there was therefore considerable urgency in moving the works to a better location to keep them out of the hands of the Russians.

General Patton, reluctant to leave behind much-needed troops to guard the gold and the art, and eager to continue his advance into Germany, gave the order for his troops to move out on 15 April, just four days after Stout's arrival at the mine. Stout

immediately began filling any available boxes and crates with a combination of art and gold, using a thousand sheepskin coats from a nearby Luftwaffe depot as packing materials. After working flat out for four days and nights, the first convoy left at daybreak on 15 April. By 9 p.m. the next night the uncrated paintings had also been brought above ground, an even more complicated job. The crates were then loaded and at 8.30 on 17 April the cream of the priceless Prussian state art collection left for Frankfurt in a convoy of 32 ten-ton trucks, with an armed escort including air cover.

Stout went on to remove 80 truckloads of artwork from another salt mine, the Altaussee, in the Austrian Alps and, with typical thoroughness, managed to inspect most of the Nazi repositories between the Rhine and Berlin. After Germany's surrender, he transferred to the Pacific theatre of war, and served as chief of the Arts and Monuments Division in Tokyo at Allied headquarters until mid-1946. Stout's work has now been given proper recognition, notably by Robert Edsel in his book *The Monuments Men: Allied Heroes, Nazi Thieves and the Greatest Treasure Hunt in History*, published in 2009, on which the film of *The Monuments Men* is based.

On returning home, Stout served briefly at the Fogg Museum and the Worcester Art Museum before becoming Director of the Isabella Stewart Gardner Museum in 1955. He served there until 1970 and cemented his reputation as one of the greatest experts in the field of conservation, which he placed at the heart of the museum's philosophy, introducing state of the art climate control and establishing a stable environment for the works of art in the collection. In addition he improved the visibility of the whole collection by upgrading the lighting and controlling the amount of daylight entering the galleries.

Stout was succeeded by Rollin van Nostrand Hadley (1970–89), whose edition of the letters of Isabella Stewart Gardner and Bernard Berenson is a fascinating account of the relationship between a patron and her art adviser. Hadley's successor Anne Hawley, the current director, inherited her post in the most traumatic circumstances, as she was greeted, almost on arrival,

with the devastating news of the burglary that took place at the Isabella Stewart Gardner Museum on 18 March 1990. This was enough to tax the most hardened museum director, but the new incumbent proved more than capable of handling the situation and, under her dynamic directorship, the museum has undergone a transformation. In Hawley's words Boston 'sat out the twentieth century in the visual arts', but ideas such an artist-in-residence have proved hugely successful. More recently, in 2012, the museum opened an extension by Renzo Piano which will serve as a temporary exhibition and performance space. There are apartments for artists-in-residence, and visitors are encouraged to listen to conversations between artists and curators.

For the director and her predecessors, the overriding concern is to respect the wishes of Isabella Stewart Gardner when she created her museum over a century ago. And this means placing the strongest emphasis on the permanent collection, which plays such an important role in attracting visitors to Boston. If the object of Isabella's life, as she told Edmund Hill, was to give people the opportunity to see beautiful things, then it is Titian's *Rape of Europa* more than any other painting, the crowning glory of the museum, which has helped to achieve this.

Conclusion

What does the future hold for the *Rape of Europa*? Although the painting, over five centuries old, is in surprisingly good condition, having suffered no more than a number of minor restorations, reflecting the care with which it has been treated by its successive owners, its fragility, as well as the terms of Isabella Stewart Gardner's will, means that it is most unlikely ever to leave the Isabella Stewart Gardner Museum again. The *Rape of Europa* has enjoyed a rich history, but now that it is housed in a museum, its fascinating journey, as it has moved progressively from Venice to Spain, France and Britain, before crossing the Atlantic to America, is over. One can only speculate what might have happened if it was still subject to market forces. Would it have been acquired by a Russian oligarch, or an oil-rich Arab, perhaps from Qatar, where the government is building some of the most impressive art museums in the world, or perhaps a wealthy Chinese, benefiting from China's fast-growing economy to begin collecting Western art in earnest?

The reality, however, is that the painting will remain in Boston, where 200,000 visitors every year come to the Isabella Stewart Gardner Museum to enjoy the collection housed in her palatial residence at Fenway. Visiting the museum is like entering a time warp, wandering through rooms that have remained unchanged since Isabella's death. Having traversed the lower floors, you find yourself upstairs in the Titian Room, where the sight of the *Rape of Europa* is enough to lift the flagging spirits of all

197

art lovers. This room alone shows Isabella Stewart Gardner to have been a worthy successor to some of the most notable art collectors in history. They constitute a diverse group, ranging from the secretive and repressed Philip II and his grandson Philip IV, indulging in their passion for the erotic figure of Europa in solitary splendour in their private apartments, to the libertine Dukes of Orléans carrying on their scandalous lifestyle beneath the gaze of Europa and her bull.

What united these collectors, and Isabella herself, was the desire to possess the finest works of Titian. They regarded the painter as without peer in his ability to use colour as a way of expressing feeling. In a long and fruitful career, the painter produced a large oeuvre, but it was his *poesie*, painted when the artist was at the height of his powers, which best demonstrate this ability and, consequently, have been the most sought after of all his works. The *Rape of Europa*, representing the culmination of this series, has not only been highly sought after, but also exerted a profound influence on Titian's fellow artists, ranging from Rubens and Velázquez in Spain, Watteau and Boucher in France, Reynolds and Lawrence in England and Whistler and Sargent in America.

It is the one painting, above all, that the National Gallery in London regrets losing when it left British shores back in the 1890s, and was one of the main reasons why the recently retired director Dr Nicholas Penny, Director of the National Gallery (2008–15), a notable Titian scholar, was so determined to purchase *Diana and Actaeon*, and *Diana and Callisto*, the two paintings most closely associated with the *Rape of Europa*. As Penny has written: 'Recollection of how the National Gallery allowed the *Rape of Europa* to leave the country strengthened the determination to secure the other two for public ownership over a century later.' The success of the National Gallery's campaign to raise £100 million to acquire the two Diana paintings, and the crowds that have flocked to see them, like those who troop into the Isabella Stewart Gardner Museum to see the *Rape of Europa*, show why these great mythological works of Titian have always been placed at the pinnacle of Old Master painting.

Bibliography

Aretino, P. (1967), *Letters*, T. C. Chubb (trans.). Hamden, CO: Archon Books.

Bedard, F. (2009), *Political Renewal and Architectural Revival during the French Regency*. California: University of California Press.

Berenson, B. (1968), *Italian Painters of the Renaissance*. Volume I. Venetian and North Italian Schools. London: Phaidon Press.

Berry, M. (1866), *Extracts of the Journals and Correspondence of Miss Berry: From the Years 1783 to 1852*, Lady Theresa Lewis (ed.). London: Longmans, Green & Co.

Black, J. (2003), *France and the Grand Tour*. Basingstoke: Palgrave Macmillan.

Boser, U. (2009), *The Gardner Heist*. New York: Harper Collins.

Brotton, J. (2006), *Sale of the Late King's Goods: Charles I and his Art Collection*. London: Macmillan.

Brown, J. (1991), *The Golden Age of Painting in Spain*. New Haven and London: Yale University Press.

Brown, J. and Elliott, J. H. (2003), *A Palace for a King: Buen Retiro and the Court of Philip IV*. New Haven: Yale University Press.

Buchanan, W. (1824), *Memoirs of Painting with a Chronological History of the Importance of Pictures of Great Masters into England by the Great Artists since the French Revolution*. London: Ackermann.

Carter, M. (1933), *Isabella Stewart Gardner and Fenway Court*. Cambridge, MA: Riverside Press.

Cohen, R. (2013), *Bernard Berenson: A Life in the Picture Trade*. New Haven and London: Yale University Press.

Crow, T. E. (1985), *Painters and Public Life in Eighteenth Century Paris*. New Haven and London: Yale University Press.

Crowe, J. A. and Cavalcaselle G. B. (1877), *Titian: his Life and Times*. London: John Murray.

Doyle, W. (1999), *Origins of the French Revolution*. New York: Oxford University Press.

Dubois de Saint-Gelais, L.-F. (1727), *Description des tableaux du Palais Royal avec la vie des peintres*. Paris:

Edsel, R. (2009), *The Monuments Men: Allied Heroes, Nazi Thieves and the Greatest Treasure Hunt in History*. New York: Hachette.

Elliott, J. H. (1963), *Imperial Spain: 1469–1716*. London: Penguin.

—(1989), *Spain and its World 1500–1700*. New Haven and London: Yale University Press.

Fitzgerald, P. (1913), *Memories of Charles Dickens*. Bristol: J. W. Arrowsmith.

Georgievska, A. and Silver, A. (2014), *Rubens, Velázquez and the King of Spain*. Farnham: Ashgate Publishing.

Goffen, R. (1997), *Titian's Women*. New Haven and London: Yale University Press.

Goldfarb, H. T. (1995), *The Isabella Stewart Gardner Museum*. New Haven and London: Yale University Press.

Grierson, E. (1974), *The King of Two Worlds: Philip II of Spain*. London: Collins.

Hadley, R. (ed.) (1987), *The Letters of Bernard Berenson and Isabella Stewart Gardner 1887–1924*. Boston: North-Eastern Press.

Hale, S. (2012), *Titian: His Life*. London: Harper Collins.

Hazlitt, W. (1998), *Selected Writings of William Hazlitt*. London: Pickering & Chatto.

Herrmann, F. (1999), *The English as Collectors*. London: John Murray.

Hibbert, C, (1969), *The Grand Tour*. London: Weidenfeld & Nicolson.

Howard, J. (2010), *Colnaghi: The History*. London: Colnaghi.

Howell, T. (1816), *A Stranger in Shrewsbury*. Shrewsbury: Printed and sold by the author.

Hudson, M. (2010), *Titian: The Last Days*. London: Bloomsbury.

Hume, M. (1928), *The Court of Philip IV: Spain in Decadence*. London: Eveleigh, Nash & Grayson.

Humphrey, P. (ed.) (2013), *The Reception of Titian in Britain: From Reynolds to Ruskin*. Turnhout, Belgium: Brepols Publishers.

Jameson, A. (1844), *Companion to the most Celebrated Private Galleries of Art*. London: Saunders & Otley.

Justi, C. (1889), *Diego Velázquez and his Times*, A. H. Keane (trans.). London: H. Grevel.

Kamen, H. (1997), *Philip II of Spain*. New Haven and London: Yale University Press.

Keble Chatterton, E. (1912), *King's Cutters and Smugglers 1700–1855*. London: George Allen.

Kimball, F. (1936), *Oppenord au Palais Royal*. Gazette des Beaux-Arts XV.

Levin, M. J. (2005), *Agents of Empire: Spanish Ambassadors in Sixteenth Century Italy*. New York and London: Cornell University Press.

Lewis, W. H. (1961), *The Scandalous Regent*. London: Andre Deutsch.

Lopez-Rey, J. (1968), *Velázquez's Work and World*. London: Faber.

McClellan, A. (1994), *Inventing the Louvre*. Cambridge: Cambridge University Press.

Matthew, H. C. G. and Harrison, B. (eds) (2004), *Dictionary of National Biography*. Oxford: Oxford University Press.

Mulcahy, R. (2004), *Philip II of Spain: Patron of the Arts*. Dublin: Four Courts.

Nash, J. C. (1985), *Veiled Images: Titian's Mythological Paintings for Philip II*. London: Associated University Press.

Nichols, T. (2013), *Titian and the End of the Venetian Renaissance*. London: Reaktion.

Orso, S. (1986), *Philip IV and the decoration of the Alcázar of Madrid*. Princeton: Princeton University Press.

Ovid (1954), *Metamorphoses*, A. E. Watts (trans.). Berkeley: University of California Press.

Parker, G. (2014), *Imprudent King: A new life of Philip II*. New Haven and London: Yale University Press.

Penny, N. (2008), *The Sixteenth Century Italian Paintings, Volume II, Venice 1540–1600*. London: National Gallery Publications.

Pergam, E. A. (2011), *Manchester Art Treasures Exhibition, 1857: Entrepreneurs, Connoisseurs and the Public*. Farnham: Ashgate.

Pope, A. (1960), *Titian's Rape of Europa*. Cambridge, MA: Harvard University Press.

Previtt, C. (1997), *Philippe, Duc d'Orléans: Regent of France*. London: Weidenfeld & Nicolson.

Pückler-Muskau, H. Furst von (1957), *A Regency Visitor: The English Tour of Prince von Pückler-Muskau Described in his Letters 1826–28*. London: Collins.

Puttfarken, T. (2005), *Titian and Tragic Painting: Aristotle's Poetics and the rise of the Modern Artist*. New Haven: Yale University Press.

Reitlinger, G. (1961), *The Economics of Taste: The Rise and Fall of Picture Prices 1760–1960*. London: Barrie and Rockliffe.

Rosand, D. (ed.) (1982), *Titian, His World and Legacy*. New York: Columbia University Press.

Saltzman, C. (2008), *Old Masters, New World: America's Raid on Europe's Great Pictures, 1880–World War I*. New York: Viking.

Samson. A. (ed.) (2006), *The Spanish Match: Prince Charles' Journey to Madrid, 1623*. Aldershot: Ashgate.

Schama, S. (1989), *Citizens: A Chronicle of the French Revolution*. London: Viking.

Scudder, E. S. (1937), *Prince of the Blood*. London: Collins.

Simpson, C. (1987), *The Partnership: The Secret Association of Bernard Berenson and Joseph Duveen*. London: Bodley Head.

Stourton, J. and Sebag-Montefiore, C. (2012), *The British as Art Collectors: From the Tudors to the Present*. London: Scala Publishers.

Tharp, L. H. (1965), *Mrs Jack*. Boston: Little Brown & Co.

Trevor-Roper, H. (1976), *Princes and Artists, Patronage and Ideology at Four Habsburg Courts 1517–1633*. London: Thames & Hudson.

Vasari, G. (1991), *The Lives of the Artists*. J. and P. Conaway Bondanella (trans). Oxford: Oxford University Press.

Vergara, A. (1999), *Rubens and his Spanish Patrons*. Cambridge: Cambridge University Press.

Waagen, G. (2003), *Galleries and Cabinets of Art in Great Britain*. London: Routledge/Thoemmes Press.

Warren J. and Turpin A. (eds) (2007), *Auctions, Agents and Dealers 1600–1830*. Oxford: Beazley Archive.

Wethey, H. E. (1969–75), *The Paintings of Titian*. London: Phaidon.

Whitley, W. T. (1928), *Art in England 1800–1820*. Cambridge: Cambridge University Press.

Wilson, H. (1957), *The Game of Hearts: Harriete Wilson and her memoirs*. London: Gryphon Books.

Exhibitions

Eye of the Beholder: Masterpieces from the Isabella Stewart Gardner Museum, in association with Beacon Press, 2003.

Goldfarb, H. T, Freedberg, D. and Mena Marques, M., *Titian and Rubens: Power, Politics and Style*, Isabella Stewart Gardner Museum, Boston, 1998.

The Rape of Europa, Staatliche Museum, Berlin, 1988.

Catalogue of the Orléans' Italian Pictures, 1798, London, Sampson Low.

Family Trees of Habsburg and Orléans

House of Habsburg Family Tree

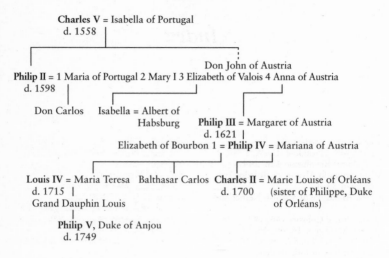

Charles **V** = Isabella of Portugal
d. 1558

Don John of Austria

Philip II = 1 Maria of Portugal 2 Mary I 3 Elizabeth of Valois 4 Anna of Austria
d. 1598

Don Carlos Isabella = Albert of
Habsburg **Philip III** = Margaret of Austria
d. 1621

Elizabeth of Bourbon 1 = **Philip IV** = Mariana of Austria

Louis IV = Maria Teresa Balthasar Carlos **Charles II** = Marie Louise of Orléans
d. 1715 d. 1700 (sister of Philippe, Duke
Grand Dauphin Louis of Orléans)

Philip V, Duke of Anjou
d. 1749

Kings of Spain and France

House of Orléans Family Tree

Louis XIII = Anne of Austria Charles I = Henrietta Maria

Louis XIV =/ Mdme de Montespan **Philippe** (Monsieur) = Henrietta Anne (Minette)
= Elizabeth Charlotte of
Palatinate

Louis-Alexandre de Bourbon Louise-Françoise Francoise-Marie de B = **Philippe**

Duke of Ponthièvre Louise-Elisabeth Louis = Johanna of Baden Baden

Louise-Henriette de Bourbon = **Louis Philippe**

Marie-Adelaide de Bourbon = **Louis Philippe Joseph** (Philippe Egalité)

Louis Philippe Duke of Montpensier Duke of Beaujolais
King of France (1830–48)

Dukes of Orléans

illegitimate descent

Index

Aboukir Bay, Battle 129
Adams, John, President, U.S.A. 173
Agricultural Revolution 126, 144
Alba, Fernando Alvarez de Toledo, 3rd
 Duke of 33–4
Albert, Archduke of Spanish Netherlands
 66
Albert, Prince Consort 146, 148
Alcázar, Madrid 3, 16, 40, 49, 55–6, 58,
 60, 66–7, 69, 80, 87, 89, 93, 97
American War of Independence 107–8,
 111, 122, 173
Ancien Regime 111, 113, 119–22, 125
Angerstein, John Julius 129, 141
Aranjuez, Palace of 40–1, 75, 88
Arce, Don Pedro de 72
Aretino, Pietro 24–5
Arkwright, Richard 147
Ariosto, Ludovico 148, 155, 169, 179–80
Armada, Spanish 34, 60
Attingham Park 3, 134–40, 142
Augsburg 10–13, 23
Auto-da-Fe 31, 79

Badovaro, Federico 9, 31
Banqueting House, Whitehall 69, 76
Barry, James 130, 133
Baxter, Sylvester 184–5
Bell, Alexander Graham 161
Bellini, Giovanni 7, 27, 174, 187, 189
Berenson, Bernard 1, 165–83, 189–90
Berenson, Mary 189–90
Bernini, Gian Lorenzo 83
Berry, Marie Louise Elisabeth d'Orléans,
 Duchess of 96–7
Berry, Mary 129
Berthollet, Claude Louis 102
Berwick, Sophia Dubouchet, Lady 136, 138
Berwick, Thomas Noel Hill, 2nd Baron
 134–40

Berwick, William, 3rd Baron 139
Bismarck, Prince Otto von 158
Blenheim Palace 155
Bode, Dr Wilhelm 156–8
Bosch, Hieronymus 36–7, 39
Boston 1, 163, 173–5, 195
Boston Museum of Fine Arts 188, 193
Botticelli, Sandro 149, 168, 180
Boucher, Francois 49, 99, 195
Bridgewater, Francis Egerton, 3rd Duke of
 127–9, 132, 144
Bridgewater Canal 127, 147
Brissot, Jaques-Pierre 105, 109–10
Bristol, John Digby, 1st Earl of 62–4
Browning, Robert 164
Bryan, Michael 127–8
Buchanan, William 131
Buckingham, George Villiers, 1st Duke of
 59–61
Buen Retiro, Palace of 73–5, 79

Calderon de la Barca, Pedro 57, 73
Calonne, Charles-Alexandre de 110
Cardenas, Don Alonso de 76–7
Carducho, Vicenzo 59, 62
Carlisle, Frederick Howard, 5th Earl of
 128, 134, 144
Carlyle, Thomas 122, 166
Carmontelle, Louis Carrogis de 102, 105
Carnegie, Andrew 162
Carracci, Annibale 92–4, 128–9, 131–3,
 137
Carter, Morris 163–4, 185, 191–3
Casals, Pablo 188
Cassatt, Mary 181
Castiglione, Baldassare 20
Catherine the Great, Empress of Russia
 115, 118, 181
Cavalcasalle, Giovanni Battista 153, 166,
 168

205

Cervantes, Miguel de 3, 54
Chantrey, Sir Francis 150
Charles, Archduke of Austria 86
Charles, Prince of Wales and later Charles
 I, King of England 56, 59–66, 69, 75–7,
 87–8, 94, 141, 171–2
Charles II, King of England 85, 95, 142
Charles II, King of Spain 3, 78, 85
Charles V, Holy Roman Emperor and King
 of Spain 9, 13–4, 32, 35, 39, 62, 69,
 75–6, 87
Charles X, King of France 108, 114
Chase, William Merritt 164
Chateau de Saint-Cloud 101–2
Christina, Queen of Sweden 94, 99
Churchill, John, 1st Duke of Marlborough
 86
Claude Lorraine 75, 83, 131–2, 137
Clement VII, Pope 62
Clive, Robert 1st Baron 122
Clooney, George 193, 195
Cobham Hall 3, 141–6, 154, 157, 180
Coke, Sir Edward 63
Coke, Thomas, 1st Earl of Leicester 89,
 126
Colbert, Jean-Baptiste 54, 83–5
Cole, Sir Henry 146
Colnaghi's 156–7, 167–8
Constable, John 149
Contant d'Ivry, Pierre 103
Conti, Prince of 98
Corday, Charlotte 105
Correggio, Antonio da 4, 22, 39, 48, 87,
 94–5, 99, 176
Cottington, Sir Francis 62–3, 65
Council of Trent 15, 26, 32
Coypel, Charles-Antoine 95, 99
Crawford, Francis 181
Cromwell, Oliver 76
Crowe, Sir Joseph Archer 153, 168
Crozat, Pierre 93–5
Curtis, Daniel 163
Curtis, Ralph 164
Cust, Lionel 155

D'Alembert, Jena le Rond 102
D'Angevillier, Count 106
D'Artois, Comte see Charles X
D'Este, Alfonso, Duke of Ferrara 8, 24,
 141
D'Orvilliers, Louis Guillouet, Comte d',
 Admiral 107
Danton, Georges 111, 113
Darby, Abraham 131
Darnley, John Bligh, 5th Earl of 3, 140–4
Darnley, John Stuart Bligh, 6th Earl of 154,
 168–9, 171, 173
Darnley, Ivo Bligh, 8th Earl of 179–80

David, Jaques-Louis 105–6, 119
Denon, Dominique Vivant 130
Desmoulins, Camille 105, 109, 111–13
Diaz del Valle, Lazaro 70
Dickens, Charles 143–4
Diderot, Denis 105
Dolce, Lodovico 18–19, 46
Domenichino, Domenico Zampieri called
 129, 132
Dubouchet, Sophia see Lady Berwick
Dumouriez, Charles-Francois du Perier,
 General 122
Durer, Albrecht 76, 156, 194
Duthe, Rosalie 102
Duveen, Joseph, Lord 170, 182

Eastlake, Sir Charles Lock 146, 153
Edison, Thomas 161
Edsel, Robert 195
Egmont, Lamoral, Count of 33
Egremont, George Wyndham, 3rd Earl of
 150
El Greco, Domenikos Theotokopoulos 34,
 38–9
El Pardo, Palace of 40–1
Eliot Norton, Charles 149, 163, 186, 188
Elizabeth I, Queen of England 141–2
Elizabeth, Queen of Spain (wife of Philip
 IV)
Elizabeth of Valois, Queen of Spain (wife
 of Philip II) 32, 41
Elliott, Grace Dalrymple 113, 121
Ellison, Henry 103
Emmanuel Philibert, Duke of Savoy 38
Engels, Friedrich 148
English Civil War 63–4
Escorial, San Lorenzo de 33, 35–40, 43,
 63, 77, 84, 151
Estates General 110–12
Eugene of Savoy, Prince 86, 95

Fairbairn, Sir Thomas 150
Farnese, Alessandro, Duke of Parma 33, 39
Farnese, Cardinal Alessandro 15
Fenway Court 173, 176, 180, 183, 191–2
Forth, Nathaniel Parker 115
Fra Angelico 149, 189
Fragonard, Jean-Honore 102
Francois I, King of France 14, 27
Francoise Marie de Bourbon, Duchess of
 Orléans 90, 95
French Revolution 4, 102, 106, 112–22
Frick, Henry Clay 162, 183, 191
Frith, William Powell 150

Gainsborough, Thomas 65, 169, 177–8
Gardner, Isabella Stewart
 Isabella and her Museum 183–92

Personal Life 159–64, 198
 Relations with Berenson 1, 165–82
Gardner, Jack 163–4, 178, 181–3
Gardner, Museum 1–5, 183–93, 196–8
Genlis, Felicite de 104, 106, 110, 129
George III, King of Great Britain 127
Gerbier, Balthasar 61, 76
Gevaerts, Jan 67
Gillot, James 150
Giordano, Luca 79
Giorgione 7, 27, 141, 175
Giotto 18, 149
Girondin Party 106
Giulio Romano 94
Gombrich, Ernst 13
Gondomar, Count of 60
Gonzaga, Federico, Duke of Mantua 8–9,
 11, 45, 66, 87
Gower, George Granville Leveson-Gower,
 Earl of Gower, later Marquess of
 Stafford and 1st Duke of Sutherland
 127–8, 144
Gramont, Antoine, 2nd Duke of 86–7
Gramont, Antoine, 4th Duke of 86–9
Grand Tour 104, 133–5, 140
Grimm, Melchior 102
Guadarrama Mountains 35, 84
Guiche, Guy Armand, Count of 88
Guillotine, Dr 112
Gutekunst, Otto 157, 168–9, 173, 182
Guzman, Eufrasia de 32

Hackert, Jacob Philipp 135
Hadley, Rollin van N 195
Hamilton, Gavin 147
Hammen, Lorenzo van der 32
Hamilton Palace 149, 155
Hardy, Simeon 111
Harman, Jeremiah 118
Haro, Don Luis, Marquis de Carpio 76–8
Harvard University 1, 166
Hastenbeck, Battle of 101
Havemeyer, Henry Osborne 162
Hearst, William Randolph 183
Henrietta Maria, Queen of England 64, 85,
 88, 90, 94, 141
Henry IV, King of France 34, 53–5, 88, 90
Herrera, Francisco 68, 79
Herrera, Juan de 35
Hertford, Francis Charles Seymour-
 Conway, 3rd Marquess of 147, 149
Hertford, Richard, 4th Marquess of 48,
 147, 149
Holkham Hall 89
Hooper, Edward William 175
Horne, Herbert 180
Horsfall, Thomas Coglan 150
Hortensio, Friar 77

Hume, Abraham 152
Huntington, Henry 162, 170, 183

I Tatti, Villa 182
Industrial Revolution 3, 126, 138, 145,
 148, 157, 161
Infanta see Maria Anna
Innocent XI, Pope 94
Inquisition, Spanish 26, 71
Ironbridge Gorge 138
Isabella, Archduchess of Spanish
 Netherlands, 66
Isabella d'Este, Duchess of Mantua 174
Isabella of Portugal, Empress 35
Isabella, Queen of Spain78

Jacobin Party 105, 11, 120–1
James I, King of England 59–60, 62, 69, 85
James II, King of England 85
James, Henry 164, 186–9
James, William 186
Jameson, Anna 131, 149
Jerusalem, Temple of 36
Joanna of Baden-Baden, Duchess of
 Orléans 98
John of Austria, Don 28, 33, 39, 56
Johnson, Dr 104
Johnson, John G. 162
Jones, Inigo 69, 144
Joseph Ferdinand, Elector of Bavaria 86
Julius II, Pope 14

Kaiser Friedrich Museum, Berlin 144, 156
Kauffmann, Angelica 135
Kent, Princess Victoria of Saxe-Coburg-
 Saalfeld, Duchess of 142
Keppel, Augustus, 1st Viscount, Admiral
 106
Kinnaird, Lord 116–17
Kress, Samuel 162
Kuntshistorisches Museum 65
Kurtz, Andrew 150

Laborde-Mereville, Francois Louis
 Jean-Joseph de 118, 127
Lafayette, Gilbert du Motier, Marquis de
 108, 113–14
La Font de Saint-Yenne 100
Laclos, Pierre Alexandre Choderlos de 110,
 112
Law, John 97
Lawrence, Sir Thomas 65
Le Brun, Charles 84, 89
Le Notre, Andre 84, 89
Le Rouge, Georges 92
Le Vau, Louis 89
Leathart, James 150
Lemercier, Jaques 90

Leo X, Pope 14
Leonardo da Vinci 14, 27, 41, 131, 174
Leoni, Leone 26, 56, 75
Leoni, Pompeo 39
Leopold William, Archduke of Austria 94
Lepanto, Battle of 28, 33, 59
Lerma, Francisco Gomez de Sandoval, Duke of 55, 66
Lindsay, Lord 149
Lippi, Filippino 48
Lorenzo de' Medici 47
Louis, Duke of Orléans 4, 98–101
Louis, Victor 103, 108
Louis XIII, King of France 54, 64, 90
Louis XIV, King of France 3, 54, 73, 81, 83, 91, 95, 97, 103–4, 184
Louis XV, King of France 90, 98, 102, 123
Louis XVI, King of France 3, 102, 106–10, 112, 120–3, 145
Louis XVIII, King of France 114, 145
Louis Philippe, Duke of Orléans 101
Louis Philippe Joseph, called Philippe Egalité, Duke of Orléans
Louis Philippe, King (formerly Duke of Chartres) 106, 110, 121
Louise Henriette de Bourbon, Duchess of Orléans 101
Louise Marie Adelaide de Bourbon, Duchess of Orléans 103
Louvre Museum (formerly Palace), Paris 4, 90, 101, 119, 130, 134
Lucas, Amabel 130
Luxembourg Palace, Paris 100
Lyceum, London 128–30

Maine, Louis Auguste, Duke of 90
Maintenon, Francoise d'Aubigne, Madame de 91
Manchester Art Treasures Exhibition 147–50, 152
Mansart, Jules Hardouin 84, 91
Mantegna, Andrea 8, 174, 189
Marais, Mathieu 92
Marat, Jean-Paul 105, 109, 113, 120
Maria Anna, Infanta of Spain 59–61, 63–4, 141, 171
Maria Teresa, Empress of Austria 107
Marianna of Austria, Queen of Spain 78
Marie Antoinette, Queen of France 107, 109, 112, 114
Marie Leszczynska, Queen of France 98
Mary, Duchess of Burgundy 11
Mary, Queen Consort of Hungary and Governor of the Netherlands 10, 36
Mary I, Queen of England 15, 32
Marx, Karl 148
Mary, Queen of Scots 172

Matthew, Tobie 60
Mawson, Samuel 147
Maximilian, Holy Roman Emperor 48
Mazarin, Jules, Cardinal 54, 78, 87
McKay, William 156
Mellon, Andrew 162, 177
Mendoza, Juan Hurtado de 11, 47
Merkers Mine, Thuringia 194
Metropolitan Museum, New York 162, 177
Meyer, Julius 156
Michelangelo Buonarotti 8, 14, 18, 22, 27, 35, 69, 132–3
Middleton, Thomas 64
Mildmay, William 100
Millais, Sir John Everett 151
Mirabeau, Henri Gabriel Riqueti, Comte de 105, 114
Miranda, Juan Carreno de 79
Mississippi Bubble 98
Molière 84, 90
Molina, Tirso de 55, 73
Monet, Claude 5
Monsigny, Pierre-Alexandre 102
Montespan, Francoise-Athenais, Madame de 90
Montesquieu, Charles-Louis de Secondat, Baron de
Montesson, Charlotte Jeanne Beraud, Madame de Montesson and Duchess of Orléans 102
Montgolfier Bros 105, 108
Monuments Men 193
Mor, Antonio 39
Mora, Juan Gomez de 56
Morelli, Giovanni 153, 166
Muhlberg, Battle of 10
Munch, Edvard 5
Murillo, Bartolome 55, 149
Murray, John 145, 148

Napoleon Buonaparte, Emperor of France 99, 105, 123, 130
Napoleonic Wars 125–32
Nash, John 137–8
National Assembly 111, 114
National Convention 118, 120
National Gallery, London 8, 12, 16, 27, 71, 93, 129, 137, 140–1, 146, 149, 155, 157, 169–70, 177, 182, 198
National Gallery, Washington 162, 176, 189
Necker, Joseph 112
Nelson, Horatio, 1st Viscount and Admiral 125, 129, 132
Nemeitz, Joachim 95
Northcote, James 152

Odescalchi, Don Livio 94
Olivares, Gaspar de Guzman, Count-Duke of 55, 59, 61, 74, 80
Olmsted, Frederick Law 1, 183
Oppenord, Gilles-Marie 91
Orléans Collection 91–5, 99–101, 103–4
Orléans Sale 115–19, 127–31, 134, 137, 141, 144, 148
Osorio, Doña Ana de 32
Otis, Elisha 161
Ovid 3, 11–12, 43, 46–7, 50–1, 59, 72, 99, 135

Pacheco, Francisco 67, 69, 77
Palais-Royal, Paris 3, 90–104, 106, 108–10, 112, 114, 117–22, 129–30
Palazzo Barbaro, Venice 163, 173
Palazzo del Te, Mantua 9; 45
Palazzo Doria, Genoa 9
Palma Giovane 21, 68
Palma Vecchio 21, 27
Palomino, Antonio 33, 40
Parmigianino, Girolamo Francesco Maria Mazzola, called 22, 48
Pastorini, Pastorini de 10
Peel, Sir Robert 149
Peiresc, Nicolas-Claude 67
Penny Dr Nicholas 156, 198
Penthievrè, Louis Jean Marie de Bourbon, Duke of 103
Perez, Antonio 33, 40
Peruggia, Vincenzo 4
Perugino, Pietro 8, 34
Philip II, King of Spain 1, 3, 9, 24, 27–9, 45, 48, 53, 55, 61–3, 77, 80, 84–5, 147, 187, 198
Philip III, King of Spain 55–6, 66, 85
Philip IV, King of Spain 56, 64–70, 73–9, 187, 198
Philip V, King of Spain 3, 86–7
Philippe, Duke of Orléans (brother of Louis XIV) 88, 90
Philippe, Duke of Orléans, Regent of France 3, 88–98, 128
Piano, Renzo 196
Pickwick Papers 143–4
Pierpont Morgan, John 162, 177, 179, 183, 191
Pieve di Cadore 7, 25
Pitt the Younger, William 125, 127, 134
Poesie see Titian
Poliziano, Angelo 47
Poussin, Nicholas 18, 66, 75, 83, 92–3, 131–2, 137
Pozzo, Cassiano del 16, 56
Prince Regent, later George IV, King of Great Britain 115, 121, 136–7
Priscianese, Francesco 25

Provence, Comte de see Louis XVIII
Pückler-Muskau, Prince von 143
Pulteney, Lord 100

Racine, Jean 84
Raleigh, Sir Walter 34
Ransom, Morland & Hammersley, Bankers 116
Raphael, Raffaello Sanzio da Urbino called 14, 22, 65–6, 69, 92, 128–9, 132–3, 137, 155, 162, 176–7, 180
Raynham Hall 89
Rembrandt van Rijn 4, 49, 156, 174, 176, 180
Reni, Guido 49, 93, 132
Repton, Humphrey 137, 143
Reveillon Riots 112
Reynolds, Sir Joshua 65, 121, 133, 142, 152
Ribera, Juseppe de 74
Richelieu, Armand Jean du Plessis, Cardinal 54, 90–1, 95
Rigby, Dr Edward 113
Rizi, Francisco 68, 79
Robber Barons 162
Robbia, Luca della 48
Robespierre, Maximilien 111, 113, 121
Rockerfeller, John D. 162, 183
Rokeby Hall 71
Romano, Giulio 45
Rosand, David 13
Ross, Robert 180
Rostand, Robert 180
Rousseau, Jean Jaques 111
Rubens, Sir Peter Paul 18, 20, 49, 55–7, 66–9, 79, 92–4, 137, 141–2, 174, 180, 187, 198
Rucellai, Giovanni 174
Rudolph II, Emperor
Ruskin, John 150, 164, 166

Saint-Georges, Chevalier de 105
Saint-Simon, Louis de Rouvray, Duke of 84, 96
Salamanca, School of 34
San Quentin, Battle of 33, 35, 38
Sansovino, Jacopo 25
Sanssouci, Potsdam, Palace of 99
Sargent, John Singer 164, 188, 198
Sarto, Andrea del 76
Scharf, George 152
Schiller, Friedrich 33
Sebastiano del Piombo 7, 93, 129
Seers, William T. 184
Seven Years' War 101, 122
Sheepshanks, John 150
Sholes, Christopher 161
Siguenza, Jose de 37

Slade, Thomas Moore 115–18, 127
Stalin, Joseph 162
Stephenson, George 126
Steuart, George 134
Sully, Maximilien de Bethune, Duke of 54

Talleyrand, Charles Maurice de Talleyrand-
 Perigord, later Prince of 105, 114
Tate Gallery, London 150, 183
Tate, Sir Henry 150
Tebaldi, Jacopo 24
Telford, Thomas 127, 138
Teresa of Avila, Saint 34
Thirty Years' War 94
Tibaldi, Pellegrino 38
Tiepolo, Paolo 32
Tintoretto, Jacopo Robusti called 27, 29,
 69, 93, 151, 155
Tirpitz, Admiral von 158
Titian, Tiziano Vecellio called
 Artists influenced by 66–72, 79, 133
 Collectors of 7–8, 55, 58–9, 61–2, 64–5,
 76–8, 134–5, 137, 141, 178–80
 Critical Opinion 18–20, 57, 99–100,
 104, 129–32, 139–40, 151–4
 Personal Relations 24–6
 Poesie 13, 15, 39–44, 52, 87, 89, 92–4
 Relations with Philip II 3, 9–15, 27, 31,
 36–7, 39
 The Rape of Europa 1–5, 16–7, 29,
 42, 56, 81, 123, 142, 146–7, 153–8,
 168–75, 187, 196–8
Toledo, Juan Battista de 35
Torre de la Parada, Palace 73
Townshend, Charles, 2nd Viscount 89
Trafalgar, Battle of 157
Treaty of Amiens 134
Treaty of Munster 78
Treaty of Pyrenees 54
Treaty of Tolentino 138
Tuileries, Paris, Palace of 114, 119
Turner, Dawson 154
Turner, Joseph Mallord William 149–50

Ushant, Battle of 107

Van Dyck, Sir Anthony 65, 133, 137, 177
Varenne, Flight to 116–17
Vargas, Diego de 15, 22
Vasari, Giorgio 18–20, 22, 70
Vaux-le-Vicomte, Chateau 89
Vecellio, Cecilia 25
Vecellio, Orsa 25
Vega, Lope de 55, 68, 71, 73

Velázquez, Diego de 3, 8, 20, 29, 55–6, 59,
 67, 149, 175–6, 180, 198
Verdi, Giuseppe 33
Vermeer, Johannes 4, 165
Vernon, Robert 150
Veronese, Paolo Cagliari called 26–7, 29,
 48–9, 70, 92–3, 131, 153, 155, 176
Versailles, Palace of 84, 89, 91, 100–1,
 103, 109–11, 113, 145
Victoria, Queen of Great Britain 143, 150,
 157
Villa Borghese, Rome 179
Vitoria, Francisco de 34
Voltaire 111
Vouet, Simon 90

Waagen, Dr Gustav 144–7, 152, 156
Walckiers, Edouard 118
Wallace Collection, London 16, 48, 133,
 146
Wallace, Sir Richard 146, 154
War of Spanish Succession 86–7, 89
Watt, James 144
Watteau, Jean-Antoine 49, 176, 198
Watten, J. 139
Watts, A. E. 50–1
Webb, John 144
Werff, Adriaen van der 96
Wellington, Arthur Wellesley, 1st Duke of
 125, 136, 149
West, Benjamin 127
Westminster, Hugh Grosvenor, 1st Duke of
 169–70
Weyden, Roger van der 36
Wharton, Edith 189
Whistler, James McNeil 164, 188, 198
Widener, Peter 176–7
Wilde, Oscar 180
Wilhelm II, Kaiser 158
William III King of England 85
William, Prince of Orange, called William
 the Silent 33
Wilson, Andrew 131
Wilson, Harriete 136
Wolfe, James 122
Worth, Charles 164
Wren, Sir Christopher 83
Wyatt, James 142

Young, Arthur 11

Zorn, Anders 164
Zuccaro, Federico 38
Zurbarán, Francisco de 55